'Khanna's work has a very immersive quality. As well as its very essential emotional aspect, Khanna's work has a strong intellectual base. His carefully conceived shapes appear both natural and man-made, with birds and bunting, fish and flags, figures and toys, motives that also populate his work as a novelist ... at once distinct, personal and universal.'

– Carol Jacoby, Tate Britain

Other books by Balraj Khanna

Fiction:

NATION OF FOOLS (Michael Joseph and Penguin)
SWEET CHILLIES (Constable and Penguin)
MISTS OF SIMLA (Hope Road)
RAJAH, KING OF JUNGLE (Mapin – for children, Illustrated)
INDIAN MAGIC (Hope Road)
LINE OF BLOOD (Palimpsest)

Art:

ART OF MODERN INDIA (Thames & Hudson)
KALIGHAT PAINTINGS (Red Stone Press)
KRISHNA, THE DIVINE LOVER, *Four Centuries of Indian Miniature Painting* (Hayward Gallery, South Bank Centre Publications)
HUMAN AND DIVINE, 2000 YEARS OF INDIAN SCULPTURE. (Hayward Gallery, South Bank Centre Publications)

BALRAJ KHANNA

Born in India
Made in England

Autobiography of an Artist

Unicorn Press

First published in Great Britain in 2021 by Unicorn Press
60 Bracondale
Norwich
NR1 2BE

tradfordhugh@gmail.com
www.unicornpublishing.org

Text and images copyright © 2021 Balraj Khanna

All rights reserved. Without limiting the rights under copyright reserved above, no part of this publication may be reproduced, stored or introduced into a retrieval system, or transmitted, in any form or by any means (electronic, mechanical, photocopying, recording or otherwise), without the prior written permission of both the copyright owner and the publisher of this book.

A CIP record of this book can be obtained from the British Library

ISBN 978 1 916495 74 6

Design by newtonworks.uk
Printed in the UK by Swallowtail Print, Norwich

For
FRANCINE

CONTENTS

PART ONE: THE BEGINNING 1

CAST OF FAMILY MEMBERS 2
WHAT'S IN A NAME? 2
PARIS OF THE PUNJAB 10
A TOWN WHERE NO ONE LOCKED THEIR DOORS 22
A NEW LEAF 50
ELECTRICITY IN DUST 61
THE CHARM AND THE SHOCK OF THE NEW 73
LOVE AT FIRST SIGHT 87
NOTHING TO DO BUT SOMETHING TO SEE 101
A LONG AND BEAUTIFUL GOODBYE 112

PART TWO: MY BRAVE NEW WORLD 123

GLOSSARY 235

WORK DURING THE COVID-19 PANDEMIC 236

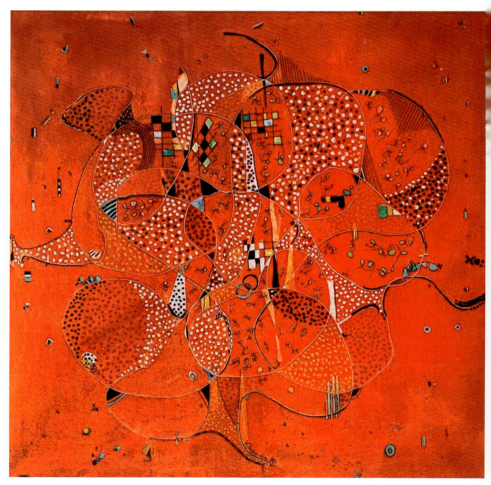

Tara Devi, 1970, oil on canvas, 52 x 52 in.

ACKNOWLEDGEMENTS

My heart-felt thanks to pow-wowing friends for their unflinching support throughout the writing of this book:

Mihir Bose
Yvonne Bristow
Spencer Cane
Caroline Collier
Andrew Dempsey
Dimitri Dimitriadis-Khanna
Isobel Johnstone
Ishrat Kanga
Roger Malbert

Reginald Massey
Laura Morris
Hubert Nazareth
Justyn Philip
Paul Pickering
Norman Smith
Jay Visvadeva
Dan Williams

My Angels of Inspiration,
RANI and KAUSHALIYA

'One of the most distinguished artists working in England.'
— Bryan Robertson

PART ONE

THE BEGINNING

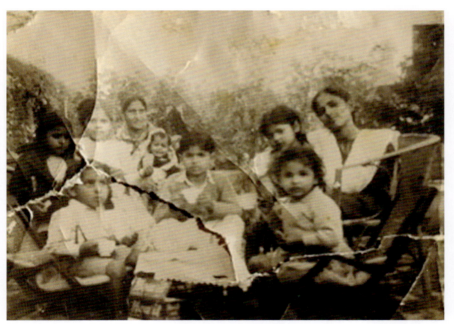

Early photograph with my family

CAST OF FAMILY MEMBERS

Mother – Biji, Kaushaliya Rani Khanna
Father – Papaji, Amar Nath Khanna, or ANK
Grandfather – Bauji, Lala (honorific title) Lal Chand Khanna
Grandmother – Bhabiji
Maternal Grandfather – Nanaji

WHAT'S IN A NAME?

In a country notorious for its ever-climbing birth rate, not every birth is wanted nor looked forward to for the fear of it being that of a girl. But as chance would have it, my birth was greatly looked forward to. A renowned divine visionary visiting my hometown ancient Jhang in the Punjab, had seen me in the stars. This had lifted greatly the spirits of my deeply aggrieved parents – they had lost a son aged one only the previous year.

Although not derivative in any historical sense – Indian history, legend or lore boasts no Balraj who did anything to merit a mention in the despatches – the name given to me was dismally unoriginal. For it had already been used by my parents, Amar Nath and Kaushaliya Rani, for my older sibling two years before my arrival, making me second hand from day one, a sort of persona only half-grata.

I turned out to be a replica of my lost sibling. Just because I was, I was given his name. But to ensure that I did not inherit Balraj the First's karma, the learned sage recommended that the name of the god Krishna be added to Balraj the Second like a charm. So I became Balraj Krishan. To make the whole thing watertight, I was accorded a nickname – Balli.

Born healthy, I remained so, much to everybody's concealed delight, concealed because it tempted fate to gloat over one's progeny's good

fortune. Biji daily put a dot of soot from the *chapati* hotplate on my cheek to ward off the evil eye.

Legend holds further that because of me being the carbon copy of my lost elder brother, my mother never needed the services of an ayah, a nanny, even though there always was one. Young maidens of the neighbourhood vied with each other to hold me to their bosom. Was it from those early days that I grew to be so fond of that part of the female anatomy, only to hold the belief in later life that a woman's breasts were nature's most beautiful creation? I'll come to that when I grow up.

. . .

One of my earliest memories is that of a sartorial nature. It concerns how I was dressed when I was two or three. I wore the common white cotton *churidar* pyjamas which inspired the jodhpurs of the equestrian fame. There was one striking difference, though. These leggings had a wide opening in front which continued to my backside, leaving my little luli and my derrière fully exposed to the elements. This was not a cloth-saving device, but one that made sense. Thus when a call of nature came, it was answered wherever I was. If I wore nothing at all and was seen running around, grown-ups pointed a finger at my bare bottom and cried, 'Shame, shame.' This was the first English word I learnt. I knew what it meant without anyone ever telling me.

But the more resonant memory of my early days is that of my father going away. I must have been four. We all went to Jhang's kerosene-lit railway station to see him off, the first time I had seen a steam engine and a train. I was fascinated.

Papaji was taking the night train to a far off place in Uttar Pradesh, Mhow, a military town. He had a degree in engineering from Lahore where he worked. Then he was selected to join the Mhow Military College as an Officer Cadet. Thanks to the Germans and the Japanese, the War in Europe and Burma had been going disastrously badly

for Britain. More and more Indian soldiers were needed – though a million and a half were already fighting for the King Emperor. More Indian officers were needed too – the Japanese were at the gates.

The family that evening was euphoric. For the entire Khanna clan it was a matter of pride that one of its sons was going to become an officer in the British Indian Army! But I was in tears – I didn't want my Papaji to go anywhere. His promise that he would come home at regular intervals did nothing to prevent tears washing my cheeks. I stopped crying only when he said:

'Alright then, I'm not coming back if you don't stop.'

Jhang was un-electrified. At night, streets were lit by oil lamps on tall wooden posts. At home, portable kerosene lanterns called *laltans* of a 19th-century design to be found all over rural India even today, did sterling work.

I had two big brothers – Eudhishter Raj and Prithvi Raj, or Pithi for short. Seven years older than me, Pithi was the more enterprising. He invented a secret night sport. It was dangerous but irresistible. If it went wrong, our Gran's name would be dragged in dust. Plus a serious shoe-beating for us.

Every Tuesday and Thursday evening, ladies from the neighbourhood went to the famous Hindu temple nearby singly or in twos to beg the Laat Saheb for boons – a sick child getting well, a son for the pregnant daughter-in-law, the husband's shop to do better … They carried in their hands a round brass tray containing sweets, fruits and flowers for the Laat Saheb. In the middle of the tray sat a tiny earthen oil *dia* lamp with a burning wick to light their passage to and fro. We let them go unimpeded, but on their way back home, we swooped on them from the kerb and blew off their lamps. Laughing, we ran away in a hail of bullets made of unholy words.

The family slept under the stars in the summer. The whole world did – streets became interminable wards of thousands in rude health with only a few feet separating them. But for my family, string *charpoys*

were laid out in a long row in the high-walled courtyard in front of our grandfather's three-storey house. My grandparents, Bauji and Bhabiji, slept on the roof of the second floor, the only ones to do so.

I shared my mother's bed. One night while Papaji was away, something happened which makes me blush even now whenever I think about it. I have never told anyone about it other than my wife, Francine, which I did a quarter of a century later. So burningly shameful it was.

My mother slept on her right side. I lay on my right side behind her. I don't remember how early or late it was, but I was certain that Biji was fast asleep.

I had an erection – my 3-inch *luli* sticking out like a finger. I didn't know why, but I began to push it against Biji's soft round bottom – once, twice, thrice …

Obviously, Biji was not asleep. Or perhaps was woken up by what I was doing. For, she began to shake with laughter. Then she simply pushed me away, mumbling, 'Mother fucker! Wait till your father comes home.'

Sometime later, Papaji did come home from Mhow for a short break, filling the house with ripples of joy. I have no idea what or if Biji said anything to him about me, though in later life I would have loved to have known. He wore an officer's uniform and hat. Blessed with a matinée idol's looks, Officer Cadet A.N. Khanna took everybody's breath away. He had brought a present for his youngest son – Balli, me – that took my breath away. It was a tiny boy scout torch. He arrived one morning. Before nightfall, the torch stopped working. All day long with friends, I had gone into dark corners and created 'night' by shrouding ourselves in blankets, switching it on and off. Batteries! And there was no electrical shop around!

The War-time Jhang was a faceless twentieth century version of a Harrapan settlement by the banks of the Chenab, the largest of Punjab's five famous rivers. It had a mixed population of 50,000 Hindus

and Muslims. For generations, the two communities had lived peacefully together. Then fell upon them the cataclysm of 1947, Partition, when India was unnecessarily and brutally divided. Jhang went to the new country Pakistan for Muslims. Overnight, neighbours of centuries old amity succumbed to blood-soaked enmity and the country became a slaughterhouse. Hindus of Jhang had to flee to seek safety in independent Hindu India.

. . .

Biji's father, Nanaji, had been Jhang's *Chaudhry*, its well-heeled Mayor. My father's father, old Bauji lived off his lands, a man of his own means – we all lived off his means.

Naniji I never saw because she was a *swaragwasi*, a heaven-dweller, and had been one for years.

Nanaji supported a head full of henna'd flaming red hair, He was tall, broad shouldered and commanding.

Bauji was bald, diminutive and uncommanding. In fact, he never opened his mouth. Yet he held all around him in the palm of his hand. Like Gandhi, he spoke with his silence. But unlike Gandhi whose silence was a political weapon, Bauji's silence was for God, we were told. He was inordinately fond of the British whom he thought to be the best people on earth, yet he gave generously to the Congress party to fight them and to get rid of them. Whenever he came down to where we were, we all talked in whispers and walked on tiptoes.

Bhabiji was different. Being a gold, silver and copper mine of stories, the thin bundle of angular bones made the place go abuzz. She could rattle off chunks of the epics of Ramayana and Mahabharata, enthralling us. Uneducated, she was an authority on the Bhagavad Gita. Gran was the acknowledged intellect of Jhang's exclusive Kashatriya sub-caste group of the Khannas, Malhotras and Kapoors who never married outside this group.

. . .

THE BEGINNING

Four years senior to me, my sister Raj was striking looking. She was popular with the girls of the neighbourhood and she had many friends among them. Raj took me along whenever she went to her friends' houses to play – no other girls brought their little brothers with them. Their favourite pastime was playing with rag-dolls. This always took place on the *barsati* rain shelter that every house had on the roof.

Because of Bauji's prohibitive life-style, the roof of our house was out. So the girls had to assemble on someone else's. They brought pieces of all kinds of cloth, scissors, thread and needles. The girls sat down on *charpoys* on which some families slept on the roof in the summer. They designed, cut and stitched up arms and legs and heads. They made he-dolls and she-dolls. Then they arranged their marriages. Singing and dancing, they held weddings and feasted on delicious imaginary food with loud oohs and aahs. I also ate the invisible stuff and enjoyed it greatly, issuing loud oohs and aahs with them.

One afternoon a girl bigger than my sister initiated a discussion pertaining to real marriages between grownups. 10 or 11, she seemed to be the leader of the bevy. She imparted an important piece of information to the 6 or 8 girls present. It concerned me, the only boy among them. She said I had something which none of them did. Then I was made to prove that she was right. Without the least bit of embarrassment, I rose to the occasion and obliged. I stood up, undid the fly of my shorts and revealed myself in all my glory. The head girl made me lie down on a *charpoy,* facing the ceiling of the *barsati*. The string bed felt hot under me. She came and sat astride me and jerked herself up and down a few times. Then one by one after her all other girls came and did to me, or rather, upon me, what the boss girl had done. I had no idea what was going on, but I have a vivid recollection I thoroughly enjoyed being the centre of female attention.

. . .

The Monsoon season in Jhang was spectacular, as elsewhere in the country. Going out when it was pelting down was strictly forbidden. But I found rain so irresistible, I used to peel off my shirt and just run upstairs to the roof to receive the matchless gift of cold and huge raindrops hitting my hot and bare back. It became a habit.

Once while frolicking in a delicious downpour on Nanaji's roof I saw a remarkable, an unbelievable sight. His roof and the side overlooking the main road and the world beyond were under universal deluge. But bright sunlight rained a few hundred yards away on the other side with a silvery crescent of the monsoon moon dangling in the blue sky! I gasped in wonder, unable to believe my eyes – how could that be, the moon shone only at night! But it lasted a mere few minutes. Then it was the dark and delightful deluge again.

During one such supreme session with my brothers and their friends, I heard them talk about a 'super bomb' which could make a hole in the earth fifty times the width of the Ganda Nullah. When I expressed my disbelief, I was told that two such bombs had already gone off in a country called Japan, incinerating two times more people than those of all Jhang.

From Nanaji's roof some time later, I saw yet another memorable sight as awesome as it was flesh-creeping. We had been forewarned it would be. Yet when the event took place, it left me agog with incomprehension at man's capacity for disporting himself strangely, oddly, perversely.

We had been forbidden to set foot outside Nanaji's house that sunny winter afternoon. Why, it became clear soon, and frighteningly so. We heard a distant roar, the sort a vociferous crowd emits from afar. As it got louder, in view came an immensely tall black cloth structure on a float. Men in black sat in it. Men in black clung to it. Men in black surrounded it. Men in black followed it – thousands of them. They were chanting just two words loudly and hysterically. Those words sounded to me, now aged five, like:

'HOW SEN, HOW SEN …'

Then, to my utter horror, I saw them beating themselves with whips and metal chains with sharp blades. It was only when I saw some of them lacerating themselves that I cried:

'LOOK, LOOK, LOOK!'

Pithi gave me a slap on the head.

'Shut up. Don't draw attention. It's dangerous,'

'Who are they?'

'Muslims. It's an important day for them.'

I couldn't understand why did they to beat themselves even if it was an important day for them? I watched, dumbfounded.

'… HOW SEN … HOW SEN …'

And the chant became more and more frenetic. There were women in black *burqas*, beating their breasts like I had seen women mourners do elsewhere. I was even more puzzled, and fascinated – why were *they* hurting themselves? They were not pretending, they were doing it for real. But why? My brothers could not tell me.

. . .

Not long after, Papaji came back. He had come back for good, putting the house in a dark mood. He had not been sacked. But he would not become an army officer after all. I learnt years later that his good looks had not served him well in that town of camp followers – a besotted Anglo-Indian lady one of many in the army station of Mhow saw to that. His fault was that he did not respond. Spurned, the woman took to the poisoned quill. His British superiors gave him an 'honourable discharge'.

Papaji now had to look for a job as an electrical engineer. Unelectrified Jhang was not the place for it. Well-qualified, talented and reasonably well-connected, he soon found one in the capital of the Punjab – Lahore 120 miles away. Known as the Paris of the Punjab, the Mughal princely city of Lahore was a city of untold glamour. We

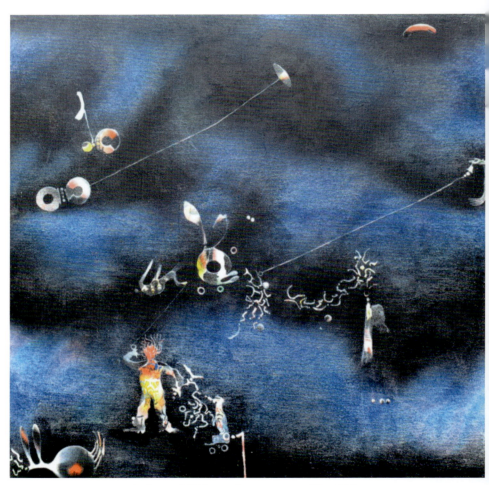

Jadugar, 1980, acrylic on canvas, 60 x 60 in.

would follow him after he had settled down, and found a place for us to join him. We couldn't wait to be in the city of gold and stars.

PARIS OF THE PUNJAB

Ancient and shabby, Jhang was without electricity. Also ancient but glamorous, Lahore was electrifying. The curious 5-year old me should have got lost on the Khannas' very first day in the Punjab's first city. But a curfew had been imposed by the high command from the moment we entered our rented house in Gawal Mandi. I was not to venture out of the house on my own. Lahore was too grand a metropolis for a simpleton like me from a backward place like Jhang. It was BIG and BAD – little kids got abducted every day and sold to God knew who. Its population of a million and a half – Hindus, Muslims and Sikhs – made the city race like an agitated animal's heart, its motor traffic murderous.

A strange surprise lay in store for my brothers and me. It was late summer, but still hot. We were at siesta. When we woke up late in the afternoon, we went up to inspect the world from the roof of our tall house. We were staggered. Not by the grand vistas of lofty but higgledy-piggledy civic architecture before us, but what was above us. The deep blue yonder was awash with hundreds of multi-coloured little shapes! What I beheld on our first day in Lahore was a sensational tournament of flying colours. It was a dance in the sky of a dizzying display. And its impression made on me that day was everlasting.

Decades later in London, kites, or rather the idea of flight in all its fancy would inform my work as a painter. Not kites as such, but flight-worthy shapes, airborne shapes would appear in my paintings against scintillating backgrounds rich in colours. Forms ascending, descending, levitating, swooping, diving, continue to enrich my visual repertoire as an ever-experimenting artist.

Child is the father of the man, Wordsworth said. My childhood undoubtedly fathered my imagination. Kite flying and street performers – jugglers, magicians, sword swallowers and fire eaters – whom I first saw in Gawal Mandi, Lahore, in the next few months would begin to illumine my work as a painter decades later. Their memories would flood back to fill my canvases to my delight, making my work my *raison d'être*.

Kite flying was the most popular, strictly male, sport in Lahore. Named after one of Lord Ram's twin sons, Luv, Lahore was the commercial centre of India north of Delhi. It was its throbbing heart for everything else as well, including education and the arts.

Lahore's famed thousand and one bazaars buzzed non-stop with both business and trickery. The queen of these bazaars was the fabulous one bearing the name of a late 16th century dancing girl of surpassing allure, Anarkali. Translated into English, the name means a pomegranate blossom. Anarkali adorned the court of the greatest of Mughal emperors, Akbar. But the *femme fatale* nearly brought his royal house down when his only son and heir, Salim, fell for her groin-grabbing allure and rose in revolt against a disapproving dad.

Lahore prided on its great 17th century Mughal fort and the famed Shalimar Gardens created by the revolting Salim when he became Emperor Jahangir. The historic city boasted many must-sees. Among them, a great museum founded by none other than Rudyard Kipling's father. On my first visit there one day with Papaji, I saw at its gate the gigantic cannon Zum Zum sung about famously in his *Kim*. I leapt off Papaji's Raleigh and did what any boy would have done, climbed up one of its giant wheels and sat astride its long barrel, and shouted:

'FIRE!'

. . .

How narrow were the roads of Jhang, how wide those of Lahore! My brothers didn't seem thrilled by it nor could they understand why I

was so. Something even more exciting for me was to watch the traffic. Mad wheel and piston, madder hoof and the naked leg competed with each other to get ahead. It was chaos, lovely chaos, grand and gargantuan. But it worked. 'Deliveries' got delivered, appointments got kept.

And Lahore had what I had not seen before – a grassy park. I was out for a walk with Pithi early one hot morning. We came to an intensely green lawn that twinkled with tiny diamonds of dew. The park was cordoned off with ground-hugging black metal chains. Unanimously, we kicked our shoes off. Walking on the deliciously cool carpet of grass trimmed to perfection was heaven.

In the middle of another such park, I saw a tall black metal statue of a big woman sitting on a big black chair. She wore a black crown and I was told she used to be queen of India a long time ago. That she lived in England across the seven seas. Naturally, it begged the question if she had been our queen then why did she live in distant England? I was informed she was an English *memsahib* and she was queen of England, too. I couldn't help asking then why was she black like a *bhangi* untouchable, and not white and beautiful like all English people were supposed to be? I must here point out that I had never seen a *gora* white person in Jhang.

I was to see one soon, an Englishman. I saw him at a *chawk* Road junction. His face was more red than white, the colour of a pomegranate. He was driving a monstrous motorbike. Attached to it was a buggy. In it sat an apparition – a young lady of supreme loveliness made of pink porcelain. The man should have stopped at the busy road junction where Pithi and I stood idly. But the dark *desi* policeman in khaki stopped the traffic instead and let him pass.

'An Englishman and his *mem*. Would you like to marry a *mem* when you grow up?' Pithi asked, somewhat prophetically.

'Marry a mem? What a good idea,' I replied, laughing (I married a French girl – Francine – twenty years later).

I had not attended school in Jhang. Time had come for me to be admitted to one. In fact, both Raj and I were put in the same one and only co-educational school in all Punjab, the fashionable Saraswati College. Modelled on English Public Schools, it attracted upper class Hindu boys and girls with English as the medium of instruction. Raj in her 4th year, had joined it soon after our arrival in the Punjab capital. As it happened, that was also the first day at this school of another five-year old boy.

I arrived there with Papaji and Biji in a horse-drawn tonga that cost eight annas for the half mile journey. This chappie made his appearance with his mum and dad on a different mode of transport. The family made a grand entrance, arriving at the school seated in the colourful howdah of a well-caparisoned jumbo elephant – in those days some super rich Indians had the odd elephant at their stables.

My first lesson was inaugurated in the most delicious manner imaginable. As the class of 20 or 25 sat down at our little desks, China plates were placed before each one of us. Then they were heaped with choice sweets. I was nervous. I was confused. Above all, I was bowled over by my welcome. Then I thought that maybe that was how a school day began. I fervidly looked forward to tomorrow. But with no elephant in sight, tomorrow was another day – long, full of yawns, interminable.

The college was named after the ancient Hindu goddess of learning and the arts – Saraswati. It was also the name of a sacred and the sixth of the Punjab rivers which flowed through it in the Vedic times of pre-history and mentioned repeatedly in ancient texts. The river dried up with the sluggish passage of time, but the goddess continued in full flow.

Within days of my being at school, my form teacher, a man, said I was too bright for the class. Therefore, I was to be 'upped'. In the 2nd year class, everybody was a genius and I the only dumb bell. They knew everything and I knew nothing. I was miserable. Second day

into this torture, I stole back to my old classroom and sat at the very back. I was spotted straight away and ordered out.

Instead of going back to my new class, I went and stationed myself outside Raj's classroom door. Raj's teacher, a young woman, spotted me, a first-year fool standing there idly. She came and asked who I was and what was doing there? I told her I was my sister's brother and that I wanted to see her.

'What for?'

'It's private.'

'Oh, really? But won't you tell me?'

I shook my head. The teacher went back to her room and had a word with Raj. Raj came, demanding what on earth was I doing there. I told her that I didn't want to go to my new class but that my old teacher wouldn't have me back. Raj gave me a thorough scolding. I was making a fool of myself and her in the eyes of her class. But I didn't care.

'Are you going to stand here all day long till home time?'

'Yes.'

Serious haggling followed, Raj cajoling and pleading with me, making this mouth-watering promise and that. But I wouldn't budge from her classroom door. Finally, she issued a threat.

'I'll never speak to you again if you don't …'

I couldn't bear the thought of that. I sulked back.

. . .

Basant Panchami was Lahore's Henley Regatta, but high up in the heavens. It was Christmas, Diwali and *Eid* of kite-flying, its *Le Mans*. On this day, *Basant*, heralding spring and the harvest season, the Lahore sky used to be a riotous stage of flying forms. That its memories would remain dormant in me for four decades and then command attention on my canvases has fascinated me. As I seldom think how I work, I rely on suggestions made to me by what I do as a painter, that

is, as I go along. Forms made or arrived at intuitively set in motion a chain reaction and, thus, I am just led on. From there on, the journey becomes as meaningful as the arrival, the point when I stop working on a piece of work. My work must delight me. Unless it does, I do not it expect to delight others.

At about that time one afternoon, Biji sent me on an errand. I had to collect a garment from a tailor in a nearby bazaar, a blouse or something. She had been given that day for collection so I was dispatched to fetch it. I raced along, hopping and skipping. But the garment was not quite ready yet. The man was at it, though, sitting cross-legged. He was rolling the wheel handle of his Singer sewing machine and singing to himself. He sat in the doorway of his shop that overlooked the madly busy bazaar. Right by the front of his shop door ran a sewer. A wooden plank across the three-foot flowing ditch connected the shop to the bazaar.

'Sit you down, son, and watch the world go by,' the tailor, a fatherly Sikh gentleman, urged me.

I sat down on the door ledge, but instead of watching the world go by, I found myself something more interesting to look at – the mobile water channel. It was a strange thing to do – stare at a sewer. It became stranger as I stared on. Soon it became a fascinating spectacle, as engrossing as the one I beheld every day from my rooftop. The slow moving water became the sky hosting stupendous duels. Little bits of debris floating became kites of different shapes and colours. They dipped and dived past each other, engaging each other as if some invisible fliers were controlling their aquatic acrobatics. One rapidly moving sequence of water-borne shapes was instantly followed by another in this ravishing drama in the gutter. I really, really thought at the time that they were real things. So engrossed I was in what I beheld that I had to be physically nudged out of my dreamy delectation.

'Here. Ready. Run along home.'

Decades later, I would see these forms and shapes again levitating in space, or half-submerged in the sea. Looking at the sky or at the sea, there are no portraits to be found, nor just one single event. Innumerable imagined events take place at the same time but against the same backdrop of the Deep or Space. This is how it has happened throughout my career – a helpful diary of unwritten visual notes.

One day after a rainfall, I saw what every child imagines – creatures great and small in the stains left on the road surface. On the white-painted wall of our *baithak* drawing room, I saw another memorable spectacle – two great armies facing each other as in the Mahabharata.

With the exception of Papaji, the whole family lay on the drawing room carpet under the ceiling fan for the daily siesta. When I described what I was seeing, I was told not to be a stupid boy and to go back to sleep. But a loud noise – DUM DUM DUM DUM DUM – from a dholuk drum in the street made us jump to our feet, for we knew what it represented. Out went our siesta from the windows and hurriedly we followed.

Besides its wondrous sky sport, Lahore had other spectacles that would leave an indelible mark on my psyche. These were brought to our doorstep, literally.

Every other week, small troupes of men and boys would take possession of our street. They were the *madaris* and *jamuras*, jugglers. They were fire-eaters, sword-swallowers, monkey masters, snake charmers, tightropewalkers, … who beat their trade drums and everyone spilled out of their houses.

The *Madari* was a self-assured man of forty, his assistant *Jamura* a cheeky lad of 14 or 15. But he did what he was told. And he was told to do all sorts of things, including tell the spectators' fortunes and finding '100% or money back' solutions for their problems for a small fee, of course. I had seen a *Jamura* convert himself into a monkey complete with a tail and red-painted face and bottom hop and jump around like a monkey stealing fountain pens from people's pockets

being a pickpocket, or tugging at the *bodi* topknot of a Brahmin, or pulling the dhoti off a bania amidst deafening roars of laughter from the crowd. Then, hat in hand, the loveable oaf danced around for the collection from a six-deep throng around.

One evening, a friend and I found a bicycle tyre in the street. We took turns to run around with it till we got tired. The question then arose who could take it home?

'It's mine. I saw it first.'

'I saw it before you. So it is mine. So get lost.'

We snatched and pulled at opposing ends of the round rubber wheel. We pulled with all our might. Then the bastard just let go. I fell, my head hitting the brick floor. I passed out. People fussed over me, but to no good effect. They thought I was dead. They carried me home. But within minutes, I came alive. I vomited and neighbours said it was a good sign. A doctor was called. Wearing a white linen suit, he came rushing on his bicycle. He said just what the neighbours had, took his fee of two rupees and rushed away.

A white-haired old gentleman living in our street used to hold races of all 5–7 year olds and watched with interest from his chair. Whoever came first, the dhoti-clad old man gave a reward to – a coin. I never came first. But one evening I did. The old man gave me a coin and made me sit in his lap, an honour and a sign of recognition of my talent at running. All other kids milled around noisily. When I wanted to jump up and join them, the man held on to me. It was then I realised that he had something hard sticking out of his middle, a sort of wooden peg. The man started caressing my thighs. He took my hand and placed it inside his dhoti. It was wet and gluey. I leapt out of his lap and ran away faster than in the race.

. . .

The first sign of impending troubles I witnessed appeared right outside our school one lunch hour the next summer. It was blazing hot. A long

jaloos procession of Muslim men carrying placards in Urdu came to a halt right in front of my school. They were shouting the well-known new slogan: Pakistan *Zindabad*. Long Live Pakistan.

Everyone knew that the Saraswati College was a Hindu institute of learning. The procession's stopping there and shouting Muslim slogans was construed as a deliberate act of provocation. An atmosphere of palpable unease descended on the street and the school. Teachers ordered children outside to go right in. Inside the school, other teachers shouted orders at us all to go up to the vast roof of the school building. A stampede for the stairs began. We all assembled on the roof and clung to its long wall overlooking the street and watched.

Down below, it became chaotic, forbidding, frightening. Danger hung in the street like a bad monsoon cloud. We saw our usually mild-mannered Principal, man not much older than my father, argue with the Muslim leaders. A number of our men teachers and some Hindu-Sikh young men passing by stood around him, as if they were guarding him. The Muslim men now shouted:

'Mohhamed Ali Jinnah Zindabad. Pakistan Zindabad.'

The Hindu-Sikh retort to it was:

'Mahatma Gandhi Zindabad. Jawaharlal Nehru Zindabad.'

It all looked very ugly. Then a piece of a broken bottle came flying from nowhere. It hit our Principal on the fore-head. We saw blood cover his whole face. The girls on the roof began screaming hysterically. In the street, a scuffle broke out. Holding our breath, we watched with wide open mouths, our hearts pounding.

What next?

It seemed that the deadly rumours of approaching violence that had suddenly become loudly audible were about to become true before our very eyes. Raj and I were terrified that our Principal was going to be badly harmed, even killed. There were hundreds of Muslim marchers. Our Principal only had a few Hindus and Sikhs around him. Half a dozen policemen in khaki stood idly by, resting their elbows on their

lathis. With bated breath, we looked on and wished our bloodied Principal would run back to the school and shut the gate. But down in the street, he was talking fast and gesticulating to men at the head of the march. Then, luckily, the march moved on. The school roof became flooded with sighs of relief. A serious clash had been averted. It was touch and go.

Raj reported the incident at home. A stern warning was issued to us – never to go anywhere near such processions.

Such protest marches were becoming more regular as the year 1946 advanced. Another took place near our house early one evening. Raj and I couldn't keep ourselves indoors. It turned out to be a peaceful protest. But Papaji was very annoyed. When we got home, he pulled Raj by the ribbon of her ponytail. She slipped and fell, her head hitting the floor. She passed out. Biji went into hysterics:

'YOU'VE KILLED MY DAUGHTER. YOU'VE KILLED MY DAUGHTER.'

Dumbfounded, we also thought the worst. An air of mourning descended on us. But Papaji threw some water on Raj's face and Raj woke up. Then he hugged her and started crying. I had never seen my father cry. We all started crying. Then, just like that, we all laughed. I did what Papaji had done. I hugged Raj. Then everybody hugged her. Now *she* started crying.

That was the first time I became aware that I was always aping Papaji. He was a voracious reader. In time, I took to reading. He wrote poetry. His chosen medium was exquisite Urdu. I became an artist – mine irresistible paint.

My father was a born entertainer, too. Every now and then a number of his poet friends assembled in our *baithak*.

Three windows opening to the busy street provided ample fresh air even though an electric ceiling fan whirred overhead. Glasses of ice-cold lime drink in hand, they recited their stuff with heartfelt flair. I noticed one day that as my father recited his compositions, the hair on

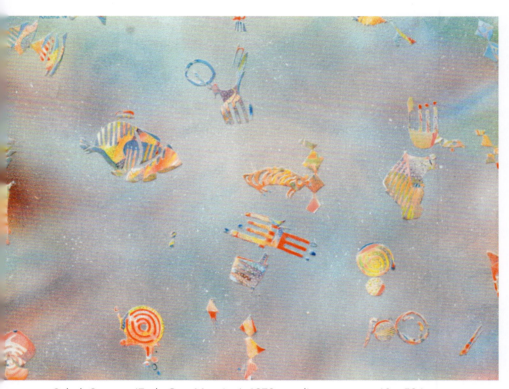
Subah Saveray (Early One Morning), 1978, acrylic on canvas, 60 x 50 in.

his fore arms and his shaven handsome face stood on end. He always stood up to recite. His moving loud, sonorous voice never failed to bring the neighbours to the *baithak* windows. His recitation and the spellbound audience made me feel he was special, my father!

Twenty-five years later, painting alone in a make-shift studio in my sister-in-law's garage-cum-*biranderie* and wine cellar in Metz, France, I would sing songs loudly that I had learnt as a boy in India. There were two small windows that gave me a good amount of daylight in the afternoons. Francine was upstairs with baby Nathalie. Her sister, Dr Caludine Kieffer was at her surgery in the Zup a kilometre away, and not far off their mother, Maman, at work by Metz's ugly post office and its hideous railways station (both built during the Germanic rule of that region between 1860 and 1918). But Maman and Claudine would be home at 6.30 in time for an aperitif. I crooned till then. I never tired.

. . .

Back in Lahore, I fell in love. The object of my passion was Miss. I owe my love for the English language to her – my favourite teacher teaching me my favourite subject.

Female teachers at the Saraswati College usually wore a muslin or silk *kamiz* over a cotton *salwar*. They supported a long chiffon scarf to cover their breasts as required by the society. But my English teacher always wore diaphanous silk saris. My favourite colour being red, I loved her more on days when she wore was a shimmering red sari. That must have been her favourite, too. For Miss wore it a lot. She was tall and slim with a very narrow waist. Because of the high blouse, I could see several inches of her bare flesh. She was so beautiful, all I could do in her lessons was just look at her.

I used to have fantasies about Miss taking me home where I would put my arms around her waist (I was only that high), hug her with all my strength and kiss her naked belly.

One of my classmates, the elephant boy who used to sit next to me, absented himself from school for a few days. When he returned, Miss asked him the obvious question where had he been? The boy had been somewhere with his family to attend a wedding. How nice, Miss said and then asked him to describe the bride and the groom. When he failed to so, Miss asked him what sort of a bride would he like for himself when he grew up. Even at that the dumbbell couldn't say anything, causing the girls to giggle. Then Miss turned to me.

'Balli, what sort of bride would you like to have when you grow up?'

'Someone just like you, Miss.'

Lahore was peaceful as it stepped into a cold new year. But only on the surface. For sinister under-currents had begun to make themselves felt. Every night vigilante groups took over. Banging steel-tipped staffs on the brick street floor, they shouted: *'Jagte Raho. Khabardar.'* Stay awake. Be cautious.

An air of foreboding filled our long nights.

But before the conflagration engulfed the Mughal princely city, a wonderful thing happened to the Khannas of Lahore. Papaji received a leaping unexpected promotion and a transfer to an unheard of place called Qadian 50 miles east.

A TOWN WHERE NO ONE LOCKED THEIR DOORS

In the 1.5 million metropolis of Lahore, Amar Nath Khanna was a small fry. In remote Qadian of about 15,000, as the Sub-Divisional Officer of PWD and the market town's boss of electricity, ANK was the top government officer. Overnight, he became a VIP and in India such hierarchies shine brighter than gold. We heard, though, that his colleagues back in Lahore had been stunned and stung by his promotion – several older and more senior ones had been passed over. And he had only been in service for less than two years!

Qadian also had its feet buried in the dust of time. A few hundred Hindu/Sikh families at its core formed its commercial heart. This was the old Qadian. The new Qadian around it consisted of about 10,000 souls, affluent Ahmadi Muslims all. They were all involved in small-scale industries.

Winter had set in. Papaji went on his own first, to 'put his feet down' and find somewhere to live. The family would join him later. In due course, he was back – he loved his new job and he had found a lovely place for us all. We were jubilant. But because of Eudhishter and Pithi's exams looming, the whole family couldn't go to Qadian with him just yet. So he took Raj and me to keep him company.

Thus, I experienced my first train journey. We had to change trains at Amritsar, the Sikh holy city of the famous Golden Temple. It was early evening as we set out for the next and the final leg of our journey to Qadian, the last station on the line. A full moon appeared as soon as we entered the endless countryside. I noticed to my utter amazement that it was moving with us. We were leaving the trees and other distant objects behind, but the low moon far away above the skyline was travelling with us just as fast as our train. I simply could not comprehend. I had to ask my father to explain this wonder of nature.

Qadian station was a one-platform, one-train-a-day lonesome place. It was pitch dark when we got there. A 20-minute tonga ride brought us to a large *kothi* villa with a very large fragrant garden. We were greeted by rose bushes and *raat ki rani* potted plants. Our part of the villa was only one-third of a sprawling mansion known as the White *Kothi* that belonged to an Ahmadi grandee. Called Khan Sahib, the soft-spoken gentleman lived in the main edifice with his large family – several sons, daughters and other relatives.

With an eye for vivacity, ANK had rented this self-contained part of the great White House. Only half of its vast garden was ours. A tall, whitewashed wall went around the house. It was a house to grow up in.

THE BEGINNING

It was also a very lonely house in that city of wide empty spaces. Papaji went to office early in the morning. A servant of 18 or 20, the dark skinned Buaditta, came to cook us lunch then he went away for hours. We were alone in that park-sized walled garden for the rest of the time. We made friends soon, though, with two Khan boys and their sister Tyeba. Tubby Shahad was my age. A permanent line of milky yellow stuff resided between his nostrils and the upper lip. It moved upward when he sniffled, but only for a few seconds. Then the mayonnaise slid down again. His elder brother Salim was a contemporary of Raj. When Salim saw Shahad sniffle, he barked:

'Nose, you fool.'

Shahad quickly wiped his nose on his sleeve and Salim gave him a whack on his head.

Their sister, beautiful Tyeba was much older – 20 or 22. We met practically every day. A door in the middle of our long pillared veranda linked us to their part of the villa.

Khan Sahib had other grown up daughters, but Tyeba took us to her heart. She was tall and ravishing. We hadn't started school yet and we got desperately lonely after Buaditta had given us lunch and gone away. One afternoon, we missed Biji so desperately that we started crying. The interconnecting door opened and in walked an apparition – Tyeba. She hugged us and wiped our tears. Then she took us home and made us a cup of tea. After that she came daily to our veranda when her brothers were at school. She played with us, told us stories and invented wonderful games. Tyeba grew particularly fond of me. Sitting on the same sofa, she often rested my head on her bosom and sang sad, haunting Hindi songs. I loved that.

. . .

Raj and I were welcome at the Khans'. Late one afternoon when the sun was dipping, I turned up there on my own for some reason. I had just had a nap. My face was unwashed, my hair dishevelled. The

Khans had guests, another large family. Struck by shyness, I nearly beat a retreat and to look for Raj. But I saw Tyeba and made my way to her instead. She gave me a stern look, surprising me, and told me off in a whisper for being in the state I was. She took my hand and led me to a bathroom. Washing my face, she dried it gently with a towel and stood me before a looking glass and gently combed my hair.

'There,' she said, caressing my face. I shall never forget the tenderness with which she did that, as if I was hers. Back in the Khan garden, Raj joined us. We were offered sweets. Raj and I did what we had been taught at home – put up our up hands in a polite 'No Thank You'. Good manners dictated you didn't accept anything offered to you on the first go. You let your hosts say please, please, please several times before you succumbed and accepted whatever it was, food or drink (they still do that in India, the damn fools).

'Go on, go on.'

This made a woman guest remark, 'How well brought up these Hindu children are.'

. . .

Papaji had the novel idea of growing some vegetables on the far side of our garden by a wall separating us from the Khans disused storage area. Buaditta and a man from his office dug up the earth and prepared long and neat beds in which okra and pumpkin seeds were planted. Our only source of water was a hand pump. I dug a foot-wide canal and had a wondrous time irrigating the 'vegetable garden'. Raj called me a silly boy, Tyeba said I was a funny boy.

Right by the end of our White *Kothi* wall was a huge crater locally called *Dhaab*. It meant just that, a crater, a hole in the ochre earth five hundred feet wide and fifty deep. Its steep slopes led down to a real lake of muddy rainwater. I often saw boys of my age in *janghia* underwear having fun in the water, making me long to join them. But I had been told by Tyeba not to. I was told they were ordinary boys and

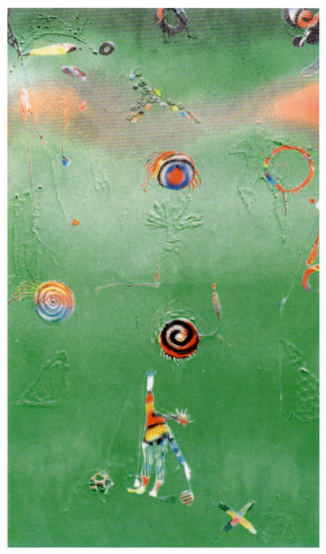

Untitled, 1978, acrylic on canvas, 60 x 50 in.

I was my father's son. When I asked didn't they feel cold with no clothes on, I received a one-word reply:

'Because.'

Bored beyond bearing late one afternoon, I climbed over our seldom open and creaky gate made of two halves of sheet iron (climbing over it was a triumph), I went to the *dhaab* just to see what the 'ordinary boys' were up to and what put them in such hysterics. Laughing and leaping in and out of the muddy water, they were having a whale of a time. They seemed to be engaged in some mind-blowing activity. Hands in the pockets of my ironed khaki shorts and wearing a spotless white shirt over a navy-blue long sleeve sweater knitted by Biji, I stood at the edge of the *dhaab*, agonising, 'Should I or should I not?'

I couldn't resist. Next moment, I was down by the dirty lakeside. As I approached the near-naked boys, they moved back – I was my father's son of the White *Kothi* and they were …

'What's your name?' someone said.

'Balli. What are you doing?'

'Can't you see?'

Then I saw – they were fishing. But their method of catching the fish was unique, if not sensational.

They mixed a powdered herb called *joon goli*, people used to wash their hair with to kill head lice, with small lumps of flour-dough. They flung these little lumps far into the lake. The result of this strange activity had to be seen to be believed. The herb took oxygen out of the water and little fishes the size of sardines, came gasping to the surface by the banks of the *dhaab*. Laughing and leaping, my nameless new friends helped themselves, filling small baskets.

I joined in that fascinating form of fishing. In the next hour or so, I had caught enough of the slimy and slippery little things to fill both pockets of my smart shorts. I ran back home. Papaji was back from his office. He stood at the gate as if he was waiting for someone. Buaditta and Raj stood behind him. Papaji looked worried.

'Where did you go?' he said, angrily.

'Nowhere.'

'Been worried sick. Buaditta has been looking for you all over the place.'

'I was only at the dhaab, Papaji.'

It didn't occur to idiot Buaditta that I might be with the boys at the dhaab. How could it, anyway?

'What were you doing there?'

'Fishing, Papaji,' I said and invited my father to put a hand in one of my pockets.

Papaji shoved his right hand in my pocket and pulled it out in a swift movement as if he had had an electric shock! The slimy little things were revolting to touch.

'Son of a pig,' he said laughing. This was not an abuse. It was a term of endearment. He often called his boys that. Or son of a dog. Indian fathers still do.

The talented electrical engineer was just as good a chef (another paternal trait I would inherit which in later days would serve me well). He dismissed Buaditta and took over the kitchen. Papaji, Raj and I had the most delicious fish supper that evening anyone ever ate – golden brown little things.

One day after a rainfall, I went down to the *dhaab* when nobody was there. A giant frog leapt at me from nowhere. Frightened, I ran. But the creature chased me. At home, Raj refused to believe I had been attacked by a frog. Papaji did not believe it either when he arrived. Yet I was telling them the truth.

They refused to believe me on another day too when I told them I had just seen an astonishing sight – a whole range of mountains! I was returning home from an errand or something. It was high noon. The sky was deep blue without a speck of cloud to blemish it. Where it normally met the earth, today there rose a long line of majestic mountains in shades of grey, brown, white with blushing snow covering

their peaks. I raced home to tell Raj and Papaji because I knew he was coming home for lunch that day. I was breathless with excitement when I arrived at our multi-pillared veranda. I could hardly speak when I told them I had just seen the famous Himalayas.

Papaji smiled, tapping me on my cheek.

'The Himalayas are hundreds of miles away. They were clouds you saw, you fool,' he said.

'Idiot,' Raj said.

I felt like one.

. . .

Our papers from Lahore came through. Raj joined the Muslim Girls High School by the *dhaab* near our *kothi*. I was admitted to Dayanand Anglo Vedic Primary School in the Hindu Qadian. Half a mile away, it was under the shadow of the Muslim mosque's 60-foot marble minaret. It was so near, we could see shadowy figures move in the open pulpit at its apex. Early every morning and evening, a mullah sonorously shouted Allahoo Akbar that could be heard as far as our *kothi* and beyond. The minaret had a clock stuck to it that served our school which had no clock of its own, nor did a teacher own a wristwatch.

The medium of instruction at the DAV Primary was Urdu. I knew not the first letter of its alphabet. I was at a serious disadvantage. Boys called me Angrez Bastard. Every day after school, they waylaid me on my way home and beat me up. I cried and cried, but I never told my father or my teacher. Often, unseen, I cried myself to sleep. Then every night. It was living hell. One day I got into a one-to-one fight with a 'Punjabi Bastard' as I called all my enemies. His name was Pooran. He aimed blow after blow at my face. I ducked. He missed, getting angrier and angrier. Then we got interlocked and fell, his face now in my hands. My fingers got into his nose. I pulled and blood flowed out, covering his whole face.

'BLOOD! BLOOD! BLOOD!' the delighted spectators screamed and Pooran started to wail loudly at the sight of his blood.

The boys left me alone after that. I was accepted as one of them and loitered with them in Hindu streets at lunch time. I squandered my pocket money of one anna on the same item every other day. Not only I enjoyed what I spent my money on, it would prove to be an investment that would pay more than handsome dividends half a century later.

A young hawker of eighteen or so daily stationed himself outside our school. He carried a thick bamboo pole. Its top had lumps of colourful types of something called *gatta*, or *nuggat* that was malleable. He hawked his stuff in a singsong voice, tore bits of multi-coloured *nuggat* and sculpted them into creatures of all sorts – birds, animals, cars, aeroplanes ... You named what you wanted and the man made it in minutes. Then he stuck it on an eight-inch long *kana* stick and you licked it slowly.

These wondrous shapes got stuck in my head. Fifty years later in 1997 when my grandson Dimitri was born, my daughter Kaushaliya asked her now well-established artist dad to make something colourful and in 3-D for his room. Ever-experimenting, I had always wanted to make something sculptural, my forms having handsome potential for translation into that medium. Well, those colourful shapes of the delicious *gatta* of my childhood came to the fore and I began making and cutting shapes of the sorts that inhabit my paintings out of board, wood (which I painted in bright colours) and later, metal. The first work I made for my grandson was entitled *Nursery Rhymes for Dimitri*. Medium-sized, about 40" by 30", it consisted of white painted slim batons of wood to which I attached these small colourful shapes. I then nailed them seven inches apart horizontally to a studio wall. The ensemble looked like some kind of an aviary, highly suitable for a nursery room. But it got me in serious trouble with my daughter.

Before I could install this work in young Dimi's room in his parental abode, a friend who was also a collector and whom I hadn't seen

for some time, dropped by to see what I had been up to. He fell in love with this piece and wanted to buy it on the spot. Delighted, I said he could have it. No problem. I was paid the asking price. It was like selling a picture while the paint was still wet.

If I was delighted, Kaushaliya was furious – how could I sell something I had made for my own grandson? My offer to make another piece for the boy was summarily dismissed. The friend in question understood. He said he would be happy if I made him *Nursery Rhyme No. 2*.

Encouraged by the success of these two works, I decided to make something more monumental, *Nursery Rhymes No. 3*.

The memorable year 1997 also commemorated 50 years of India's independence and that of Pakistan. To celebrate the epochal occasion, the then Prime Minister of Great Britain, the gentle John Major, hosted a glamorous dinner at the Banqueting House in Whitehall. I was invited, the only painter in a throng of three hundred beside Sir Howard Hodgkin. Mrs Khanna was not invited. It turned out spouses were not asked to this glittering black-tie affair due to lack of space in this dining hall with its famous ceiling painted by Rubens – even Major's predecessor Margaret Thatcher was there without Mr Thatcher.

Among other dinner guests was the Director of Bradford's Cartwright Hall that had a strong representation of art from the subcontinent, Nima Poovayia Smith. She said she was there just for the evening, but would like to see my new work (they had a painting of mine in their permanent collection, FOREST WALK 1969, which would be given pride of place and was well-received in Tate Britain's mega historic show, ARTIST & EMPIRE circa 2015–16). Could she not come for breakfast the next day?

At the time I was working on *Nursery Rhymes No. 3* measuring 2M by 2M. It was only half done. Well, early next morning, Nima Smith came and was instantly bowled over. She bought the half-finished work stuck on a wooden surface. It was collected when I was through

with it. *Nursery Rhymes for Dimitri 1997* is now on permanent display in Bradford's Cartwright Hall.

The *Sculptural Reliefs* as I called them, took off in a purposeful way from that year on. Even though it was hard work all that cutting by hand – but all those organic shapes made me look at nature in a new way. They charmed Dimitri when he grew up a bit. They continue to delight me, my double reward.

. . .

Papaji enjoyed entertaining and often had guests to dinner – pillars of the local Ahmadi society. His Hindu friends, notably Uncle Seth, the jeweller, also attended these sumptuous meals making Papaji's guests remark what a generous host he was. Some even wondered how he could afford to be so lavish. It was put down to family wealth.

Papaji was invited back. We sometimes went to Seth Uncle's house near my school in the Hindu area for dinner. Money spoke volumes from the jeweller's walls. Uncle Seth's house was like my grandfather's – old. The windowpanes inside were made of coloured glass and crystal chandeliers twinkled in the baithak drawing room. There was no garden, only a veranda like Bauji's in Jhang. Seth Uncle was my father's closest Hindu friend.

His close Muslim friends were Majid Uncle and Zaffar Uncle. When they met, they embraced each other like brothers.

. . .

By now I had many friends beside Shahad where we lived, Muslim boys all. Because Shahad had many brothers and cousins, he had a number of hockey sticks lying around in his house. There was a Muslim High School for boys behind the White *Kothi*. Its playing fields were grassless and white, not ochre.

Raj, too, had made several friends. Her best friend was Sagan, a midget of a girl who was always laughing and being told off by her

mother who called her a slut for laughing like that. She lived right behind our *kothi*. Raj went to see her every other evening and I went to play hockey with my friends. We boys armed ourselves with Shahad's hockey sticks, took a white hard ball and turned up at the school's fields. I became rather good at this sport which I enjoyed.

One bright and sunny Sunday morning my friends turned up at our gate. Shahad was not with them. They took me on an 'important outing', an errand their families had sent them on. In a small *maidan* common ground, a large crowd of Muslim men had assembled looking busy. More men were coming and were walking away with something wrapped up in old newspaper. The epicentre of it all was an open-air butcher's shop with vast quantities of meat on sale. A couple of men had hand-held balances. They were hacking chunks of meat from immense carcasses hanging from hooks, weighing and selling it. My friends also bought some and had it wrapped up. On our way back, one of them asked me to carry his packet for him. Then he recited a verse and asked me to repeat it after him. I thought it was in Urdu. It was not. It was in Arabic which the boys, too, did not understand. My friends made me recite it many times.

When the evening came, we all went looking for Shahad. He was sick. So he didn't come out to play and we couldn't have our game of hockey after all. But my friends took me to the hockey field anyway and made me recite that verse again and again and again till I knew it by heart. I remember it to this day. It went something like:

La ill la, ill-lill la. Mohammed a-rasul ill la

Then they said I had become a Muslim.

'Nothing of the sort.' I was flabbergasted.

'You have recited our *kalima* so you have become one of us.'

'I have not. Nor do I want to. Why should I?'

'Whoever recites our *kalima* becomes a Muslim. Anyway, what do you think you were carrying in your hands this morning?'

'What was it?'

'Meat of a cow. You are a Muslim now and we are going to do the *sunnat* on you to confirm that you are one.'

'What is *sunnat*?'

'Nothing, really, yaar. Only a little cut.'

Saying that, the son of a bitch pulled out a razor blade the sort my father used every morning to shave. It was the *7 O'clock* razor from the well-known yellow wrapper. Two boys held me by my arms and two others pulled my shorts down to my ankles. Now I understood. I tried with all my might to shake them off. But I was overpowered.

'If you don't struggle, you'll be alright.'

'Mother fuckers, let me go.'

The mother fuckers wouldn't let me go.

'MOTHER FUCKERS LET ME GO! LET ME GO!'

'It won't hurt. Just a tiny cut.'

A sharp pain shot up my penis as the blade cut my skin. I howled and howled. Hot blood trickled down my cold thighs and excruciating pain shot up.

'BASTARDS,' I screamed and screamed.

Hearing my screams, the gardener of the school, a Muslim of course, working nearby, came running. He carried a thin long stick. In one glance, he knew what had taken place.

'You little satans, your own mothers' curses. You'll burn in hell for this,' he shouted and started whipping the boys. As the bloody devils ran, laughing, the kindly man took me to the school hand pump under a tree close by. He gently rinsed the injured symbol of manhood and cleansed my thighs. Luckily, the cut was not deep being only a symbolic formality.

'They are stupid boys. Worst of the worst. Promise me one thing, son. Don't tell your father. Otherwise there'll trouble. Promise?' he said caressing my cheeks in a fatherly way. Five minutes later, he waved me on, 'Now run along.'

Of course, I did not tell my father when I got home – I never told anyone ever. Then I forgot all about it.

. . .

Raj's ever-laughing friend's house was nothing like the Khan villa. It consisted of three tiny rooms, kitchen and a bathroom around a small square brick-floored veranda.

Dusk was descending on Qadian. Sagan, Raj and I sat in a room without Sagan making any effort to switch the light on. Today, Sagan never once giggled, and the two friends talked in whispers. I wondered why. But I was not really interested in knowing why. I was bored. I wanted to go home. I kept pestering Raj when we were going home? Raj just shooed me away and Sagan said:

'*Abba jaan* is at prayer,' Sagan whispered. I knew the Muslim term *Abba jaan* – darling Father.

'When are we going home, Raj? When? I'm fed up.'

'Alright then. You go. I'll follow you soon.'

I stood up. As I walked past another unlit room with an open door, I saw a man holding both his hands open before his face. It seemed as if he was reading a book. But it was only his bare hands he was 'reading'. He stood facing the corner where two walls met. He was nodding to himself! What a way to pray? And pray to a wall corner?

Climbing our sheet iron gate from the street was quite a task. Reason being there were no cross wooden bars as there were on the inside of it. The challenge of it, therefore, made the exercise all the more tempting, even if dangerous – you could cut yourself badly.

Without a mishap, I lowered myself on to the driveway noiselessly. It was a clear evening with stars starting to produce their magic. Our house was quiet as it would be because Papaji read the newspaper after coming home. But there was no light on anywhere – in any room or our pillared veranda. Fear filled me at finding myself all alone in that rambling house and sprawling garden. I nearly re-climbed the

gate to get back to my sister. But then I heard someone talking very softly. I bucked up and made my way to where someone was talking, or rather whispering like the girls at Sagan's. At the far end of the house where Papaji's vegetable garden was, I saw Papaji standing on a stool by the wall, talking to someone on the other side who was similarly propped up. His arms were around that person's neck as that person's arms were around his, their cheeks pressed upon each other's.

Tyeba!

. . .

Then the family arrived one evening from Lahore. It gave our garden a unique new fragrance that night. The first thing Biji did was place a framed colour print of Lord Krishna she had brought on the centrepiece jali cupboard in the sumptuous drawing room. So excited, nobody wanted to go to sleep. With the exception of Papaji and Biji, we all slept in the same room, two to a bed and on the carpeted floor. We loved it.

Every day, visitors came to meet the SDO Sahib's wife. Khan Auntie and her off springs – Tyeba, her sisters and brothers had only to walk through the inter-connecting door. The Seths, the Zaffars, Majid Uncle with his family and others came in horse-driven tongas. The Khannas went to see them using the same mode of transport.

With these blissful social goings on, one could not have imagined that one of history's greatest tragedies was just round the corner. For us in Qadian, life went on as usual.

Life was bliss.

Then, suddenly, it all changed. Dramatically so.

It was a pleasant late afternoon/early evening and I was loitering in the Hindu streets with some school chums. I saw a small crowd of anxious-looking men outside Seth Uncle's house. I recognised Papaji's Raleigh parked there. I went in. A number of gentlemen were listening

Hendon Way, 1967, oil on canvas, 30 x 18 in.

to the radio rather glumly. The new Viceroy, Mountbatten we had seen pictures of in the papers said that freedom would come in a few weeks on the 15th of August. But it would divide the country in two. Half of the Punjab and Bengal a thousand miles apart would go to Pakistan. The architect of this division, Muslim League Mohammed Ali Jinnah, had demanded it. Congress Leader Jawahar Lal Nehru had accepted it. The line of Partition would be announced only after the 15th of August to avoid sectarian violence.

Both Jinnah and Nehru spoke after the Viceroy. They had not yet finished when all present in the room began to weep audibly – Papaji, Seth Uncle, Zaffar Uncle Maji Uncle, my Headmaster … It was a bizarre spectacle, as if a close relative had just died a horrible death. It tied my heart in knots. I too started crying as I put my arms around Papaji's neck. Only one man spoke through sobs. Zaffar Uncle just said,

'Go to hell, Jinnaaah!'.

. . .

Now the question on every lip was where would Qadian go when Partition came – to India or Pakistan? Qadian was the holy headquarters of the Ahmadis. The Ahmadis were Muslim. Pakistan was being formed on the basis of religion. So …?

So the Hindu-Sikh Qadian got the runs. Biji began to make frequent trips to the latrine in the outhouse.

News daily came of what was happening elsewhere in the world. Lahore was in flames, all of Hindu Lahore. The deeply holy city Amritsar was burning, areas where the Muslims lived. Hindus and Sikhs were being put to the sword in the Muslim majority countryside north of the Punjab capital, their women raped and their homes looted. Muslims were being massacred in Sikh majority areas southwest of the Amritsar, their women and homes suffering a similar fate.

Early one morning when it had become too hot to stay in our *charpoys* out in the sun, Zaffar Uncle arrived on his phit-phitti motorbike. He had a passenger clinging to his back, Majid Uncle. Papaji dismissed us kids and conferred with them in whispers. Then the two visitors went away. Bapaji now shouted instructions at Biji, Eudhishter and Pithi. He dashed inside the house and all four of them started putting clothes in suitcases and bags and running around to get this and that. In a flurry of activity, beddings were rolled up, utensils from the kitchen and knick-knacks gathered. A small truck turned up at our gate. It was let in. Zaffar Uncle and Majid Uncle leapt out of it. It was loaded up in minutes and we were made to climb in. Ten minutes later, we arrived at a very tall house in a very narrow street in the heart of the Hindu area.

The rooftop of our new home had a commanding view of the countryside. Every day, we saw hordes of Muslim families from the mainly Sikh villages around pour into Qadian for safety. They carried mountains of their belongings on their heads. Our house had the Hindu temple right below its tall back wall. With every house around being either Hindu or Sikh and the house of God with a party wall – we felt we had come to a safe haven. My mother's toilet condition improved.

But were we really safe? Our cheeks burned. For we knew we were not. We knew we were sitting by a keg of gunpowder. Any minute and … There was a Congress presence in Qadian as there was in every other town. But it was ineffectual and unable to inspire the small Hindu-Sikh population with any confidence. The people felt forgotten and forlorn – even I, at the age of six and a half felt that. They felt betrayed by their leaders.

They prayed. They knew that their prayer wasn't going to move even a molehill this time around. Yet they prayed. Every morning when the mullah in his marble tower of the not far off Muslim mosque announced Allah's greatness – the frightening and repulsive cry of

Allahoo Akbar – and we the Khanna children sat cross-legged on our veranda floor and chanted Sanskrit mantras we did not know the meaning of, eyes firmly shut – that made our prayer purer!

. . .

But life had to go on.

Papaji being what he was, the highest government officer around now living in the Hindu part of Qadian, attracted a following immediately. The reason for it was, together with his office, his personality. Nearly six feet tall with an athletic build, ANK was articulate. His presence there was confidence-inspiring for folks now besieged by a vastly growing enemy. His quasi-military background added to his physical presence.

That would also make him No. 1 on the Muslim Hit List.

Meanwhile, as the Sub-Divisional Officer ANK went about his official duties as usual as he had to, our house soon became the meeting place of the local Hindu-Sikh leadership. They met to formulate strategies of how to protect us from the Muslims now numbering twenty to one with the in-flow of them from the countryside around. ANK formed plans for our defence in case of an attack. It was only a matter of time now when that would take place. Scores of young men were drilled every day and taught to make crude arms and to erect street blockades.

All this was being done in full view of the 60-foot-high Marble Minaret of the Ahmadi mosque five hundred yards away.

We could see far from our rooftop – the less affluent Ahmadi spread on one side, the endless open countryside on the other. We saw Muslims build a mud wall around their enclave.

Majid Uncle came one day to warn our father:

'Be careful, Khanna sahib. Don't go out unless you have to, and don't go far. You have some friends among us, but more enemies who have been watching you from the Minaret.'

But it did not prevent the government servant ANK from discharging his duties which took him to his office every day and the office was on Railway Road in the Muslim area.

We all worried when Papaji went out which he did laughing every morning and saying to Biji:

'Don't you worry, Rani. I have lots of Muslim friends.'

Biji worried. She didn't touch a grain of food or a drop of water till he came home for lunch which was daily very late. She tortured herself with the fear that one day he would not come back.

One day, Papaji did not come back.

. . .

It was raining cats and dogs. Biji's face went white like a sheet. Word spread. Neighbours turned up at our door. They stood in the street in knots like mourners. A few young men and my brothers went around with hockey sticks on bicycles to look. I took it upon myself to do the same to go looking for my Papaji. Unseen, I slipped out of our street and our area. I walked all the way to his office. There was not a soul to be seen. I wanted to go to Majid Uncle's house. But I did not know the way. I found myself walking towards our White *Kothi*.

I had a big surprise, or rather, a shock. Our street was unrecognisable – hundreds and hundreds of Muslim refugees from the villages around Qadian who had walked in the rain were huddled there under trees. Our big sheet iron gate was wide open and I saw scores of them camping in our garden. Anyone could have kidnapped me for ransom if they knew whose son I was. Or an evil-minded fanatic could have dashed my head against a wall. It was well-known that thousands of Hindu-Sikh children in other parts of the Punjab were meeting that fate.

Soaked to my skin, I turned up at the Khan door, knowing in my heart who would open it. As chance would have it, she did.

'Balli!' cried Tyeba, her face contorted with sudden pain. 'What are you doing here, silly boy? Don't you know?' Tyeba hugged me and

fired a barrage of questions at me. Was I alone? Why had I come? I could be abducted, even beheaded?

Tyeba took me to the kitchen – the rest of the Khan family was somewhere else in the big rambling house – saying again and again as she dried my face and hair:

'How am I going to get you back safely? How …?'

She gave me something to eat, a leftover chapati which she coated with white butter and sugar.

'… Someone in the street is bound to recognise you. Then what? What am I going to do? How am I going to get you back safely?'

I had put Tyeba in a serious quandary. There was only one way of dealing with that.

'Wait here, Balli. Let me talk to *Ammi Jaan*.'

As Tyeba went away to talk to her mother, I got my chance. I ran out of the kitchen and into the street, water still coming down in sheets. I had gone a mere hundred yards teeming with men when someone shouted from a first floor window:

'Catch the Hindu dog. Catch the Hindu dog.'

The bully with the razor blade!

A very tall wrestler-type man with a ferocious-looking beard half a yard long lifted me off the earth by my hair.

'Kill the Hindu dog. Kill him,' roared the razor blade bully from his window.

'Hindu bitch son? Hindu bitch son?'

'Yes, he is. Smash his head against the wall.'

The man dropped me and bent down to catch me by my foot and smash me against our *kothi* wall, as it was being done elsewhere.

But I was saved by the very bullying of the razor boy and his friends. In spite of the pain and the extraordinary drama of the moment, I blurted out what they had made me learn by heart which no Hindu boy would know – the Muslim *kalima*:

'La ill la, ill-lill la, Mohammed a-rasul lill la.'

'So you are a good Musalman. Good.'

'DON'T TOUCH MY SON!' screamed a woman in a burqa from behind us. Tyeba came rushing up and took my hand in hers. She walked me to the Hindu-Muslim divide, to safety.

'Now run home, Balli. Run, run, run.'

I ran and ran and ran.

At home, Papaji was safely back, and search parties were now being dispatched to go looking for *me*. There was untold instantly relief followed by hugs and a memorable hiding when my family learnt where I had been – to the Muslim area. It was just as well that I didn't tell them what had happened to me.

. . .

Street life in Qadian was nothing like the street life back in Lahore. In fact, there was no life here to speak of. These streets were so narrow, my friends and I used to hold competitions from first floor windows to see who could pee the farthest towards the other side. You were a hero if you could hit the wall opposite. A hero had yet to emerge.

People didn't go out. They couldn't – go where being the awesome question. Besides, they didn't even want to. Those who did, had put padlocks on their doors and had taken the train and just gone away to relatives in other cities like Amritsar which was bound to go to India because of the decisive Sikh connection. Those of us left behind were locked inside our enclave, victims of history in the making. Papaji had considered sending the family to Jhang where Bauji and Nanaji still were. He very nearly did so. The day he took us all to Qadian station, the train from Amritsar failed to arrive. That very day, we were shocked to learn that trains had begun to be attacked and harrowing stories were being told of them arriving at Amritsar and Lahore stations full of body parts. He regarded the news as a godsend.

People were praying and waiting. Waiting for deliverance. Waiting for the big day of independence.

THE BEGINNING

The Big Day came. It went unnoticed.

. . .

India was free. But still the Qadianis did not know whether they had become Pakistani or had remained Indian. I have no recollection of the 15th of August 1947. Nor even of the day when the line of division was announced or published a few days later. Against all odds, the Punjab was carved up in such a manner that the forgotten little Qadian went to India.

There must have been oceanic relief in Hindu Qadian. But again, there was no celebration to mark that day. None that I can recall. Then all Muslim shops were looted.

At night, we began to hear bombs go off in the distance – muffled booms from far away.

During the day, we saw long *kafila* caravans of people trudging away in the fields – the unfortunate Muslim refugees and Ahmadis were now fleeing from Qadian for their lives, mountainous bundles of belongings on their heads and goats by their sides. We saw hordes of Hindu-Sikh marauders on horseback hacking them with naked swords and fleeing with their young women flung across their horses' backs.

One day, a couple of local young men brought a few small photographs, generating feverish interest. I followed my brothers to the growing crowd of eager men and boys pushing each other to take a look at them. My brothers didn't want me to see those photos and pushed me away. But I disregarded their command. What I saw made me gasp. A large number of stark naked young women were being paraded by a mosque. Men in the Muslim fez wearing long beards and carrying long naked swords were urging them on with the tips of their swords. The women covered their breasts with one hand and they held the other to their genitals, but tufts of black pubic hairs were still visible. We were told the photographs were taken in Lahore now in Pakistan and somehow smuggled out.

A Sikh policeman who lived in another street nearby came and tore up the photographs, ordering everybody to disperse. He was called Kalu, meaning black. The same age as Papaji, Kalu was a confirmed *charra* bachelor who had had no luck in finding a wife perhaps because of the colour of his skin which was really black.

Rumour spread one day soon after that Kalu was a *charra* no more. Eyebrows in the neighbourhood rose sky high. We hadn't heard of a wedding taking place. So with many curious friends, I went along to investigate. Lo and behold, a young maiden fair as a princess sat on a *charpoy* on Kalu's small veranda packed with astounded neighbours.

'Gift from Jinnah', Kalu announced, twirling his moustache, or rather, from a Muslim *kafila*, he should have said.

The 'gift from Jinnah' had veiled most of her head and face with a white, translucent *dupatta* breast scarf. She was staring quietly at her twitching bare toes. We would hear later that Kalu married her properly and thus made her a Sikh.

Not long after, we could go wherever we liked. All Qadian's Muslims had gone, leaving behind everything they once owned – most of their worldly possessions, their houses and villas with what they contained. Now looting began. Every house in the outer Qadian of the Ahmadis was systematically ransacked by organised gangs of Hindus and Sikhs. Our part of the White *Kothi* was also broken into. But the presence of that little colour print of Lord Krishna on the jali cupboard in our drawing room saved it from being looted.

Almost immediately, we returned to the White *Kothi* where we would now live rent free, its owners having gone forever. All the furniture filling our part of their villa now became legitimately ours. The one-time town of 15,000, had swollen to more than twice that number with Hindu-Sikh refugees having taken over every Muslim home. The Khan part of the of White *Kothi* was now home to six different families of 50 plus souls – we had to board up the inter-connecting door. Life was beginning to return to normal, but in a visibly abnormal

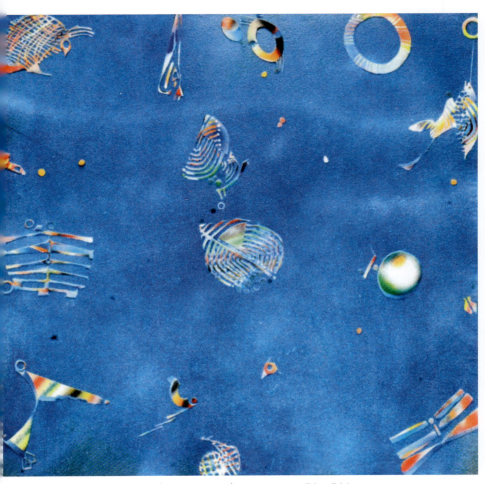

Sky is the Limit, acrylic on canvas, 54 x 54 in.

and belly-churning way. There was sorrow, great sorrow. It came in a package of relief, great relief. In all this time, we did not once see a single Englishman, a mere handful of whose superiors over five thousand miles away in London had wrought that holocaust about – puppeteers controlling destinies.

. . .

Partition made 1947 an Amazon of sorrow. Its impact was far greater than that of *Independence*. Among that infernal year's millions of imagination-defying personal tragedies, two that struck the Khannas may seem small, but they were tragedies nonetheless, causing no small amounts of enduring suffering.

Whatever had happened to the Muslims in Qadian, happened to the Hindus in Jhang. Somehow, all of my three grandparents managed to leave when there was still time. Bauji and Bhabiji went to their second son Sriram in historic Kanpur in Uttar Pradesh. Nanaji made his way to his only son in holy Kurukeshetra. Although they had to leave everything they owned behind, my grandparents were lucky. Through Bauji's connection in the Muslim high society, they escaped with cash and gold sewn inside their clothing. They avoided the fate that befell those Hindus who waited on to see which way the wind would blow.

Good fortune decided to abandon the Khannas in Qadian, too. Some 11 million crossed the border during those weeks, seeking safety with their co-religionists in India or Pakistan – one in ten getting slaughtered on the way. Among them were scores of Hindu/Sikh engineers of my father's status, but much older with many more years of service. They had to be given suitable positions in their new homeland. This led to my father's sudden fall from the dizzy heights (for us little people in our little town) of SDO-ship to suddenly becoming a lowly junior engineer in a nameless other town nearby.

With the loss of status came the loss in income and the disappearance of servants. Before, we received gifts of what the land produced

from grateful zamindar farmowners the SDO had provided with an all-important electricity connection … sacks of wheat, seasonal fruits, vegetables, small game …

All that stopped suddenly.

Before, beside Buaditta and the maid servant, there were always a couple of men from Papaji's office at our command doing gardening, shining our shoes and running around to do our bidding. Now we had to do all the dirty work they used to do.

I had never seen my mother hand-cleanse the brass utensils as the maid did – scrub them with grey/white ash from the hearth and then wash them under the hand pump. Now pregnant with her ninth child, Biji did so three times a day. She cooked and cleaned and washed clothes with Raj helping.

Now we were always desperately short of money. Food stuff mostly came on credit, but our credit rating soon began to dwindle. The vegetable garden produced a few ladies' fingers and small pumpkins which nobody had ever liked. Now we thought they were manna. But it was *dal* and chapati most meals. Barley flour was cheaper than wheat flour. I remember a small sack of barley weighing 10 seers, or kilos, being bought. Because there was no servant around, I had to carry it on my head to a flour mill half a mile away and have it ground. Unable to bear the sight, My dear sister Raj cried when it was placed on my head – her little brother had become an ordinary coolie! The load felt heavy and cold. But after the barley had been ground into flour by machines, the sack felt hot on my head when I carried it back home. Strangely, the warmth made the load feel a little lighter.

Barely flour chapatis had a ghastly taste. But we had no choice. Sometime, there wasn't anything to eat. My indelible memory of those days is that we were always hungry. It broke my heart to note that my heavily pregnant mother had made a habit of missing meals. This would put her share of the chapatis into our hungry mouths. Papaji was posted 30 miles away. He came home now and then, bicycling

to and fro to save money on bus fares. He sent a money order every month, but it didn't go far. Biji had to sell something of her precious old family gold jewellery regularly to get by. That tore her heart, to part with ornaments worn by her mother.

We were not alone in that state of penury. Every family around us was a refugee family, living from hand to mouth. These people thought of us as being the local aristocracy. Appearances being all, they had only to look at us to draw that conclusion – we were always well turned-out. We did nothing to correct that impression. Vanity begins at home!

Our lean days were also our lonely days without our father in that big now rent-free house. Winter came and the house became lonelier in the short days and evenings. Sometimes, the whole family slept in the same room – so lonely we all felt – three to a bed.

On a very cold early evening, news came that Mahatma Gandhi had been shot by a Hindu fanatic. Papaji was away and my brothers were not at home. I remember that the sky at the horizon was orange with streaks of red. We came out of our gate in a sudden need to be with other folks. People in the street were hugging each other and weeping. I knew who Gandhi was, we saw him in the newspapers every day – a thin and bald old man with a walking stick, thick round spectacle and rubbery lips. It was a puzzling, but a very moving spectacle to see people who had never seen him in the flesh cry so. Biji also broke down. Raj and I couldn't stop either.

. . .

The new arrival to the family was my fourth brother. Because little Vimal came early one morning a few days after Mahatma Gandhi's assassination, it was said that perhaps he was the Mahatma's reincarnation. It caused mirth all around when it was pointed out that the bald little Vimmi with a smiling little face even looked like the Father of the Nation.

There was no money for celebrations. On hard times, we were simply incapable of dealing with our plight. But I never once saw a tear in my mother's eyes. Then Bauji and Bhabiji came to stay with us. We were overjoyed. It filled our garden with roses. Bauji had cash, but he had changed. A man of few words at the best of times, the prince of yesteryear had lost all he owned, his lands and the rest. Yet, he never complained. When not praying, he seemed to be staring, but at nothing. My gran, however, had not lost her penchant for talk. She was angry with Nehru, though, very angry.

'Promised us a land of milk and honey. Look at his promise.' She would say, pointing to her old emaciated frame. This was followed by a little laugh. 'At least we are alive. And we are free. But to tell you the truth, we were not unhappy under the Angrez. He was good, even if he was bad.'

This made us laugh: how could anyone be good and bad?

'But he was. Both. The Englishman. Believe you me.'

That it was all over had brought indescribable relief to one and all, to the great and small. It also made life drab, dull. Nothing happened now and this nothingness was blessed. The only thing that I can recall of any interest of the next two years is how my brother Pithi, a boy from the Paris of the Punjab and now a college student with an eye for fashion, had made the great White Kothi shake by its foundation.

The trendy young man wore trousers ironed by himself to razor-sharp creases. His favourite colour was white. So in all white, my brother looked stunning – his poplin white shirt shimmering in the electric summer sun. I felt proud when I stood at a street corner with friends and he passed, his jet black hair treated with mustard oil and combed down to shiny cemented surface. He took good care about how he looked. There was a good reason for that. And she lived on the premises, on the top floor of the White Kothi.

Kamla Suri was Raj's age. The two were in the same class at school and spent hours together, mostly in the shade of the fruit trees in our

Continents, acrylic on canvas, 60 x 60 in.

garden. Pithi was always in evidence when Kamla came, more so in the evening. Unknown to us, the two of them were having an affair. A bit plain-looking, Kamla was a very pleasant girl. But she was careless. A love letter from Pithi passed on to her in a book fell out to be picked up by her much older and very stern brother, Shanti, which meant peace. Then a whole correspondence course was discovered in her books.

Shanti's response was anything but peaceful. Having beaten up his sister black and blue, the man on fire turned up at our gate early one evening to take the life of the destroyer of his family's honour. What Partition had failed to do – take a Khanna life – our neighbour since Partition now seemed determined to achieve. I had never seen a human being so red in the face. Shanti carried a hockey stick with which he intended to beat Pithi to pulp.

Pithi, alerted, had dissolved in the garden shadows.

'Where is he? Where?'

Bhabiji rose to the occasion.

'Have you asked your sister how many letters she has written to Pithi?'

'She is taken care of. Dead tomorrow. Now I want to take care of your grandson. Dead tonight, old hag.'

'How dare you speak to me, wife of Lala Lal Chand Khanna, like that? *The* Lala Lal Chand Khanna of Jhang. How dare you?'

'I don't care who this Lala Shala is. I don't …'

Thereupon, and this was magnificent, the 'old hag' became the veritable Goddess Kali – full of wrath. The bundle of angular bones took her jutti shoe off and raised it sky high.

'Have you no respect for the elders? Shame on you. Go blacken your face. Just go away. Or …'

'I want his life or a written apology.'

A little haggling followed. My pragmatic gran presided with elan. An apology could be arranged.

And it was. Bhabiji dictated. It saved the Lothario's life.

Soon, it was time, sadly, for Bauji and Bhabiji to return to their other son Sriram in Kanpur. They gave us quite a lot of rupees. We paid off all our huge debts, but were left broke again.

A letter came from Papaji. He had got a transfer to a far off town called Karnal near Delhi. He had found a nice little place to live. He would call us all over when he was settled. My big brother Eudhishter announced he would go there now to live with Papaji. I insisted on going with him.

A NEW LEAF

It was said that Karnal was founded by Prince Karan of Mahabharat thousands of years ago. The city of 50/60 thousand had sprouted into three Karnals by the time I, almost 9, got there on 14th of August 1947. I remember the date because a man in our 3rd Class compartment told us he was on his way to Delhi to see the Independence Day celebrations the next day.

There was the old city itself of with a disintegrating high wall around parts of it. In its middle stood the imposing medieval Karan Gate opening to the famous, traffic harassed Grand Trunk Road made famous by Kipling. Karnals Numbers Two and Three respectively were post-Independence creations.

A large body of 'dislocated' families from Pakistan inevitably arrived in Karnal in the post-Partition sad mad muddle. Middle class refugees immediately usurped vacated middle class Muslim properties. That left several thousand poorer families, ones who could only have the sky over head as their roof. The harassed government hurriedly erected a city of canvas in the wasteland on the other side of the railway station at the city limits. Known simply as the Camp, it was just that – a camp made up entirely of tents, a hovel. The countryside was its toilet, a couple of wells the bath.

The third Karnal was a different story. A mile out in the countryside, it was brand new and it was called Model Town. It had the Kunj Pura Road and Karnal's famed Dairy Farm on one side and endless wasteland on the other. In between were some five hundred purpose-built dwelling units painted white and yellow. They provided accommodation for a thousand families, all of them refugees. Called 'Quarters', they were laid out in two rows at a time flanked by well-swept roads on side. In the summer, their occupants slept outside at night. So, an aerial view of MT after hours would have presented the intriguing sight of hundreds upon hundreds of hospital beds laid out in formation for hundreds of yards.

Standpipes in the streets provided the Model Town with water. This was a standing civic joke, but no laughing matter. For while they became daily meeting points for people to gossip and passing on the news of the world, they sometimes turned into scene for head-splitting street fights when people began cheating to get water before others.

Papaji had rented half of a self-contained four-room house with a veranda with two arches and a bathroom. I have a memory of that bathroom which can still make me laugh. It is of being caught playing with myself. Our bathroom in the arched veranda had a high glass curtain-less window. I was bathing one morning and having fun with the lather. I looked up for some reason and saw my big brother peeping through the windowpane and laughing like mad at seeing me do what I was doing. (Years later, a close friend Pat Rai told me that he had got beaten black and blue by his mother for being caught playing with himself). I hurled a jugful of water at the window.

Once again, I had to wait for my papers to come through for me to enrol in Karnal. Meanwhile, I had nothing to do, nowhere to go except on an occasional field trip with Papaji in his PWD truck. He was then constructing 11 KV transmission lines through the countryside. He had gangs of skilled and unskilled labourers. The unskilled labourers

earned 49 rupees per month. We had a man servant Ram who cooked, cleaned and washed for just over half that amount with the meals thrown in. Ram was a pleasant young man of 18 or 20. He lived with his family in the Camp and wore shoes made from a car tyre – a few strips of thick rubber sewn together. He came early every morning and went back to the Camp after having cooked our supper. I loved the runny omelettes he made for breakfast. Ram addressed me as Balli babu, a sign of respect.

Then one morning I woke up to behold the most beautiful apparition that a boy ever saw – the face of my own mother! Biji had come unannounced by the very train that Eudhishter and I had boarded. The surprise was total and totally delightful. That very night, I had another surprise, but one of a shocking nature. I saw Biji smoking! Although it was not chilly at all, my parents chose to sleep indoors. I slept on a mattress on the floor by their bed. After a while, a small noise woke me up – they were kissing. Then I saw Papaji light a cigarette and hand it to Biji. She took a drag and I saw the tip of the cigarette glow. Soon after, I saw my father heaving above Biji in the feint light from the window behind their bed. I felt that I shouldn't be watching their love-making and asked my favourite God Krishna to make me go back to sleep. He obliged. Next morning, I was happy to have seen them being intimate.

But Biji only stayed with us a mere few days – she had to get back to the family in Qadian. We were in hard times again, getting harder and harder by the day.

. . .

I made a large number of friends very quickly – it seemed every boy of my age around wanted to be a friend of mine – it often happens when a new face suddenly appears in the vicinity. But they all went to school every day. I was by myself all the time. I was not bored really. Only lonely. In due course, I began to enjoy being on my own for long

periods of time. It made me different in my own eyes from other boys. I can say that it was a character-forming time for me. I began to be conscious of having an inner life, a feeling which in course would fill me with a sense of purpose.

I remember that I had fashioned a bow and made some arrows from reeds plucked from the marshy wasteland between Kunj Pura Road and the Dairy Farm. The arrowhead was a strong needle-sharp thorn from a palm tree. I tipped its base in coal tar from a drum by the roadside and had an arrow that could be deadly. It could also shoot deep into the sky. I loved to see it shoot up majestically a good hundred feet with a whirring sound and stop mid-air for a split second before diving down to earth, a miraculous sight never to be forgotten.

Sometimes, I felt I too had gone up in the air and enjoyed a bird's eye view. Or rather, saw myself standing alone on the bald earth that was our garden. In a shimmering white poplin shirt and cotton *churidar* pyjamas, I conducted my solitary archery sessions with nothing to aim at except the limitless blue yonder. During those special moments, I had a certain sense of myself, of me being me, Balli.

I was all alone. But not lonely, as I said. Good early training for a distant future. An artist's life is lonely.

Yet I was not really all alone. For in the next quarter, No. 87, there came to live a family as large as our own. My co-ageist dusky Prem was a beauty I couldn't take my eyes off. Her 10-year old brother, Romesh, became my best friend. Neither of them knew how to cycle. One day, I took them both on my father's Raleigh for a ride, she on the rod between my saddle and the handlebar and he on the carrier behind.

In the middle of the road somewhere, there sat a yellow-beaked lali bird, oblivious of the scant traffic. In a highly imaginative move as I thought then it was, I tried to run it over and made perhaps too abrupt a turning of the handlebar.

Disaster.

The bicycle rumpled up on the tarred surface and the three of us fell upon each other in a heap, bruised badly. The net result of it was that my machine got one of its pedals badly deformed. In other words, the cycle had become un-cyclable We had to foot it the rest of the way home. Reaching home, I received my first ever beating by my father. I had rendered his bicycle useless by my being stupid. There was only one way to teach me a lesson.

ANK picked up a stick and ...

Neighbours dashed to our quarter on hearing my howls. But no one held my father's hand – it is no bad thing for a son to get a good hiding from time to time. It's only for his own good, anyway. Every boy in India needs it. And gets it, too.

I cried and yelled in pain. Finally, the beating was over. The onlookers dispersed and I went to a *charpoy* string bed on the veranda and laid down my weary little body to lick my wounds, as it were, but still crying. A few minutes later, Papaji came and lay down next to me and hugged me.

'Go have a wash. We are going somewhere.'

After my wash, Papaji hailed a passing rickshaw and told the driver to head to Karan Gate. In the bustling bazaar inside the historic gate, we entered a smart cloth shop and my father bought me a readymade shirt, one that came in its own transparent wrapping. It was a posh purchase, the envy of all my friends – readymade garments were mainly for the well-off, posh people in those days. I saw my father sign in the shopkeeper's credit register. I wished I was dead.

. . .

Although Papaji was still on tour a lot, the rest of our family in Qadian couldn't wait for us all to be together. Eventually, we were, in an explosion of mirth – two to a bed, the Khan sofas that had come with the family from Qadian as sleepers, dhurries on the floor ... Life had

no greater joy. The only thing missing was money. But it didn't matter for the moment.

I joined the Sanatam Dharam High in the far extremity of the old city a mile away, a new chapter in my life.

Sleeping out under the stars at night was fun. We cracked jokes with our neighbours on our right, left and front till we dropped off. One night, the head of a Brahmin family in front of us farted so loudly, it caused us all around to erupt into an orgy of laughter. Next evening, there were loud requests from us all for a repeat performance. The good man said that when he was ready, we would all be the first to hear about it.

Something or the other happened every now and then to keep us in stitches. But one night we all held our breath by something not funny at all.

A young couple came to live nearby. They didn't mix with anyone. The man, a burly fellow, was 30 or 32, his pretty wife ten years younger. Mr and Mrs X seldom slept out – they had an electric overhead fan on all night, a costly luxury. One night at ten or after when we were all about to fade out, there came loud screams from the couple's house. It was the woman screaming. When some of us young stood up to investigate, we were told by grownups to mind our own business and remain in our *charpoys*. We heard those screams every other night.

While our discreet neighbourhood turned a deaf ear to them, I simply could not do so. One night, I slipped out of my *charpoy* and stole away to look. What I saw through the cracks in the wooden door of the couple's bedroom sent me reeling back to my string bed. In a dim electric light, I saw a muscular naked male figure heaving up and down on a stark naked female – I had never seen a naked woman before. Arms akimbo, she was having a serious asthma attack. I never told anyone about it. Only my bum chums. The buggers laughed.

'She was having the time of her life, dumbo.'

'Get lost,' I said – how could anyone screaming be having the time of their life?

Sleeping under the sky meant that people had to leave the shoes under their beds while they slept. One morning, we woke up to a puzzle – one of Biji's new slippers was missing.

'You sure you left it under the *charpoy*, Biji?' we asked.

It was a silly question. We searched everywhere. But the shoe was gone. Mine went the next night. I had to go barefoot. Biji bought the cheapest footwear imaginable – a pair of *kharrawan*, wooden clogs that made a loud slap-slap noise.

Another morning, the same fate befell our 'atom bomb' Brahmin neighbour – one of his brand-new shoes could not be found. Mystery deepened and laughter became louder when the same thing happened to the housewallah of No. 87. There was a strange thief about with a perverse sense of humour and a bizarre interest in shoes. And shoes cost money. The thief had to be caught. The question was how? Someone suggested that a vigilante squad be formed. It was dismissed as being beneath our dignity. Yet, four shoes going missing within as many days, or rather nights!

What to do?

Then we heard that we were not the only ones in Model Town who had been subjected to this strange and puzzling theft. Families all over MT were losing shoes in the dead of night, but always just one of a pair, including one of mine.

This was not the sort of theft a thief would brave because what use was a single shoe to him or an accomplice?

Then it all came out. A mongrel owned by someone well away in the C Quarters area had this habit of taking long nocturnal walks in Model Town with houses that had no boundary walls or hedges. No one was able to explain why or when the dog decided to go back home with a shoe from the barren garden of this house and that every night? The result was that his master had two sacks full, one marked

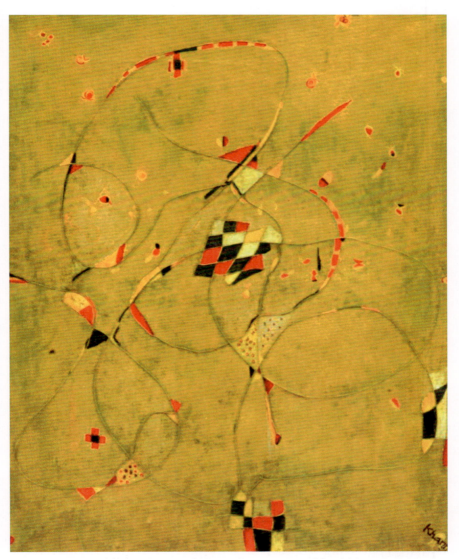

Haldighat Petite, 1965, acrylic on canvas, 22 x 14 in.
(Stolen from my show at the Zari Gallery, London, in 2019)

'right', the other 'left' robbed people went to search. The Brahmin gent got his shoe back. But not Biji nor me. I had to go barefoot.

We lived in utter penury again. We had to fight for every crumb on the table, or rather, the cement floor where we ate sitting cross-legged. Sometimes, there simply wasn't enough food. Biji ate after us all. Often, she didn't eat anything at all, feigning a stomach disorder. Her words hit me in the chest because I knew she was lying like she used to back in Qadian. We all knew she was lying. This happened every other night.

One evening, led by Raj, we went on strike. We refused the food presented on our thalis, insisting she ate first. She beamed a beautiful smile and turned her back on us. My heart in my throat, I saw her quickly wipe her eyes with her chuni scarf. She smiled again and took a mouthful. It filled us with joy.

. . .

Papaji was away on a long assignment somewhere. Biji was making ends meet somehow, feeding the family on credit. She had an old pair of slap-slap clogs. Even the strap of one broke one day, making her walk barefoot like me. She was at the verge of tears. She always was. But stoically, she said, 'Things have got to get better sooner or later.'

And, God bless, they did.

A day before Papaji came back home came the news we had all been waiting for with blazing impatience. An important gentleman came from Papaji's Power House early one evening to see *Mrs Khanna*. Biji, expecting the next young Khanna, received the visitor in our small *baithak* room in the company of her two older sons. We kids peeped from the sides of the doors. The man had news of utmost importance. The PWD Electricity Department's head office in far off Simla had decided to restore Mr Khanna to his former position.

It was happiest day of our life. We all hugged our mother when the harbinger of good news left. But she cried and cried.

Even though no one ever complained, we were rather cramped in No. 88. But changes were afoot elsewhere, too. Bauji had submitted, with the help of Papaji and his legal friends, a claim to the government months ago for the loss of his house and his lands in Pakistan. In lieu of our house in Jhang, we would be given a large house in Model Town here and some land elsewhere with a suitable sum of money in compensation. It would take a while. But by now we had become a patient lot.

One cold December morning soon after, Biji gave birth to her seventh son. He was given the name Karan, after the prince of the Mahabharat, the city's founding father.

. . .

It was to take longer than we had anticipated for us to get our house. But we were no longer starving. Old habits die hard. Ours of living reasonably well returned with a maid, a cook and a manservant, the latter two on government pay as became an SDO. The years of penury overnight became a distant memory for me. Papaji had been given a new posting somewhere called Dhulkote and a brand new American jeep – Willy's – with registration number plate saying PNK (Punjab Karnal) 748. Being the son of an SDO with a jeep parked outside my house did no harm to my standing in my little world.

SD High was housed in a pre-Partition Muslim *serai*, inn. Because of my early grounding in English, I was good at it. But no good at Maths. And I talked during lessons. To shut me up, monster Amir Chand of the subject I loathed would aim a loud kick at my backside. It failed to uplift my maths.

(I would meet him again by chance on a roadside just before I left for England a decade later. What he said on that occasion hit me for six – *Balli, you were one of the most promising pupils I had ever taught*.)

A new teacher came to the SD High to teach a new subject – Art, or rather, Drawing, as it was called. His name was Gopal. On his first day,

he asked the class to draw in our rough books a vegetable or a fruit. I drew an apple in the middle of the page. His eyes widened when he saw my drawing. The treatment I received from Master Gopal from then on was pleasantly different. He was the first person to say that there was an artist in me.

One afternoon at home, a friend of my brothers' ER and PR came to see them. They began to play cards, a game called Three, Two, Five. Only three players could play the game. But I insisted on being included. It was not possible. I sat by and sulked. There lay a magazine near me with a picture of Mahatma Gandhi on its cover. I took up pencil and paper and within a few minutes I had drawn the Mahatma – a perfect likeness. When I showed it to the card players, my brothers' guest simply wouldn't accept that I had made the drawing. He put it under the magazine cover to see if I had traced it, the bloody fool.

I was not a particularly bright student. Yet I became our new headteacher's pet. He allotted me a task the brightest boy in the school would have given an arm or leg for. The task was special. It was prestigious. It required me to present myself at his office every morning, take the School Attendance Book and go from classroom to classroom after registration, put down each class attendance figure, return to HM's office and write the total school attendance on a blackboard outside it for the school and rest of the world to see.

I never knew what he saw in me, but it was this Headmaster who gave me an unforgettable and inspirational compliment:

Hone haar birwan kay chichney, chickney paat.

Translated, it meant something like, 'You can tell who will get there one day.' Well, I'm still trying.

Our new home was a spacious house. Identical to No. 88 in other respects, it was more than twice as large – four bedrooms, two bathrooms, storerooms and tall-pillared verandas … It was airy and full of light. And it was ours.

'God liveth in heaven! God liveth in Model Town too!' I said to Raj.
'He wrote you a letter?'
'Yes.'
'Me too.'

Our move to our new house coincided with a new addition to the family, angelic little Pommey. Another gift from the same God. Soon after her Bauji and Bhabiji arrived to bless the new house we had got because of them, and to live with us.

The next big thing for me was my exams. I passed. Now only a few weeks away was Dhulkote.

We were told that Dhulkote was a gigantic new powerhouse with a new colony for its employees. ANK had been given a large villa with a large garden and servants' quarters.

ELECTRICITY IN DUST

We arrived at the single-platform Dhulkote station on the evening of 18th July 1953. We were the only passengers to get off the train on that lonely station. The Hindi word *dhul* means dust and this station was meant for a dust-coated village of that name a couple of furlongs away. Now it also served the sprawling new Power House a few hundred yards in front of it in the middle of no nowhere.

New India had launched mammoth new undertakings of all varieties from the industrial to the agricultural with everything else in between. Up north in the Himalayan foothills at an unheard place called Bhakra, a great dam had been constructed. It generated vast amounts of electricity. Asia's only 220 KV transmission line would carry it all the way to the Indian capital Delhi 250 miles down south. Dhulkote was a half-way house from where power would radiate to other parts of the Punjab. Papaji was one of the three engineers selected to construct this line, enhancing his name.

Between the railway station and the Power House lay the old road to Simla, the summer capital of the British Raj till 1947. Now it connected the world to independent India's great new experiment in architecture and town-planning – Chandigarh. A brainchild of Nehru, the plush new capital of the Punjab was designed at his invitation by the world's most celebrated architect, the Swiss-French le Corbusier. Dhulkote was twenty-five miles south of his masterpiece.

Our *Electric* colony was a well-laid spread of single storey houses. Ours, an officer's villa smiled with four bedrooms, a large drawing-cum-dining room, two bathrooms, a storeroom, kitchen, pantry and, servants' quarters at the back of the house, not to mention a driveway and a large garden in the front and one no smaller at the back.

There was more to Dhulkote than mere dust – endless green fields and on the northern horizon, a curvy line of Himalayan foothills, the blue Shivaliks so named after the great Hindu God Shiva.

Anglo Sanskrit High School was a good cycle ride away in Ambala City. A typically old Indian city – it was grubby, crowded and filthy. A.S. High lay on the left bank of its *Ganda Nullah*, the broad city sewage stream which became a wide river of muddy water when the monsoons came. It overlooked the school's imposing arched verandas.

Papaji dropped me on my first day. He came in to meet the Headmaster, the burly Girdhari Lal. My recollection of the occasion is that my new Headmaster was flattered to meet the handsome young SDO Sahib.

The 9th Standard had three Sections. I was put in its best, Section C. Again, with the exception of English, I proved poor at studies. Yet I became a favourite of the HM here also for nothing except perhaps how I spoke. He also taught 9C my favourite subject. But here too, the boys behaved towards me as if I was different from them.

There were quite a few Dhulkote Power House boys at AS High. Cycling to school, we had to take a right turn at Camp Baldev Nagar half a mile on. This was a camp like the one in Karnal of mud houses

made for refugees after 1947. It had a bustling bazaar, but the sons of government Power House staff shunned it. It was beneath them. One day I suggested we went around just for a look. I was laughed at. But I made a friend from the Camp – Om Prakash, a classmate. The only son of the local primary school's headmaster, orb-faced, ever-smiling Omi often came to my house in the Power House and I cycled to his in the Camp, sometime sharing lunch at his place and mine. We became best friends. Three decades later, I modelled the hero of my first novel, *Nation of Fools* on him.

On the whole, I was popular at AS High. But not in the Power House colony. The boys here soon began to avoid me. It puzzled me. In the beginning, I played all sorts of games with them at weekends, such as football and volleyball. But as time passed, the buggers began to exclude me. Then they simply boycotted me. The Dhulkote Colony held a raffle. For a two anna ticket, I won a prize – a cricket ball. It was of no use. For I had no one here to play cricket with. So I made a wicket of a few bricks in our long garden and used to bowl at it from 22 yards to India's top batsman, Vino Mankad. I taught myself how to bowl a leg break – it came naturally. Within a few weeks I could bowl well enough to get him LBW. At the same time, I had to contend with my loneliness. Only the younger brother Manu of a classmate of mine remained loyal to me.

'Why have they all boycotted me?' I asked him one day.

'Because they are jealous.'

'But why?' They had no reason to be jealous.

'Because of how you speak English and how you look.'

'How do I speak English?'

'Like Khanna Uncle.'

'And what's wrong with how I look?'

'That's what they hate. And your ironed shirts and shorts.'

Nothing is more painful than your contemporaries' total indifference. Especially in a confined space which Dhulkote Colony was. They made me feel I did not exist. At the weekends I felt very, very lonely.

Then something happened which turned the tables on the loonies. First, it dropped them in a pit of leaping flames of intense jealousy. Then they all began to eat out of my hands.

. . .

The villa on our right was occupied by an officer a grade higher than Papaji, a Christian called Blair. Mr and Mrs Blair were both quite dark of skin – Indian Christians usually are, being converted from lower castes, many from the Untouchables – but very good looking, Mrs Blair in particular. They were very Westernised, spoke mainly English among themselves, and regularly went clubbing in fashionable Ambala Cantt. They had parties where glamorous guests from the Cantt drank and danced in each other's arms to English music.

The Blairs had a daughter Sunita. She was of the same age as my younger sister Kamlesh. So when Sunita's Mummy and Daddy went clubbing in the Cantt, they left Sunita with us to look after. The two girls became close friends. Indirectly, it was Sunita who brought about the change in my position with my 'friends', now become, inexplicably my sworn enemies.

Unknown to me, they were plotting my destruction!

Manu came over to our house every Sunday morning to listen to the popular *Children's Programme* at 10 on the radio. After the hour-long show, my new ally would sit by me in my room and tell me all about what was being plotted against me in the enemy camp. All sorts of schemes to humiliate me were being cooked up in the Clerks Street, as the street behind ours was referred to. A laughable one was to somehow make me eat a strong laxative mixed with some mithai sweet that would make me acquire a permanent residency in the latrine. One Sunday, Manu told me something which gave me shivers.

The enemy plan was to lure me to a distant field or a desolate grove and talk me into eating the you-can't-say-no-to *pakoras*, deep fried vegetable mixed with gram flour dough, containing opium.

'When drugged, the "pretty boy" would be gang raped.' My informer told me this plan was conceived by a tall and muscular 'two-time matric failer' of 17 or 18, the son of a clerk who lived in the lowest-rent quarters at the back. This bastard always looked at me hungrily. Then my brothers ER and PR had come home one weekend. ER noticed Manu in my room conferring with me in whispers. He demanded to know what mischief we were up to? Young Manu needed no encouragement to tell him all. Immediately, he blurted out what he had told me about the 'two-time matric failer's' scheme. I saw my brother's face go tomato-red.

'Where does he live? Come and show me,' ER asked us.

He took a log from the pile of firewood outside the kitchen, the size of a cricket stump. The three of us hurried off to the last of the quarters. We found the boy sitting in his doorway. Next to him sat his father in a chair, his shoes by his bare feet. The father and son were basking in the sun. Sensing danger upon seeing my big brother with a wooden rod, the latter stood up and tried to make a run for it. But ER caught him by a wrist in a vice-like grip to beat him up 'into the shape of a peacock's arse' as in the popular slang.

'What the hell are you doing?' the father shouted at ER.

'Tell your father why I am here or I'll break your legs.'

'I don't know. How should I know?' the swine screamed.

'You don't know? Then I will tell him.'

ER gave the SOB a mighty kick in his arse and told his father the story. The transformation in the man's demeanour was dramatic. He picked up a shoe from the floor and hammered his son on the head and face as neighbours turned up to watch. The hammering went on and on but no one tried to stop the enraged father, a father beating up a son in public not being an uncommon sight. But people wanted to know what had made so soft-spoken a gentleman so murderous. When ER told them, they spat in the face of the would-be rapist and went home.

. . .

At school, I excelled at English and Drawing. We actually had a Drawing Room. Our Drawing Master arranged desks in a semi-circle. In the middle stood a table, supporting 3D geometrical objects like a sphere, a cube or a pyramid along side a half open hardcover book. From the window on the side sunlight came flooding in. Shading was the thing and I was pretty good at this sum total of our art education. Nothing else was ever attempted or even thought of by our Art, or rather, Drawing Master.

Two happy events: my annual exams came and with them the arrival of our grandparents. I moved to Class Ten.

Being rather good at English would stand me in good stead shortly concerning the remarkable change in my fortunes. Responsible for this were none other than our English-speaking good Christian neighbours!

Sunita Blair had two cousins in the far, far off princely Lucknow in UP. They were Leela of my age and a younger sister. In our world today distorted by sick religions, we have suicide bombers. In those times of loveable innocence, there used to be 'bombshells'. Leela was one twice over. She was an Anglo-Indian with the pigmentation of an English girl. Tall with shapely legs as her skirts revealed, she had a girlie bosom crushed by a tight bodice and a face Homer must have dreamt of when he imagined Helen launching a thousand ships. Ours was love at first sight. And, ahh, her broad-minded Christian uncle did not dispatch a battalion of armed servants from next door to dispatch me to the next world.

For the first few days, we darted melting glances at each other from our enjoined, unfenced gardens. Leela always had a hint of a smile and a sudden touch of redness in her cheeks. Then one day, Sunita brought me a small autograph book with a request from her cousin to write something in it. Write something to a girl? You didn't do that in India. Not in the Punjab where your leg would acquire multiple fractures if you did. Admittedly, Leela was not a Punjabi girl, not even

one Indian, being more English than anything else. Still, what could I write to girl I did not know? When nothing came to me, I just drew an apple in that 6-inch long slab of a book made up of smooth coloured pages. Leela wrote back on a chit:

Thank you. My favourite fruit.

No girl of my age, pushing 15, had ever said 'thank you' to me. Teenage boys and girls were not allowed to talk to each other. Their vocabulary did not have such terms of politeness. They just did not talk to each other.

Then we met. In the Blair drawing room. In the presence of her very graceful aunt.

And then we went for a walk down the middle colony road, the Officers' Road that led to the open countryside, speaking in English. Kamlesh, Sunita and her other cousin were in front of us like a shield with Leela and me behind them. That was decidedly the finest hour of my young life.

We walked again the next evening. And the next when accidentally our hands touched and the great Power House was ignited when I gingerly dared to hold it in mine. Leela did nothing to withdraw it. That was the moment to die. On the spot. And I did many a time in that one moment. Pulverised.

The Power House was electrified by now anyway. Every son of a bitch knew that Balli had got an English girl. Every evening, when the five of us went walking down Officers' Road towards the open fields at the bottom end, the bloody bastards followed us at a distance of 50/60 yards from the Clerks' Street. I never looked back and I knew that Leela wasn't even remotely aware of them.

In no time at all, the A.S. High was abuzz with the sensational news that Balli was 'having it off' with an 'English girl' – not one of the 100 pupils in the 10th had ever spoken to a contemporary of the opposite sex, let alone 'having it off' with one. So to 'hook', the term used to catch a fish, a rarely seen white girl was beyond their wildest dreams.

'Have you fucked the English pussy yet?' one crude fool asked. I aimed a golf-sized stone at his head. It covered his face in blood. I was caned publicly by Girdhari Lal whose favourite I was and excluded from the school for a week.

And my enemies closer to home did a *volte face*. They now became desperate to be seen with me, ready to polish my shoes.

One evening, Leela pressed a chit of paper in my palm. It said: *I Love You*. Then she told me they were leaving the next morning, going back to Lucknow. I was heartbroken.

'Leela!' I felt a needle pierce my chest.

'But I will write to you from Lucknow.'

. . .

There was quite a bit of an aristocrat in my dad. He liked the good things of life and he liked us all to have them too. Nothing unusual about that, but he was the only one from all the fathers of the lads I ever knew to go on shikar. He kept two guns, a Spanish double-barrel beauty with intricate designs engraved on its body, and an American .22 Remington rifle. Two of his men carried them on a shoot. When on tour, he lived amongst his men in tent camps out in the wilderness.

Game in those days was plentiful and he often returned home with something – a hare, a brace of partridges or a duck. On rare occasions the hunter returned with a deer. Lacking any sort of refrigeration in those days, venison was immediately distributed to the neighbourhood which made us popular around. Papaji liked to cook game himself. In fact he loved it, another of his traits I am happy to have inherited.

The skinning and cutting was done by servants. If it was a plain deer or the white-spotted Cheetal, the hide was sent to a taxidermist in Ambala Cantt – (our drawing room was full of skins, and stuffed heads looked down at us from our walls).

THE BEGINNING

One of the first things Papaji did when he came home after a shoot was to clean his guns with slim long cleaners of two or more varieties. He did so till the inside of the barrels shone. Then he put the guns away under lock and key in his private cupboard called *almari* where he also kept his personal papers and valuable possessions.

I was very curious to know what else my father kept in that cupboard. Once when he was away on a tour, I managed to fashion a key to his blue padlock. Among other things of wonderment, I saw a beautiful wallet made of straw, the sort you find in all Indian handicraft shops, though less so those days. Curious, I opened it. Inside was a bundle of letters neatly tied up with a ribbon. They were in Urdu, a script I knew but only a little. Yet I knew enough of it to decipher the name of their author – Tyeba. Of course, Pithi knew the language well. Biji threw the letters in the kitchen fire. Only the presence of my grandparents in the adjoining room saved a full-scale revolution when Papaji came home. All the same, a fierce one-sided war of whispers broke out and for days, Biji did not talk to Papaji. Next time he came back from a tour, he brought an expensive Banarsi silk sari for her. Of course, Biji refused even to look at the shimmering blue sweet'n'sexy irresistible. Several days were to pass before she agreed to wear it. And, Boy, did she look good in it, the nearly forty mother of ten? PR and ER issued loutish whistles. I could not resist hugging her. She smiled for the first time in days. Now it was Papaji's turn to do his thing, take her in his arms and whisper the equivalent of SORRY, adding, 'That was seven years ago, Rani, Queen of my Heart.'

. . .

All Colony post was delivered to the Power House Office. We had to send a servant to Papaji's own office to collect our mail, or we went there ourselves. Just before lunch one day, Pithi and I went along to see if there was anything for us. Papaji was away and yes, there was something for us – a letter. And it was for me! My first ever.

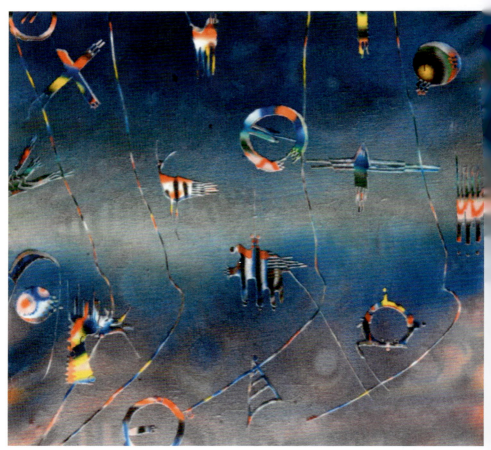

Out of the Yonder Blue, 1988, acrylic on canvas, 72 x 72 in.

As if he knew who it was from, Pithi snatched it from my hand the moment Papaji's clerk handed it to me. I demanded it be given back to me. But Pithi wouldn't have any of it. On our way back home, he opened the envelope, read the contents of the two-page letter a couple of time. Then he folded it in two, tore it to bits and fed the bits to the wind.

'WHY DID YOU TEAR IT, PITHI? IT WAS MY LETTER!'

'Stupid boy, carrying on with an Anglo slut. Have you no shame? You come from a decent family.'

'You are jealous. Plain jealous. Shame on YOU. Shame.'

'How dare you answer back to your elder brother?' Whack.

'What about you and that Suri girl in Qadian?'

Whack. Whack.

Hitting your elder brother in India is a heinous crime. I picked up a little rock and hit a tree trunk as hard as I could, wishing it was him. At lunch time, I refused to eat. I was incensed – my big brother had not even let me read Leela's letter to me! Then he had hit me because I had dared express anger at what was a despicable thing to do. Now I did what I had to do. I walked out of my home.

For good.

The sun was searing. But I didn't feel a thing. I walked and walked along the road to Chandigarh. Sometime later, I didn't know how much later, I sat down under a tree, dog-tired, dog-hungry and dog-thirsty. Next to me stood a wayside shrine devoted to a local goddess or holy sage. I leaned against it and fell asleep. I had a long holy sleep.

I was woken up by a truck coming to a halt. It was one of my father's. The driver had recognised me.

At home, Biji had thrown a fit. She had some strange inner intimation that I had run away for good. But being deposited by a Papaji's truck driver at our doorstep just like that was, therefore, cause for celebration. But I still wouldn't touch a morsel. I said a firm no to supper when supper was served.

I withdrew to be alone in my room. Raj came to see me. She smuggled in my favourite butter *paratha* with a finger-licking fried egg on top of it, a sight more delicious was seldom seen by this famished human being. But I still wouldn't succumb.

'Eat. I will not tell anyone. No one knows anyway.'

I was on hunger strike like Mahatma Gandhi, ready to lay down my life for my principles. I wasn't even going to look at food, howsoever maddeningly inviting.

'Balli, for my sake. Eat. No one need know.'

Well, if I succumbed, it was only to please my sister I so loved. She went back to the kitchen and came back with more.

I had not uttered a single word since that morning. I would not utter one till the dead of that night as we all slept under the stars. Just one word.

In the mood I was, I picked up my *charpoy* and went away from all other *charpoys*. I located myself 30 feet from the hen coops, two four foot by three wooden cages with handles.

It was a starry night ruled by a rising full moon which made it enchanting. As the rest of the family settled down in their *charpoys* and the doors were being locked for the night, soon, I fell fast asleep. Well into the night, a noise coming from the hen coops woke me up. The chickens were clucking loudly and flapping their wings in panic. I stood up to see. What I saw made me jump onto my bed in total dread – a thick long black rope stuck outside one of the hen houses!

'SNAKE! SNAKE! SNAKE!' I yelled. 'SNAKE! SNAKE! SNAKE!'

My mother woke up. Raj, Pithi and Eudhishter woke up. Eudhishter foolishly ran to the hen cages and just lifted up the one with the serpent's long tail dangling from it.

'SNAKE!' Everybody yelled in primal fear of a snake. They all stood up on their *charpoys* to be safe. Instantly, two servants came running from the back garden with logs from the pile of kitchen firewood. They beat the poor creature to death and laid it out on the driveway

right in front of my room. It was black, six feet long and about four inches thick. The moon now shone directly above our garden and the dead snake glistened in its magnificent light. We still dared not go near it. We looked at it from the safe distance of our string beds. The morning brought the colony to see the awesome dead snake, a king cobra.

. . .

At about that time, I began to think about the phenomenon of life for myself. I don't know what triggered it off, but I began to marvel at the fact of our being, of IT – the phenomenon of being. Of THIS, HERE, NOW – and asked myself come from? Where are going to? It may sound clichéd now, but to one pushing 15 they were real. I could not answer them. Standing all by myself in the fields behind our colony I felt God come in me whatever that meant. Coming back home, I started to pray to Krishna representing Vishnu, the Preserver of the universe, and enigmatic Shiva, the Destroyer. I did not know how to pray. I felt that just thinking about those questions was praying. That I never got any answer didn't seem to matter. But I felt good about it. That I thought was the Answer.

Winter had cantered its way in. Every morning, as Bauji sat cross-legged in his bed and prayed before beginning to play with little Pommey, I sat cross-legged in mine in my room, shut my eyes and thought of God. Sometimes, I saw blue Krishna in yellow silk with his bejewelled crown and a flute. Sometimes I saw Shiva with his extraordinary body adornments – a little cobra for a necklace, two more as armlets and the holy Ganges shooting out of his matted locks. As in colour prints after the paintings by the turn of the century artist Ravi Varma, I saw the Lord of the Cosmic Dance of birth, death and rebirth, in the company of his radiantly beautiful wife, Parvati, and their son Ganesha with an elephant's head. What a family! Even though I loved them as I had been taught to, I used to wonder with a smile what my

family would say if the divines came to live next door when Mr Blair got transferred to another town? I felt God inside me. I also felt baffled by Him. My matric exam looming, sometimes I begged God for a pass in it.

Early in the evening, I read from Krishna's Bhagavad Gita without understanding a single word. Tiny sweety pie Pommey would come to my room – it was time for Bauji to return from his daily walk. He always had a little pressie for her. I a would take Pommey in my arms and wait for Bauji.

Meanwhile, Papaji's field work was nearing completion. Now engaged on the last leg of the ambitious project leading up to Delhi, he was still travelling a great deal. Finally, the Pride of India, the mega transmission line from Bhakra to the Indian capital, was complete.

Prayers up and down the long line were said minutes before the test switch was turned on at the Dam. On the D Day itself, a grand ceremony was held at the basecamp, a place called Nangal ten miles below the Dam. India's President, the grandfatherly Dr Rajendra Prasad, declared the Dam open and switched the button on which would instantly light up his Lutyens-designed palace in New Delhi 250 miles away, and tens of millions home in between. The leading engineers were felicitated. ANK was awarded a gold watch. Our tenure at Dhulkote coming to an end, ANK would be given a new posting. Much to my delight, it was to be in Chandigarh itself. The exams came. I did pretty well and was pretty sure of getting a First.

THE CHARM AND THE SHOCK OF THE NEW

Le Corbusier's wonderland went to my head. Whichever way I looked, novelty sprang at me. Grey concrete, solid steel and glistening glass spoke a mind-spinning new visual language.

The daring architect had said goodbye to graceful curves and inveterate ornamentation so dear to decorative India – there was not an arch or a dome to be seen – and had instead chosen straight lines and right angles. They worked.

My first sight of a skyscraper, the 10-storey Punjab Secretariat radiating its imperious presence for miles around, left me bubbling with joy – *we too can do it!* This feeling doubled itself when I first stood under the new High Court's parasol-type roof that made me of think of a football stadium. The grand State Assembly had a sort of a big factory funnel soaring upwards with what my eyes made out as a boat of some sort on its top. All this newness made me cycle between these novel edifices for yet another look.

Fronted by endless flat land, these monumental buildings presented an alien sight against the low-lying bald clay hills right behind them. Dominating the picture postcard setting was the lofty and lush Mount Kasauli in the Shivaliks beyond with a thin veil of the seasonal mist. To the right of this stage-setting there shimmered a vast artificial lake created by damming a monsoon muddy river descending from the ochre humps of the mud hills presiding over it mutely.

Being the state capital, Chandigarh in 1955 was home to tens of thousands of bureaucrats. Housing for all was constructed according to their income levels. Those with the topmost salaries lived in spacious villas with sprawling gardens in the very top end of the city in Sectors 2, 3, 4 and 5. The next lot were housed in the middle, in Sector 16. The middle-order officials, such as ANK, were located in identical semi-detached houses below in the popular Sectors 22 and 23.

Of the two, Sector 22 was the hub of the city of wonders with the lordly Kiran cinema in pastel colours. Before it lay a vast shopping centre spelling glamour.

We were given a five-room two-storey house in Sector 22. 9FD No. 20 was painted yellow. It had 'sun-breakers', hollow squares stuck to its front to defeat the merciless Punjabi sun. From a balcony at its back,

we could look straight at the bustling mall of shops bursting with fancy goods, leading to trendy restaurants like Kwality and Embassy.

. . .

Within weeks, it became clear that coming to Chandigarh had not been a good career move for ANK – he was given a desk job. For a man of action, a desk job was torture. Yet, at least he was chief of the Punjab capital's electricity supply. And he had his Jeep which was essential for his work and status. Happily, there was talk of another something big on its way, such as another transmission line albeit of the lesser 66KV. But this would take time.

I was cocksure of getting a First. I missed it by a mere 12 marks, getting 498 out of total of 850. I joined the glamorous Government College in the spring of 1955. A good two or three hundred eye-opening beauties daily criss-crossed its glassy corridors and grassy lawns, clutching books to their pointed bosoms and giggling and talking non-stop. Some of them in senior 3rd and 4th years wore shimmering silk saris and blouses that revealed a maddening six inches of flesh.

Another immediately noticeable feature of these girls and boys of the same background was that they all had rosy cheeks. And they only spoke English. But it was English with a difference. It was posh. It set them apart from 'ordinaries', other Indians who spoke it with a jarring ring to it. There was a reason for their classy speech and rosy cheeks.

After Partition in 1947, the most important departments of the Indian Punjab's government were located at the Queen of Hill Stations, Simla, in the deliciously cool Himalayan foothills. The British quit Simla that year, but they had left a durable legacy of sophistication. The cosmopolitan hill city had several boys' and girls' public schools plus a co-ed college where 'English' English only was spoken. On top of that was its famed 'English weather' with its healthy air and water. This 'English weather' had put a rose in every Simla cheek.

In 1955, all the government departments had been moved down to the new capital, Chandigarh. Many of my college mates had come from Simla schools. They had brought with them Simla English and rosy cheeks. My private name for them, used in my novel *Nation of Fools* was 'Simla Pinks', snobbiest of snobs and God's special gift to India. They were the sons and daughters of the rich who inhabited the North End of Chandigarh under the shadows of its Corbusier-designed world-famous masterpieces. Wearing the factory-made fashionable Drip-Dry nylon shirts and bottom hugging jeans, they came and went in cars and jeeps, on Vespa scooters or the monstrous Enfield motorbikes, making the mother of all motor noises. They mixed only with themselves – going to Sunday English matinée shows together and thronging at the capital's classy restaurants. They went a-picnicking in the Shivaliks in cars and jeeps. For them, boys and girls from the Punjab plains were plain 'ordinaries', not for the Simla Pink world.

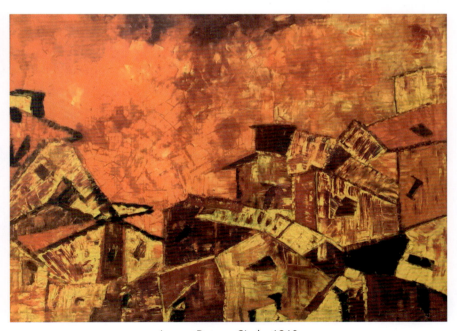

Lower Bazaar, Simla, 1960

Did I long to be in that world? I needn't have worried. For I was in that world without my knowing it. My English. I had inherited my father's speech (who had got it from his fellow Brits in the army). I had his looks too, the very looks that had cost him a military career and nearly his life and his family's for *affairing* with a young Muslim virgin in brutal 1947. So from day one I became one of 'them' without there being a rose in my cheeks, and was shunned by the 'ordinaries' who formed the majority in the college. But I lacked something important. In that city of concrete, what cemented your social standing was money. And I had little of it. Even though it didn't seem to matter to 'them', it mattered to me.

. . .

One morning in the college library, I saw a large photograph of our Prime Minister and his daughter Indira Gandhi dominating the front page of every newspaper. We saw his pictures daily, but there was something special about this one. Attired in his hallmark long white achkan and Gandhi cap, he was walking down a street in an Indonesian city called Bandung. At college assembly the same morning before the national anthem, our Principal good man Mr Varma told us what he was doing there. Nehru had visited our great neighbour China recently to a rapturous welcome and was now presiding over the historic 1955 Bandung Conference of newly independent nations, bringing India high prestige. Also, he was introducing the hitherto pariah China to the world by leading its Prime Minister Chau En Lai almost by the hand to the podium. We all felt very proud that day and we sang the national anthem, Tagore's song, with heart. A few weeks later, we were delighted to learn that we would soon have the important Chinaman in our midst.

Chau En Lai came to Chandigarh in a blaze of publicity – Nehru returning his hospitality. Nehru wanted to show off independent India's shining achievements. The Bhakra Dam and Chandigarh were top of the list.

THE BEGINNING

It was a briskly clear day. 50,000 Chandigarhians lined the broad road from the Kiran cinema to the far end of Sector 22 where gorgeous sari stores jostled with glittering jewellery Aladdin caves and shops selling from anything to everything. School children had been given the day off and ordered to look tiptop. The collegiates needed no such bidding. They were always tiptop, if not over the top. The boys had come not for Chau, but for the girls, hoping to rub their elbows on their tits in the mad rush.

The leaders were late. But no one minded. In fact, it heightened the atmosphere, adding to the feeling of fun at being there. Then suddenly there were shouts of:

'HINDI CHINI BHAI BHAI!' Indians and Chinese are brothers.

Soon, we saw them, two small men standing in a big roofless car, beaming beatific smiles and waving to children. No one could have foretold that day that soon things would change.

India had had a 2,000-year old relationship with China. But it was one-sided – China becoming Buddhist through India and thus imbibing Indian thought and philosophy. Sadly, as Napoleon's Sleeping Giant would start to wake up, it was to became aggressive … 'expansionist', claiming tens of thousands square miles of Indian territory. But that day in Chandigarh Hindis and Chinese were *bhai bhai*, brothers.

. . .

I began to attract attention. Fifteen, I was the only one in the college who could bowl a leg break. It was a ball difficult for a bowler to bowl and difficult for a batsman to play. So I was chosen for the college First XI, its youngest member. Not far from our nets lay a farmer's field complete with a well and the equipment to draw water for the crops. After our lectures, I turned up early one evening at the nets. I wandered off to the well for a drink. I was treated to the rarest of rare treats, a spectacle which was and must remain unequalled in the annals of history.

I saw an immense camel resting on the ground after having drawn water for its owner. I saw a fully-grown male pig behind him doing something bizarre. The pig had an erection – a long slimy carrot jutting out of his crotch. He was trying to mount the camel whose backside was taller than the pig's full height. He tried again and again to reach the camel's ass, but it was much too high. The incredulous well-owner and I roared with laughter, wondering if the camel knew how near it was to meeting a fate worse than death. Eventually the camel, a she, shook its backside and stood up. Disappointed, the pig went away at half-mast.

When my team mates finally turned up, they refused to believe me. They went to the well to have my story verified. Then they roared with laughter to hear about the near-rape of a camel by a pig. Nobody at college believed us either the next day. But the story went viral, as it were.

. . .

I joined the Young Speakers Association, an exclusive club that also had several Simla Pinkies as its members. A debate was in the offing, something about War – if mankind had benefited from it? I elected to speak for the motion and wrote what I thought was a lovely speech. Even my father thought it was well-written. Every morning before college, I went to a clump of mango trees across the road and rehearsed. I said, Mr President to an imposing mango tree. I then turned to the lesser trees, as Ladies and Gentlemen, and thundered out my speech. Soon, I knew it by heart, every word of it.

My hour of fame was at hand. Fearful of hubris, I kept rehearsing till the last moment and felt only a distant twinge of nervousness when my name was called up from the stage. In a measured walk and in pin-drop silence of a hall of over 500, I mounted the stage. I felt so self-assured that I didn't even spread my notes out by the mike like other speakers had done.

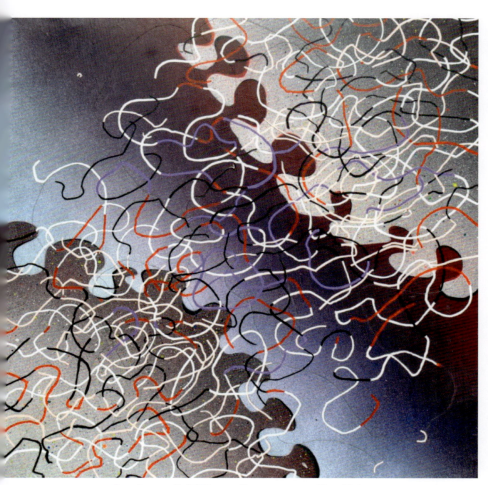
Continents II, 1978, acrylic on canvas, 60 x 60 in.

'Mr President, Ladies and Gentlemen …'

A pregnant pause for effect and I continued:

'… WAR …'

There I got stuck. I began again:

'Mr President, Ladies and Gentlemen … WAR …'

I had forgotten what came after WAR. Boos loud and clear echoed in our indigo blue hall. Deafening laughter and shouts of rudeness ricocheted from its indigo blue walls. Pandemonium at its best, or worst. In spite of myself, I realised that the most vociferous was the very centre of the hall where sat my cricket bum chums. This was not cricket, but a total betrayal. Anger total and totally uncontrollable took over. I forgot myself, and the fact that I was speaking through loudspeakers:

'BASTARDS. FUCK YOU ALL. FUCK YOU …'

The hall exploded.

'141,' screamed Principal Varma my roll number – he also taught us English – when I was summoned to his office. 'I am expelling you for using such foul language at a debate.'

'Sir …' I explained the hall's provocative behaviour.

'Ummm.' Principal Varma understood. He forgave me.

'As a public speaker, you have to put up with all kinds of provocations. Abuse even,' he added for good measure. 'Make sure you don't give in to it next time.'

Next time? You must be joking, Sir, I nearly said.

But there was a next time – I couldn't let the bastards make such a total and permanent ass of me.

This time, I spread my notes before me, and this time I went through the whole five minutes of my speech without making a fool of myself. However, at the third debate, I spoke without notes and spoke as I used to the mango trees – thunderously – and won a good sitting ovation plus a six-inch tall silver-coated egg cup. Papaji placed it in the middle of the mantelpiece in our drawing room.

. . .

THE BEGINNING

A happy family event came. This was Raj's engagement to a handsome young engineer. 27-year old Harkrishan Lal Vij had forsaken a lucrative government job to launch what turned out to be a highly rewarding career in automobile engineering.

Well, Raj became engaged with a surfeit of presents for the boy and his family over a mountain of sweets and so forth. The darling of the family seemed to have changed with the simplest of ceremonies held. She began to radiate beauty and filled the house with a palpable feeling of joy.

. . .

I decided to begin preparing for my FSc exams in earnestness. They proved to be tough. I failed. To deal with my shame, I decided to run away from home. I had a few rupees saved up. I would go to the old Camp near Ambala where my old friend Omi would find me some work. I wrote a letter to my parents:

Most highly respected Papaji and Biji

Please forgive me for dishonouring you by failing in my FSc exams. I am going away to return one day fully worthy of your love and affection. I have to do this because I cannot continue as I am. I have always loved you and I will always love you. Please forgive me and give my love to everybody, all my beloved brothers and sisters.

Your affectionate son Balli

Since leaving Dhulkote, I had seen Omi only twice when he had come on a sightseeing visit and stayed with us. So my turning up out of the blue was a bit of a shock for my old chum. But he was glad to see me. He had also taken the same FSc exam and had passed. He was sorry that I had not and that as a result of which, I was running away from home. Over a cup of tea and a bucketful of sympathy, he tried to make me see sense and go back home tomorrow. But my resolve was firm. Soon Omi would find me work at his father's school, teaching primary school children under a neem tree on the main road by the

bus stop. I would work hard at my books. Really hard. Other things would follow. A First this time and self-respect.

As we made our way to the primary school early next morning and passed by the bus stop, a bus arrived from Chandigarh. Only one passenger got off.

'Your family servant Sant Ram!' shouted Omi.

Sant Ram hailed from Camp Baldev Nagar and it was entirely possible that he was coming home on leave or a day's visit. But something about his body language said something else.

'Sant Ram, what are you doing here?' I called out.

With tears in his eyes, the loyal old family servant rushed to me and embraced me like a brother.

'Khanna sahib. Having a heart attack.' That was all the lovely man could say, removing the earth from beneath my feet.

A Punjab Roadways bus was leaving for the Punjab capital in a minute. Omi looked at me ominously.

'Catch it, Balli.'

. . .

It was the way I walked, hurriedly, that announced me as I walked into the open door of mortuary silence of 9FD 20.

'HE'S COME! HE'S COME HOME!' the houses resounded with Raj's shouts.

I dashed upstairs where everybody was. There, I found my father unshaven and pale. He lay in his big *palang* bed, staring at the whitewashed ceiling. My mother sat by him, vacant-faced. I wrapped myself around her. She gurgled a sob, then another … it became a stream. I broke down. Raj started crying. Kamlesh Usha, Shoki, Vimmi, Karan too. Overhead, the electric fan whirred quietly.

'What is this nonsense you all crying?' my father said, sitting up. 'The boy has come home and the boy is hungry. Give him something to eat, Rani,' he said to my mother.

Papaji had not had a heart attack. He was just devastated at what I had done. It had made him sick. He had taken to bed. That was all. My body echoed with resounding relief.

Within minutes, a glass of hot milk arrived along with a piping hot *paratha* with a perfectly fried egg in its middle. No questions were asked. I was not grilled. It was all back to normal with Raj muttering with moist eyes, 'Silly boy.' I did not have to say sorry. There seemed no need to. I would have belittled everything.

Nobody at college took any particular notice of my having failed. It was business as usual or as unusual. Though not for me. To deal with my increasing loneliness, I began going on long walks that impelled me to the Chandigarh Lake. The bald hills beyond offered a special gift of soothing silence and irresistible beauty. I began to paint what I beheld. There was something compelling about the untainted grandeur of clay hilltops where not a rock was in evidence. Nor any greenery. They were not sad hills, they were just lonely hills. Nor were my pictures sad. If anything, they were happy watercolours even if they depicted only mounds of ancient earth with the gigantic blue Mount Kasauli far behind them. Ten years later in France I would paint the very different Alsace landscape, combining foliage and rock formations standing as kith and kin of undulating grassland dotted with vineyards renowned for Alsace wines. Memories of my past excursions to those hills of my early youth and these vistas new coalesced to form my own brand of abstraction. I had broken a leg in a road accident in London and Francine, pregnant with our first daughter, Nathalie, my young French wife had taken me to the bosom of her family in Metz to recover. Surrounding the charming medieval French cathedral city with ugly post-Franco-Prussian War Germanic architecture – the massive railway station and the fortress-like post office in particular – were pockets of seductive Alsacien forests. They brought to mind Pope's 'nature methodised'. With my leg still in plaster, I used to draw and paint and felt free as a bird, sometime succumbing gleefully to a glass of

chilled Alsace white – I felt at one with what I beheld. A very large oil I painted there a mere few years later, FOREST WALK 72" by 96" would be included in the historic mega exhibition entitled *ARTIST & EMPIRE* at Tate Britain in 2015–16, becoming one of its star exhibits.

. . .

Back in college, I made a new friend in my new class. Those one year behind me last year were my classmates now. Lali, a Sikh, was one of them. A Simla public school product, he was without any of the Simla Pink airs. Lali was special. With an ever-winning smile, he was warm-hearted and generous to a fault. And he always had something good to say about me:

'Balli, how nice you look, you bugger,' he said when he saw me in cricket whites. 'Girls would faint when they saw you.'

Lali lived with his sister in a grand house in the affluent Sector 9 up north. She was married to a successful young lawyer and even she grew to be fond of me.

Lali had a birthday. He threw a party. I was invited. It lit up my life. I had never been invited to a Simla Pink party in spite of my English accent. And the 'Ordinaires' never had birthday parties.

Of a land-owning family, Lali was always loaded. Knowing that I never was, he would go to the counter at Kwality and settle the bill out of sight. It was well in keeping with friendship among Punjabi men – you simply didn't let the other pay the bill. Nor did you ever take advantage.

Good looking, fun-to-be-with, Lali was a natural for popularity – he didn't have to try to be popular. He just was. He knew everybody and everybody loved him. I felt privileged that he held me in such esteem. He invited me to his party to which 'everybody' was coming.

'Everybody' was the Simla Pink cream, some from as far as Delhi – yum, yum curves and cleavages. My English was my dad's and my vocabulary that of a well-read lad. I had just started shaving and the

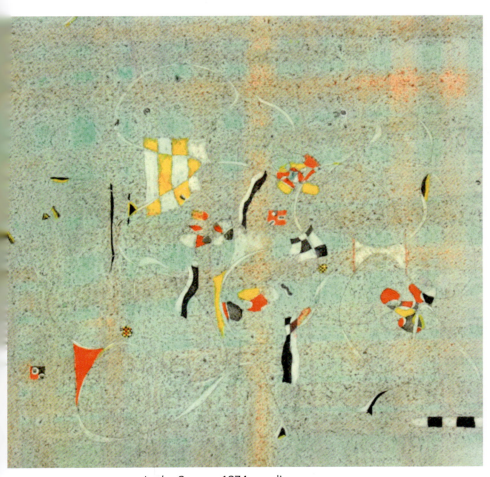
In the Square, 1974, acrylic on canvas.

mirror now said, 'BK, you are OK.' If there was a snag, it was that I did not know how to dance.

Was I OK? I don't know. But it didn't matter at all that I didn't know how to dance. My luck was running in. The middle of the three Rana Sisters from the delirium-inducing Miranda House of Delhi, 'heart-palpitator' Pea, took charge of me. Before the end of the balmy evening growing balmier by the minute and after repeated One Two Three, One Two Three, I could waltz with ease. I could also do a fox trot and quickstep to His Master's Voice gramophone and 78 rpm English records.

'Practice makes perfect, Balli. Practice does,' whispered my teacher, faintly brushing my ear with her lips, or was I imagining? Now we were many double silhouettes on the candle-lit back veranda and the sprawling walled garden beyond it. Just like the shadows glued together at the Blair parties back in Dhulkote (Lali's sister and brother-in-law had thoughtfully accepted a dinner invitation).

The Rana sisters were only here for a few days, staying with an uncle and aunt who were also Lali's uncle and aunt. This made them 'cousins' of sorts. Lali made sure that his Miranda House cousins dropped in every other day and his friend got some more practise to His Master's Voice.

It was a sad day when the Rana sisters went back to Delhi. But practise had done me no harm. It would come handy in time.

Meanwhile, I had yet another set of exams to reckon with. The dreaded exams came. This time, my luck was running good. I passed. Not unexpected, I had worked for it this time.

Then came the news the Khannas were desperately waiting for – ANK's next posting. The government was to construct another big transmission line, one not as great as the previous 220KV, but one important enough nonetheless with a large work force for ANK! It was to carry electricity from Chandigarh to the Queen of Hill Stations, Simla! ANK's new job was to construct this 66KV mountainous

engineering feat. His headquarters would be the half-way house Solan, a sleepy little hill station 25 miles south of the city made by the 'heaven-born' British. We were grateful.

If there was a cloud on our brow, it was little Pommey being taken suddenly and seriously ill. It was a dark cloud. We sat cross-legged on the cold cement floor that evening and prayed. It was thanksgiving. But essentially, it was begging God for Pommey's health. Then every evening, we all sat down on the bare floor. Our folded hands upon our chest we begged our maker for precious little Pommey's recovery.

LOVE AT FIRST SIGHT

It was just that, love at first sight with sleepy Solan at five thousand feet up in the Himalayas. My first sight of mountains, of being among them filled me with chills. As a child, I had mistaken distant clouds on the earth's horizon for mountains and had ran home to tell my father so to be greeted by smiles. Now real mountains were around me, singing to me. Once, I had lyricised them childlike in watercolours which I was learning to mix. Surrounded by them, it was natural to paint them and now I knew about mixing colours. Spread before me was the drama of heights and depths. The prevailing smell was that of Christmas – pine trees covered hillsides and slopes made slippery by golden pine needles.

A small garrison town, Solan was drab with a bazaar and a half in the summer of 1958. It was the halfway house between even drabber Kalka in the plains, and the glittering Simla 60 miles away at seven thousand feet. Papaji had decided that's where I would go as a boarder to get a degree.

Our house, *Kapoor Lodge,* looked over a wide expanse of airy emptiness of humps and bumps cut by the Kalka-Simla railway line, the eighth wonder of the world I'll come to in due course. The tiny station

with Swiss gables and flower bushes in bloom was also visible. A rash of half-timbered houses with corrugated iron roofs clung to steep slopes and the military hill gaped at us from the left. Then, at the far end of the valley a mile away, there rose a lofty mountain. It was a place to live and paint.

In the city of the high and the mighty, of the rich and the richer – Chandigarh – we Khannas were middlings. In sleepy Solan of sweet simplicity, we again became what we had once been accustomed to as in Qadian – toplings. There were many army officers, but they lived a life of their own. ANK had no one to answer to here – his boss was back in Chandigarh. Again, he had a large work force working under him. It fetched us importance in all Solan's eyes.

. . .

Known as 'the poor man's Simla', sleepy Solan's only claim to fame was its Dyer Meakins Brewery, also a distillery. Golden Eagle Lager and Solan No. 1 whisky flew down its slopes reaching all corners of India. The name Dyer is one of the most infamous in the annals of the 200-year British Raj. For it was a descendent of that 19th century co-founder of the brewery, General Reginald Dyer who had ordered the shocking shooting in cold blood of hundreds of innocent Indians at Amritsar in 1919, hurrying a steep and irreversible demise of the 200-year old British Raj less than 30 years later.

. . .

Little Pommey had shown no sign of improvement ever since we left Chandigarh. We decided on a trip to Simla to consult a renowned paediatrician our Solan doctor had recommended. This would also allow me to register at the famous co-ed Sanatam Dharma Bhargava Municipal College, or the SDBM College.

Papaji took a day off. With Biji and Raj cradling our withering gem in their arms, we all went in his jeep to the 'Capua of India' as the

Brits regarded Simla, or the Mount Olympus, another of their names for this koh-i-noor.

Our doctor had praised the paediatrician sky high, guaranteeing a cent percent recovery. This had lifted our spirits sky high. None of us with the exception of Papaji had been to the fabled Queen of Hill Stations. We bubblingly looked forward to it. The plan was that while I went to my college half a mile away from the hub of the city, they would take Pommey to be seen by the famous paediatrician on Simla's famous Mall Road, its commercial and glamour-drenched heart.

The jeep wound its way up the steep, winding road slowly. As we rose higher, I could feel that the air was cooler on my cheeks. Twenty miles on and five miles still to go, we came in full view of our prize. We were now at a place called Tara Devi where the road ran with the narrow gauge railway line for a while and we saw a toy train crawl its way up like an earthworm. Simla was always an army HQ. In the British Empire's heyday, while the officer chaps and their families lived up in the sixth or the seventh inn of happiness that was Simla, British footsoldiers and non-commissioned officers – lived in camps here at Tara Devi and others well below it – the Brits had their own caste system, didn't they?

A long-crescent-shaped spread of an English town was hoisted piecemeal to unimaginable heights before us – Mount Olympus! It was a picture postcard that became bigger and bigger as we climbed higher and higher.

We parked in Cart Road the base of the mountain. Motor traffic being forbidden in Simla, we had to walk up a steep and beautiful road with staggering views leading to the heart of the city, its jewel-like Mall. Something about what I beheld, reminded me of something I had read somewhere:

'*What wonderful architecture! If the monkeys have done it, they should be shot, lest they do it over again.*'

Of course, its author was the great architect of New Delhi, Edwin Lutyens. But I disagreed. For someone accustomed to le Corbusier's straight lines and grey concrete, mock Tudor domestic and civic architecture which Simla presented was yet another deliciously non-Indian spectacle. But it was an English spectacle, suddenly making me long to see the original, England itself. I promised myself that one day I would go to see it for myself. Maybe live there even. What my bewitched eyes beheld brought to my boggling mind a line of something about Simla I had read somewhere:

'See Simla and sigh!'

I did. A wry smile accompanied the sigh.

I parted company with my family at the Raj-time Gaiety Theatre in the middle of the mile-long Mall Road to be reunited with it later. I climbed the near-vertical steps leading up to the famous Ridge, a large and flat table-top strip of tarred mountain earth where scores of well-dressed tourists loitered around. From its far end stood a life-size bronze statue of Mahatma Gandhi. Towering behind it was the massive Mount Jakhoo where prowled a large tribe of monkeys. In fact, the entire hillside was infested by these holy descendent of the monkey god Hanuman. I was directed to Lakkar Bazaar which would lead me to the steep descent towards my college. By the Regal Cinema nearby something entirely unexpected caught my eye, a milestone saying TIBET 200 M. For the first time ever, I became aware of the existence of another, a foreign country – the new word Pakistan didn't quite convey the same meaning, being torn out of India. Timeless Tibet did, shrouded in the mystery of Buddhist monks, monasteries, lamas and strange animals called yaks.

SDBM College was perched on a spur in the Elysium Hill on Cart Road well below Lakkar Bazaar. At a loveable spot with loveable views and vistas, it used to be a glory of a hotel, the Elysium, one of so many that sparkled in the 'season'.

My registration didn't take long. Within an hour, I was back at the Mall. Pommey had been seen and diagnosed as having some wasting

disease. She had been put on some very strong medication. My family looked subdued – gone was the morning's bubbly optimism and enthusiasm. We had lunch somewhere in silence and we drove back home in silence.

As days passed, even the medicine prescribed by the Simla specialist didn't seem to do Pommey any good. Her condition deteriorated rapidly. She became spectre thin and, horror of horrors, the unfortunate little thing contracted smallpox.

Smallpox disease was called *mata*, or MOTHER. Uttering the word *mata* was to invoke the great Mother Goddess – Kali – representing the more important of the Female-Male principle of Creation. It was a prayer to Her caring aspect to spare the life of one afflicted – *Mata* often proved fatal. My mother and Raj prayed all day. We all did. Kapoor Lodge became a house of sadness. Melancholy hung in its every nook and corner. We chanted the prayer all the time, begging the Great Mother to save our little darling. One morning, Pommey's condition became critical. Neighbours came and stood outside our house silently. Some even came inside and sat down cross-legged with us on the bare veranda. Our local doctor was called. He gave Pommey an injection of something called coramine. It didn't work. The long-suffering four-year old was no longer in pain. He eyes were clear, staring at the ceiling. Just after noon, her eyelids closed. They didn't open again.

The cruel irony of fate was that Papaji was away on tour at his base camp at Kalka 30 miles downhill. He wouldn't be back till late in the evening. But custom dictated that the rite of cremation be performed within a few hours. It was at the town's cremation ground outside the city limits, attended by men only. Then we all had a ritual bath.

Papaji wept bitterly when he got home that night. We all wept bitterly in each other's arms. Bitterly. Bitterly.

. . .

Then came the day when I left home to become a boarder. I could have gone by bus which did the 25 mountain miles in a mere 90 minutes. But I wanted a ride on the famed toy train that plied between the two terminuses – Kalka down in the scalding plains and Simla up in the refrigerated heavens.

The Kalka-Simla line is 60 mountain miles long. Its 107 tunnels, aggregating 7 miles and dozens of breath-stopping viaducts three miles in length, make this line a unique feat of engineering of its time, 1907.

At Simla station, a sturdy Kashmiri coolie, Salim, strapped my trunk, suitcase and holdall on his back for a mere half mile-long uphill ordeal for one rupee, the going rate. SDBM College Hostel, too, used to be a glory of a hotel once. Perched precariously on a ledge in the shadow of Mount Jakhoo, it was known as the Peak Hotel. From its long veranda there unfolded a kingly valley with an endless undulation of pine and deodar peaks peeping out of a layer of clouds. My room on the first floor at the back overlooked another vast pine and deodar covered valley, but with a difference. Beyond the valley in the midday sun towered snow-capped Himalayan cones behind at least four ranges of mountains.

If my first college in Chandigarh three years ago had made the head of a boy from the Place of Dust spin, SDBM of Simla simply sent it reeling. The girls were walking-talking confectionery, the boys held up proof of SDBM's sartorial fame. And every cheek had that rose, a gift of good mountain air and water from natural springs. Added to that was the Simla Mall Road where glamour walked and shopped in Aladdin caves and ate and drank and danced in hotels and restaurants just as the builders of the city had done in glory-days gone by. The 'season' was still swinging when I arrived there in the middle of August 1958 when the Mall daily became a river of humanity dressed to kill – locals and tourists – moving on leisurely, sluggishly.

That's what college attendees did every evening – walk up and down the Mall to see and be seen, what life was all about. Wasn't it?

But within days, I felt I had had enough of it. I missed home so desperately, I could have died of it. The college confectionery no longer seemed sweet. Tight jeans' bottoms on the Mall didn't make me salivate. I didn't want any of whatever bewitching stuff Simla had to offer. I had no one to talk to. No one had any time for me. I had no interest in doing a BSc with science and maths I could not handle. So what was I doing here?

By my fifth day on the Mount bloody Olympus, I simply could not take it any longer. So, I packed my suitcase and began my long trek down to the railway station. I was accosted.

'Not going back, are you, sir? But you've just come!' said my old coolie Salim at the station gate. He could see home-sickness plastered on my mug. 'Give me your suitcase. I'll take you back for free. You'll be all right in no time at all.'

. . .

Slowly but surely, things began to change to lighten my inner turmoil. I started to paint the moody drama I beheld daily. It changed as the day advanced. There was always a veil of mist in the morning. It made me feel I was looking through air and water, a hallmark of my paintings as noted by art critics decades later. The mid-day sun poured out amphorae of honey on Mount Olympus. Then a faint fluorescence laced the air as the day wore on and the distant snow-capped Himalayan peaks began to become golden when the sun god decided to take a dip.

My hostel mates were vaguely impressed. But on the whole they thought I was a bloody fool sitting hours on end on my arse while they had such fun loafing on the Mall, ogling.

Other changes were afoot, too. The college had a cricket team. Net sessions were held daily after lectures in a disused Raj-time tennis

court halfway up Mount Jakhoo that looked down at Simla. I made my mark. There were no playing fields in mountainous Simla. The boys therefore never got the chance to practise enough. It reflected in their game. The captaincy trial was coming up. I was the only one to turn up in whites at the spectacular net 500 feet above a gorge.

'So you take your cricket seriously,' said the professor in charge. 'Let's see if you can keep a straight bat.'

I hadn't thought about it. I was going to the cricket net, I had to be in whites. And I kept a straight bat, not to mention my unplayable leg break.

'Ah, we have a new captain,' announced Professor Sharma, 'a jolly nice chap' as he would have been called by the Brits at the end of the practice session.

Cricket captaincy was glamorous, the thing to die for. It changed my life overnight. And I also spoke well in debates which did me no harm. Girls now had eyes for me. But society dictated that girls did not talk to the boys. Only a few brazen hussies were known to be 'affairing'. I longed for a brazen hussy to 'affair' with me and wondered why she was taking so long.

College life became fun from the day I switched science subjects to arts for my BA. I needed my father's permission for this. I asked my wicketkeeper and classmate Ram Mohan to forge his signatures. He more than readily obliged. I took up English (which was compulsory anyway), Political Science and Economics with NCC – National Cadets Corps – army training as an optional subject. For NCC, I needed a medical. I knew I would fail it because of my tone-deaf left ear. But Ram Mohan, who too had taken up NCC came up with a brilliant idea.

'Let's skip the official one and do what I say.'

We didn't show up when the medical was conducted in the college by a retired Sikh army Major – Dr Arjun Singh IMC Rtd, the SDBM medic. He lived in a Simla suburb, Sanjauli a mile away. The city and its suburb were at the same altitude. Therefore, the road linking them

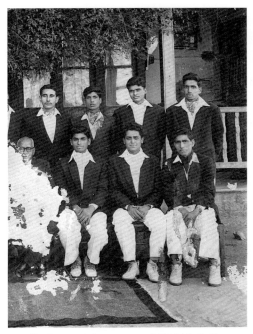

Half of my cricket team of SDBM College, Simla in 1960. The other half got eaten by Indian Monsoon!

was flat. There was a bicycle shop in Lakkar Bazaar. You hired a cycle from there for a quarter and handed it to its sister shop in Sanjauli. You did the same coming back. Ram Mohan's idea was that we would turn up at the Major's house and beg for a medical. Not having all the equipment for the medical at home, the doctor was bound to find me fit because I was fully fit otherwise. Even a genius could not have come up with a better solution to my problem. But a different sort of problem arose half way at the white and green painted Snowdon Hospital, one-time residence of the C-in-C's of the Indian Army like Kitchener, Wavell and Co. My friend spotted an ageing Sikh gentleman cycling towards us. Ram Mohan leapt off his machine, shouting:

'Major Sahib, Major Sahib, most urgent!'

'What, boy, what?' the gentleman said, stopping.

'Our medical, Sir. Unless it's done, we can't join.'

'But I'm coming to the college tomorrow.'

'Too late tomorrow, Sir. A full parade tomorrow. Captain Sethi would perform some awesome surgery on our manhood.'

'You mean …?' The Major chopped Ram Mohan's manhood off with an imaginary surgeon's knife.

'Yes, Major sahib. Believe it or not.'

'So?'

'So please help us or …'

'That so? Ummm. You swine look fit enough to me. So …' So the good retired army medic wrote 'Fit', on two chits.

Life was taking off smooth and fast – Lectures till midday, lunch at the hostel, an afternoon lecture. I painted a good couple of hours lofty peaks, measureless ravines and rugged mountain folk. The cricket net followed. Now came the most delicious part of the day. In threes or fours, we did the Mall, my mates and I. We merged with the sluggish river of 'see and be seen' peacocks and peahens.

To round off the evening, we had a coffee at the popular India Coffee House 100 yards from Scandal Point, the epicentre of that tourist town where stood a statue of the Punjab patriot Lala Lajpat Rai. One evening my wicket keeper took me to the star of Simla, the 'world-famous' Davico's a few doors away from the coffee house.

'Place's full of Parsee pussies from Bombay and Christian cunts from Cal. All itching for guess what, Kaptaan?'

The 'world-famous' restaurant proved to be an eye-opener – vast with a vast glass wall at the back overlooking distant valleys and peaks. The view was the stuff dreams were made of. Another breath-taking sight was right in front of my eyes – intertwined men and women on the parquet floor dancing to live tunes from a five-piece band. RM whispered some practical advice on how 'to make us irresistible to women'.

After a while, we met two dusky beauties, 22 both, Ruby and Doreen from Cal (short for Calcutta in Raj-time speak).

'Prince Balli. Ram Mohan,' my friend said with a bow.

'Prince of where?' Ruby said.

'Solan.'

'Oh, that sleepy little town? We stopped there.'

'Needs a decent somewhere for travellers, a little like this. Give the place a facelift,' Ruby said.

'Prince Balli's Uncle is doing something about it.' My Uncle was the Rana Saheb of Solan, its king.

RM went to the Gents. This was part of the plan.

'A little weird-looking, your friend,' Doreen said.

'A bit funny. But he is alright, the Rajkumar of Kulu?'

'So he is also a prince then?'

'Don't be too impressed. Simla is full of princes.'

They were not. Their coffee drunk, they walked away without a second look at the 'princes'. My friend was heart-broken.

'Strange. Never failed before. Maybe next time.'

The two Parsee ladies we met two days later were equally unimpressed by our royal status. They even turned down Raj-kumar's invitation to an elephant ride in his kingdom, Kulu.

'Third time lucky.'

And we were. We hit it off with jet-black Sylvia and Suzie, Christians both from Banglore. RM whispered as we danced:

'The giving type. If you know how to take.'

That, frankly, I did not know. I could tell and feel that Suzie was being very friendly.

'Naughty boy. Wicked boy,' Suzie said, dancing close – she had pulled me in, making me wish I wore a cricket box.

'Should I go away?'

In answer, Suzie pressed herself against me.

This happened more than once with other ladies, too.

But that was as far as it went with the fun-seeking tourists from the plains, excruciatingly innocent. I was too dumb to get on the gravy train going, said Kulu's Raj Kumar.

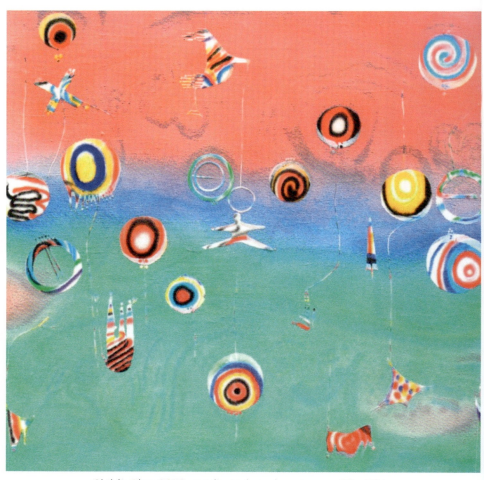

Child's Play, 2019, acrylic and sand on canvas, 72 x 72 in.

'You deserve a mention in the dispatches.'

'Next time.'

'Next time go missing in action, Captain sahib. I would.'

'I bet you would, Wicketkeeper ji.'

'Anything goes in this city of snobs and nawabs.'

The SDBM had an "ICBM". The entire male population of the college, all its 350 nutters, were 'head over heels' with her. A mass suicide was on the cards.

RM was quite pally with the ICBM's younger brother Sunnu in the First Year, and Number 11 of my team. Sunnu told my friend what the girls called me – Champagne. None of the 150 girls in the college had probably ever tasted a drop of the divine drink, nor even seen an empty bottle of it.

But there were one or two who had eyes for me. In fact, three. Sadly, only one or two liners pressed between a book's pages ever passed between us.

. . .

Life had become a colour by technicolour film reel, rolling double fast time. Dances at Davico's, cricket matches at Annandale (a Raj-time mini racecourse at the bottom of a giddy Gorge) and an occasional whole college picnics at the Glen nearby surrounded by majestic 120 feet tall deodars. All that plus more kept our hearts racing and minds working double time to engineer that which was the burning ambition of our life – losing our unwanted virginity – 'Laying an SDBM ICBM,' as my imaginative teammates put it so cogently. Alas, the idea never got translated into reality.

The college Fine Art Society held an art competition. I turned away when I looked at other entries – they were childish trivia by grown-ups.

'Don't be an arsehole,' said RM, now my inseparable friend. He grabbed a mountain-scape from my room and entered it. The display

was awful. I felt ashamed of it. One evening my mates and I were 'eating the air' on the Mall when he came rushing.

'You won, you bastard.'

'Won what?'

'Fucking first prize, believe it or not. Our fucking judging professors. Blind as bats.'

That was Punjabi friends talking. It meant affection. I never collected the prize, but I still have the certificate.

Winter was upon us. It brought something even more bewitching than the 'city of snobs and nawabs' Simla had revealed to me hitherto – ice skating! Below the Scandal Point there was a two-star hotel, the Blessington, by Cart Road. This road linked the Queen of Hill Stations to all other stations in India. Among the hotel's best features were its three tennis courts. They were flooded with 3/4 inches of water on a cold November night and had salt sprinkled on them. The weather did its magic and next morning Simla woke up to India's first and only Ice Skating Rink.

The beauty of this place was that here men and women could do that which no other Indian could do anywhere else in full public gaze, go swirling round and round on ice holding each other by the hand as English songs blared on the Rink's loudspeaker. Those who could, even danced together watched by two hundred plus, yet no one was stoned to death.

I learnt to skate quite quickly. Anybody who was somebody came to skate, among them none other than the college ICBM. She came with her brother Sunnu. We skated together. Sometimes, one of them had to cling to me when he or she lost balance. My dilemma was how to separate the sister from the brother. Impossible. India! But I got mentioned in the dispatches – now every one of those 350 bastards wanted to chop my balls off.

The winter hols began just before Christmas – Simla had its 'summer holidays' in the winter. But the Khannas' biggest ever

family event came before that – Raj's wedding. It was to take place in Chandigarh on the 12th of December. Papaji rented a big, three-storey house in Sector 21 in front of the Aroma Hotel. We all assembled there, all our friends and relatives. Dozens of us slept wherever a 6 foot by 4 *dhurrie* could be laid out. Great feasts followed and lavish gifts made to the groom and his family accompanied by a stunning dowry. We Indians go bananas at weddings because money grows on trees.

Back at college, our annual winter vacation was approaching. Then I would sit for my BA exams. I went home to prepare.

Just then, Papaji had yet another transfer, the already-mentioned but very important Nangal, our new hometown.

NOTHING TO DO BUT SOMETHING TO SEE

Once a jungle, Nangal was the BIG OFFICE that served the great Bhaktra Dam. It was a new colony like Dhulkote, but on a much grander scale.

Everyone here had something to do with electricity – generating it, measuring it and transmitting it to other parts of the Punjab right up to Delhi with the necessary paperwork and red tape. Or they had to do with water – taming it, containing and channelling it. The little old Nangal town itself lay prostrate at the foot of the concrete marvel a few miles above it in the pre-Himalayas. One of the five great Punjab rivers, the Sutlej, had been dammed there to create a vast lake called Gobind Sagar. It was named after the 17th-century Sikh Guru Gobind – the tenth and last – whose historic HQ stood close by. From above the world's highest straight gravity dam gushed down controlled torrents of water to work the mega generators producing mega quantities of electricity. The used waters then rushed on downstream.

In the Colony there was nothing to do. But there was much to see – waters from the great Dam arrested here by a smaller dam for irrigational purposes. A sturdy new bridge spanned the river bearing all manner of traffic. This body of water formed a longish beautiful lake. It was less than two hundred yards from our *kothi*, one identical to that we had in Dhulkote. Walking on the bankside was special. It was uniquely engrossing to stare into the crystal-clear water and see huge and small shapes move sluggishly in the deep blue. Sitting there with a sketch book in the winter sun was mystical. Ever in love with vast amounts of water – canals, rivers and lakes (I had yet to see the sea) – I never tired of sitting by the lakeside and just gaping at it while I should have been revising. Looking back across decades, I can now attest how formative those few months by the waters' edge were for the budding artist. For from the mid-1970s onward, my fascination for water would sprout into a full-scale inquiry on canvas into its inexhaustible mysteries. Strange marine shapes, non-existent creatures would appear in my paintings of their own accord, as it were. I had never seen them, nor imagined them. There are times when a painter merely becomes an instrument of delivery. A force from without comes and resides in him or her, dictating. Well, I was aware of this force even then. It came and went. It brought a good feeling when it came. And I felt no loss when it slipped away. It was the same when I sat outside Peak Hotel in Simla, gleaning a valley, marvelling at the beauty of its emptiness. Or heard the music of a gorge as I peeped down into an abyss. And felt the lightness of the mountain air, making me feel so light inside, I could have flown across the valley. Which I did in a way, all the time. I still do – the first apparent and palpable aspect of my work is its atmospheric appeal, and a joyful weightlessness. Gravity defying shapes and forms inhabit spaces that could extend in all cardinal directions, often in a state of flux. Or they could simply be immersed in the sea.

. . .

Back in sweet Simla, my exams came and went. Summer was knocking at our door. The fashionable world was leaping up to the cool heights of the Queen of Hill Stations. My tenure there having come to an end, I had to descend to the burning Punjabi plain. The old question burning my earlobes in the scalding summer sun was would I pass? I had looked more at Simla's mountain sides than I had looked at my books during the pre-exam period. Worse, because I was painting pine trees of Mount Jakhoo on the day of my NCC exam, I forgot to turn up.

The wait for the results was long. And agonising.

But I passed, if only just. I needed 180 marks to pass. I got 184. Had I taken the NCC exam in which I would have done well – I was told I was 'officer material' – I would have got at least 40 out of 50 marks, making my aggregate a fraction more respectable. The fool that I was.

But what next? I took my time deciding. By the time I had decided, it was almost too late. For when I turned up at Punjab University's grand new campus in Chandigarh's Sector 14 to enrol for an MA in English, a wall rose before me:

1. Enrolment had closed yesterday.
2. Minimum BA marks required in English were 70. I had 69.
3. Classes had already begun.

The English Department said sorry, young man. No.

But the young man was not one to take no for an answer.

I cycled off to the main office block of the brand new campus to seek out the Vice Chancellor. He was not in that day. I then looked for his No. 2, the Dean. Another wall appeared outside his office in the shape of a peon in khaki – Mr Mehra sahib didn't see anyone without an appointment. But if I greased the man's palm with a pink two-rupee note ...

I was not going to grease his palm even with loo paper. I brushed past the fool and went and knocked at the Dean's half open door. In a

A character reference from my Simla tutor, 1960

manner most ardent, I described my plight, the worst of which was a whole year's wait would be staring me in the eye if not accepted – and rounded off my plea in six words: one day late, one mark short …!

'Where did you acquire your accent?' said Mr Mehra, a man with a pleasant face.

Accent? What accent? I was going to say. I desisted.

'From my father I presume, Sir,' I said instead. 'He was in the British Indian Army briefly …'

A little chitchat followed. Then the beautiful man did a beautiful thing. He did exactly what once Major Arjun Singh IMC Rtd had done on the roadside in front of Field Marshal Wavell's former residence in Simla.

'Admit', Dean Mehra wrote on a chit and signed it. The rest was poetry on a bicycle. It changed the roadmap of my life.

. . .

Chandigarh was sweet homecoming, but with a difference – Sweeter Simla had changed me and it had changed Chandigarh in my eyes. Its lifestyle had rubbed itself off on me, given me self-confidence. Now I knew what I wanted. Now I could talk. Although chronically short of cash, my new friends still liked to be seen with me. A History Lecturer of that period, later to become the country's most distinguished art critic and art historian Dr B.N. Goswami, would say four decades later in 2006 (noted down in my diary of that year), 'Balraj, you were an iconic figure at the PU Campus, did you know?' How flattering. But I did not know, sir.

What mattered more than studies now was just being there. That was real education. My intellect sharpened, my creative side showed signs of blossoming and, without my knowing it, I began to train my intuition to respond to the world around me, seen and unseen, to mould my future work as an artist.

There was inspiration, too. It came from two of my new teachers: the adorable Dr Raj Kaul (London University) and the wonderful Englishman Paul Vernon (also of London University). The latter became my tutor and a friend. In a country where bloated bureaucrats ruled, Vernon would play a pivotal role in my efforts two years later to get to England.

Our Nehru's one-time friend Chau En Lai of China unleashed a land-grab border war with an unprepared India on bogus grounds. Our government had to stop giving pounds and dollars to its nationals going abroad, even to students. In fact, Vernon undertook to be responsible for me until I was able to fend for myself in London.

Both Kaul and Vernon did something invaluable for me, inspire me to delve into the realm of gold of my own minting. They looked at my

paintings and were the only Campus teachers who did not say I was wasting time.

. . .

My First Year had a 50/50 ratio of the male and the fair sex. The latter half of the ratio was very fair indeed. It looked at me with eyes that were seductive. I was seduced all right, and there the matter ended. They say that looks can kill. I was killed every day. Dr Kaul took us for poetry, Mr Vernon for Drama. I cried when the former sang the verses. I shuddered as the latter carried the roof with his voice. I loved the Romantic poets. The History of English Literature taught me more than England's literature. It gave me an immensely helpful insight into the English way of life itself. It made me dream of England.

Yet another university exam, the MA Part I. I did not much look forward to, being dim at studies.

I needed 160 marks. I got 160 marks, the lowest anyone from the entire university ever got in all its hundred years, a record in itself – and I passed.

Everybody laughed – we Khannas do have a sense of humour.

I did what every bad workman does. I blamed the tools.

'It's our system of education. Rotten to the core. Doesn't like an inquiring mind, nor encourages independent thinking. It's motto is: "promote learning by rote". Cram or be damned.'

. . .

My final year began with a bang. Who should I see on my very first day at our own new building in burning red stone – none other than SDBM's ICBM! Now a year junior to me, she had come down from the Queen of Hills to study English in the city of cement and concrete as a boarder. Being the only two Simla wallahs in the English Department brought us together.

THE BEGINNING

While on post-exam hols, I had been painting furiously, experimenting with light and shadows and trying to evolve my own kind of abstraction. It was not difficult. Back in my old room in the campus, its walls soon got plastered with paintings. Friends brought friends to see them. My cubicle became a sort of tourist attraction. Close friends like Pat Rai, Surinder Sharma and Prince Harry of Kapurthala had a certain respect for me. I was no good at studies, but then they couldn't paint.

From day one, ICBM and I became sort of an item. We were together a lot. It was tacitly assumed she was my official Girl Friend. ICBM became my GF in all things but the most important – I couldn't touch the woman. Even when we went to see a film, I dared not take her hand. There was something sanctimonious about her. It dropped a holy curtain between us. I longed for her to see my work. But hostel rules were against that. So, alas, I couldn't take her to my room to see my etchings!

We talked a great deal about art. I had never seen a painting by a professional artist. Nor was there any art literature available at the campus – no art magazine ever made its appearance in our immense library. So I learnt from myself as I went along. I knew what was meant by abstraction in art. I began to evolve my own version of it – distilling in colours and lines the mood of what I beheld, what I felt inside me. The secret was not to think too much about it, only just do it. It was the beginning of a life-long journey, requiring constant experimentation, ever questioning myself and to be satisfied only momentarily. Let the good moments do their job.

Life in my second and final year at the campus was very full. I did everything other than what I had been sent here to do – study. But I was studying life, the best education. Life was painting and cricket. Life was girls, even if they were untouchable.

My co-Simla friend and I met regularly, going here and there together. But nothing ever happened that could be mentioned in my

other Simla friend, my ex-wicketkeeper Ram Mohan's 'dispatches'. I gave her a secret new name – ICE. Every time we met, I had to sort of win ICE all over again. It was a drill and a ritual which I conducted with an absent-minded panache. But stretched painfully over time …?

In the meantime, other developments were developing and they were developing right under ICE's nose and right in front of her eyes. These developments were Praveen and Meera, both classmates of ICE. The firepower ICE lacked, they possessed in quantities. Daughter of a Sikh Brigadier, Praveen was tiny. Well-endowed to bursting, she was trusting and willing.

An army major's daughter, Brahmin Meera Sharma was a boarder. She had the natural Brahmin grace and looked elegant in a sari. Being a boarder, MS could meet me only during the day. Female boarders all had 'local guardians', usually family relatives. They sometimes spent an odd night with them, but with their Hostel Warden's permission …

Meera and I hailed a passing cycle rickshaw, pulled up the hood and told the man to drive to the lake. There, she cried the whole time. Meera was meek, desperately in love and ready to go all the way. That placed a huge responsibility on me. So I tried to make her talk all the time and to make her laugh.

My men friends were in stitches. 'Yours is not a triangle, it's a rectangle, a bloody parallelogram', my bum chums brayed over bellyfuls of banter (with the exception of Pat, no one else had a 'GF').

As the final exams approached, the pace of life at the campus suffered a blow. Praveen sort of abandoned me and the hostel birds started flying home to cram. Even of Meera I saw but little now. One day I ran into her passing by and suggested a coffee in town before she went home. She agreed.

We met for an hour early one evening at Kwality over a pot of sweet tea and a spicy samosa. We agreed to walk all the way back to the campus two miles away. We were approaching Sector 16 when

THE BEGINNING

Meera said something which sent me rocketing to the moon with my heart in my throat.

'I have permission to stay the night at my guardian's, but I don't want to nor do I have to.'

The daughter of an army major had made a major statement. Did she mean she wanted to spend the night with me? My room was out of the question. So was going to a hotel even if I had the money for it – Chandigarh would go up in flames.

We spent the night in the delectable bushy wilderness of the neighbouring Sector 15. Frail-looking Meera astounded me with her fire. Hungry we were not. Nor thirsty. But we were both measurelessly so for each other. The night advanced. So did our need. Yet when we attempted to fulfil it, the result was total failure – Meera was far too constrained for me to make an entry. She cried and cried. It broke my heart. The night was long, endless. Unslept and exhausted, we walked as dawn broke to an early-rising *dhaba* wayside tea stall for a desperately needed cup.

The weeks at home leading to the exams were lonely. ICE corresponded with me. She spoke mostly of the beauties of Simla. Her letters were sort of day-to-day weather reports. I could not quite understand why she was writing to me at all. Then suddenly, her letters stopped.

Meera wrote me just one letter. Written in Hindi, it was tear-soaked – tears she had shed while writing. Ink-drenched pearls that crushed my heart – what was I to do? What? What? I looked up at the sky for an answer. I got none. I nearly cried myself.

The Exams came. Then the results and an MA after my name.

. . .

Our University had just created the first ever Chair for Fine Arts. India's best art critic and novelist, Mulk Raj Anand was to occupy it. I happened to meet him. It changed my life.

I had given Harry a few watercolours. They were of light dreamily percolating through leafy fruit trees in our garden by a pool of clear water. Harry wrote me a postcard:

'… Last night, Mulk Raj Anand came to dinner with us. He saw your paintings and said they showed talent. Who painted them, he asked? When I told him they were by you, he asked me to send you to him, believe it or not. So roll up your paintings and take the first bus …'

I could have somersaulted all the way to the Punjab capital – show my paintings to God on Earth Mulk Raj Anand? A protégé of T.S. Eliot, a friend of Virginia Woolf (whose *Mrs Dalloway* was on my course) and other greats of the Bloomsbury set of the 1930s, Anand was a towering literary figure in India. He had asked to see me, a nobody? Harry had gone mad.

A few weeks earlier, I had seen an ad. in *The Tribune* from the British High Commission in Delhi, asking qualified young men to apply for Employment Vouchers to work in Britain. I had applied just like that and was invited to an interview in Delhi. But my aim to go to England was not to seek employment. It was mainly and only to become a painter.

While in Delhi, I saw an exhibition for the first time of the work by a professional artist, the London-based F.N. Souza. This was at the Kumar Gallery (where I would have my own first one-man show in India five years later).

Souza's powerful work gave me a jolt. It said go home and paint. (Little did I then know that the man would soon be playing a pivotal role in my life, changing its course forever. Or that he would become my mentor and that we would forge a friendship strong enough for him to let me have his flat in London when he went to live in New York in 1967).

I rolled up a good selection of my work and took a bus to Chandigarh to stay with my sister Raj. I felt a peculiar sort of excitement in

me bordering on fever when I took a rickshaw the next day to go to my old campus in Sector 14. I did not know that my future was to be decided in the next hour or so.

In his mid-fifties of medium height, Mulk Raj Anand had Nehru's camel-like protruding lower lip, but an otherwise pleasant face. With a cup of tea in hand, the renowned critic had a good look at my motley display on the floor of twenty watercolours and rolled out oils. Tensely, I observed every twitch of his facial muscles to fathom what he was thinking.

I could not fathom what he was thinking. The critic seemed in no hurry to alleviate my plight. Finally, he looked me straight in the eye.

'Ah. So you really want to be a painter?'

'Yes, Sir.'

'And you want to go to England for that?'

'Yes, Sir.'

'You need much more than talent to become an artist.'

Anand told me in one word what that was – dedication.

This was the first of our several meetings over the next six months till I left for London late in November 1962.

'I can see that you have it in you, yet I would suggest you consider a different career. One more secure. But I also know you won't listen to me because you are a Punjabi ziddi nut like me. You will suffer in London that which you have never known at home – pitiless prejudice, indifference and scorn. But you won't give in because you are Punjabi …'

Anand's words would sustain me during my darkest hours in alien corn. Then he gave me introductions to five people in the London art world.

'They are important men all. Go meet them. They'll be kind and helpful to you.'

A LONG AND BEAUTIFUL GOODBYE

Life at home was oceanic family love. It was sleeping and eating and painting and going out for walks in the evening. There was no shop in town that sold painting equipment. One bookshop had tiny Japanese made gouache tubes and that was all. I began to use old razor blades as palette knives and I painted straight from the tube itself, creating textured surfaces I so enjoyed making. Come the evening, I dressed in all white or all black and went out for a long walk on Model Town roads. A peacock in the mating season!

Success came in spades. With it, risk to life and limb.

At the gate of a house a hundred yards away every evening, there stood a gawky eighteen-year old when I passed. A slim line beauty stood at hers further down the road. Every evening they stood there, as if on duty. They looked and they sighed, the sum total of whatever it was, it being out of the question that we talked. A couple of others cycled past our house a couple times to and fro, darting glances at my

With my Dad at home in Karnal, 1962

THE BEGINNING

A family photo, Karnal, 1962

room, the last of the house, where I often sat painting, with my door open. They were my muses all of unwritten verse and unsung songs.

At night, I slept outside my door with a barbed wire fence separating me from the street. Two teenage sisters walked past our house early every morning. They were 'going out' to the fresh and fragrant fields. They carried two brass lotas of water to wash themselves after. It was melting *eyes right* when they traversed past my room and *kiss me* smiles. My chin cupped in my right hand, I watched them from my *charpoy*. One morning, one of them threw pebble wrapped in a chit towards me. Ahha, a love note! No. It was a rupee note. I was blown to pieces. I never saw them again. It was their last day in Karnal – their father, a government employee had been transferred. The rupee? I kept it as a lucky charm.

But pushing all my mute muses in the shade was the ravishing princess of the last house in our row. She came every other day with a little boy of eight or ten as a bodyguard. It was long molten glances with faint smiles and that was all. The princess, 18, had a nodding

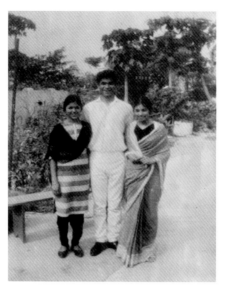

With my sisters Usha and Kamlesh in Karnal, 1962

acquaintance with my sisters, Kamlesh and Usha, both at College now.

In the First Year Mohini was junior to them. She lived in the very last house in our street. She had two or three much older sisters, all married. The sweet seventeen lived alone with her elderly parents. One day, Mohini and her bodyguard came and just sat down on the pale grass by the side of the road 60/70 feet from my room, her gaze directed at me.

This clearly was an invitation for me to present myself. But where was the courage to do so?

'Man or a mouse?' she said with her eyes.

I walked to her. She stood up – tall, narrow-waisted, oval-faced, 'drunken doe' eyes. I used English – Punjabi would have been common.

'May I have your permission to speak to you?' I said.

'What do you want to say?' she replied in convent school English – perfect.

'Oh, just to get to know you. May I introduce myself?'

'You don't need to. Everybody know who you are.'
'How come?'
'Ask anyone.'
'You mean to say I am famous without my knowing it?'
'Notorious.'
'Who says?'
'Ask any girl.'
'I don't know any girl here. So may I introduce myself?'
'I know all about you.'
'That leaves me at a great disadvantage. For I know nothing about you. But would love to know everything.'
'What for?'
'What a question?'
'Well, is that what you had to say to me?'
'No.'
'What then?'
'May I invite you to tea at my place tomorrow?'
'Mister Balli, has anyone ever told you that you are mad?'
'No.'
'Then let me be the first …'
'Will you come?'
'You are totally mad – you must see someone. Your mother would break my legs with her washing bat if I came …'
'No, she won't. Tomorrow at 4 then. We'll all be waiting.'
'Who is we?'
'My sisters Kamlesh, Usha and I.'
'You are mad,' Mohini said in farewell, moving away.

Phew! The big question was would she come? The simple answer she wouldn't. I told my sisters of my invitation, adding I knew she wouldn't come.

Yet lo and behold, on the dot of four the next day, Mohini arrived at our gate with her bodyguard. Kamlesh and Usha rushed out to receive

her. Tea was hurriedly made and a little party was held in our drawing room. It included all five younger Khannas. But at Kamlesh's orders, I was denied entry to it. The irony of it all! Yet I was walking on air.

. . .

Soon, we were both walking on air. But we had to be careful. Three sides of the Model Town were surrounded by endless wilderness. It was wilderness to sing about. For it was fragrant and it was laced with honey. Now and then, taking great care that we were not seen, we ventured into it and lay briefly in each other's arms under a shady tree.

Karnal was notorious for its dust storms. Early one evening, a spectacular such visitor descended on us. It was still perfect daylight. Mohini and I were in the southern side of Model Town where housing was privately constructed. The wind howled and mother earth threw dust up with such enthusiasm and generosity, it became pitch dark within minutes. It was magical, the transformation of the day into night before our very eyes – pitch dark. My diary says it was on the 13th of June. We laughed like lunatics at this lunatic antic of the weather. I had never seen anything like that before, nor have I since. Rain followed, clearing our vision. Even walking in the rain was maddening, liquid joy.

But we were seen despite all our cat and mouse game with the world. In no time at all, it seemed, the whole Model Town knew that the interloper Balli from the cement city Chandigarh had its most beautiful gem in thrall. If now Mohini and I went for a walk down our lonesome street, young men and boys oozed out of thin evening air and followed us at a distance of a hundred yards, laughing at remarks we couldn't make out, thank God. I had as many enemies now in the Model Town as there were male heads under 20 to 22. Now the girls 'on duty' made taunts:

'What has she got that we haven't?'

'She is a slut, that one. Ask anybody.'

I began to receive hate mail from those young males. It was dropped in our letterbox at the gate, saying:

'You see her again and you are a dead man.'

'We'll slice your balls off and post them to her.'

It was chilling. But I never told Mohini or anyone in my family. My new men friends said the letters were written by jealous bastards and sour-grapes cheap cases.

'Ignore the cowardly mother-fuckers.'

It had become increasingly difficult to meet. Now we met mostly at night. But on a seething afternoon when the whole world slept the longed-for siesta, including my family, I smuggled Mohini into my room and we sat by my paintings.

'Make me immortal with your brush', she said, shocking me – where did the sweet seventeen get that one from?

The scorching summer sun shed on us a light that was searing and white. The countryside around Model Town was flat, featureless and so, uninspiring. But I found inspiration all right, in my own house, or rather, its modest garden. Lying under the only guava tree there on a *charpoy* one afternoon for a snooze, I looked up and saw the meaning of 'abstraction'.

A thousand shadows played tricks with light. The ever-shifting, the ever-changing patterned compositions that the divine play made, made me see in a few long and lovely minutes of looking that a painting did not have to have a subject or even a meaning. The 'feeling' was all. Colours arouse feelings. Red makes a bull go bananas. Colours are music. They become a symphony when stirred by movement.

This was a new dawn for me. It carried me on its wings. I journeyed thus day in and day out.

In between, I journeyed to Delhi and Chandigarh. I went to the Indian capital for my passport – it was monstrously difficult in those days to get the prized, hardbound blue booklet with 3rd century BC

Buddhist Emperor Ashoka's lion capital in gold blazoned on the cover.

I went to the Punjab capital to talk to Mulk Raj. Or rather, to listen to him.

. . .

Suddenly we began to read in the newspapers of China playing 'dangerous games' on our northern and eastern borders, the North East Frontier Agency, or NEFA. The old *Hindi Chini Bhai Bhai* had been smashed.

As the summer advanced, news of Chinese troops' build-up in NEFA became a daily affair. They were massing men and massive weaponry at the border, the McMahon Line in the higher reaches of the Himalayas. *The Tribune* said this line was drawn on the map nearly fifty years previously at a conference in Simla between British India, China and Tibet. It was named after India's then Foreign Secretary, Sir Henry McMahon.

As the summer came to an end, the NEFA story began to unfold like a fast-forward film reel. Yet our trusting Nehru went on thinking that the storm would blow over. But the storm had only just begun. One day in October we read in the papers what was music to our ears:

INDIAN ARMY POISED FOR ALL-OUT EFFORT

But soon, too soon, the music began to sour. *'We were stabbed in the back,'* Nehru was to say later. The stab came in the pitch dark 5 A.M mountain jungle morning by the fast-flowing river Namka Chu in NEFA on Saturday, 20th October. The mammoth Chinese dragon belched out fire from 150 mountain guns and heavy mortars, wiping out a whole brigade.

But worse was to follow as the Chinese kept demolishing our posts like nine pins and advancing. Meanwhile, we in Model Town, Karnal, were holding passionate public meetings, denouncing the 'treacherous

Peking duck', and raising funds for the 'war effort'. Speakers said to the ladies in the audience go home and knit sweaters for our jawans fighting in the snows of high Himalayas. Give your jewellery if don't have cash. They shouted: ORNAMENTS FOR ARMAMENTS.

During our walk together in the deserted Kunjpura Road flowing past MT that evening, I told that to my love and said I was attending a meeting of the National Defence Fund Committee the next day. Mohini took off her slim gold earrings.

'Give these from me.'

It broke my heart. I lifted her off her feet and swung her round and round till we both nearly fainted.

'Balli, why are you such a fool?'

'That's what you do to me.'

'Oh, really? And what else?'

'I want to die in your arms. Honest'.

In a strange sort of way, it was a hugely euphoric moment for us young people. The country was united as I had never known it to be. The mood once again became positive nationwide. By early November all was set for my departure on the 21st. On the 16th, the nation woke up to the news it longed for:

JAWANS SPRING INTO ACTION

Our *jawans* sprang into action to order, but they were cut down, blown to pieces. Wave after wave of them. Within days, the rout of the great British-trained Indian army, the fourth largest in the world and one of the best, was no longer in NEFA. Not a single Indian brave stood between the 'forcibly conscripted yellows' of China and the luscious tea gardens of Assam. It was all theirs for the taking. So was the province of Bengal and India's greatest seaport, Calcutta. The overall feeling everywhere now was of impending doom.

My own life for some time had been one of a flurry of activity. All I needed now was a letter from my 'sponsor' in the UK, Mr Paul

Vernon. That came soon enough. I went ahead and bought a one-way Air India ticket for Rs 1,800 and wrote to him giving him details of my arrival, its times etc.

In Delhi again, I had a very private little bit of shopping to do. It had be done in Delhi and in total secrecy.

I had my last meeting with Mohini on my last night on Indian soil. As usual now, we met at about eleven when her elderly parents were cosily snuggled up and fast asleep inside the house – nights in November do get pretty cold in north India. We met in our usual corner of her garden under a mango tree behind a tall wall of sweet peas that used to bring back some sweet memories of my childhood. We were both tremulous. Fragrant as ever, Mohini felt strangely light that night when I tried to lift her off her feet. I could have carried her in my arms and flown away. It was an intensely dark night. But our bodies glowed with desire more intense. I had come prepared with an FL (as a condom was then called for a *French Letter*) in my breast pocket. I had first considered buying one from Karnal's only department store, Gopinath, itself. But I knew that before I had gone a furlong from the shop, half of Karnal would know and a mother of all scandals would erupt.

Even in Delhi's crowded Connaught Place I kept looking over my shoulder as I went into a chemist's, fearful of being seen in that city of four million where I knew not a soul. The knowledge that it was our last time together throbbed in us. It was now or never. But great mutual courage was needed.

With those three words echoing and re-echoing in us – *now or never ... now or never* – that courage came to us. The great Bhakra Dam broke. All the waters of the Himalayas burst forth and we were carried away on the crest of a tsunami.

The night after next, I was at Palam Airport to board an Air India Flight. All my family was there. Also there was my friend Pat who had a parcel for his sister in London.

In all the ensuing hubbub, I saw a newspaper at a stand – an evening paper or the first edition of next morning's. It had the most heartening headlines:

CHINA DECLARES UNILATERAL CEASEFIRE

This had caused a buzz at the airport, lifting our spirits and our hearts – the war was over! My family was fussing over me with heaps of garlands. But nobody had tears in their eyes at seeing me go. Far from it, great pride radiated from every face – their son was going to the world's best country, England.

In the background stood my father, sunburnt and pensive, puffing away at a cigar. Suddenly, I suffered a pang, a twinge in my heart and felt a lump in my throat. I had this uncanny, this tortuous feeling that I was seeing him for the last time.

Then my flight was called. I pushed this feeling back as I hugged everybody yet again. When at last I walked away towards the barrier, I realised I couldn't go any further. I walked back to where my father stood and bent down to touch his feet, in gratitude, in love. He lifted me up and hugged me. We both had tears rolling down our cheeks.

END OF PART ONE

Balraj and Francine

PART TWO

MY BRAVE NEW WORLD

Photo of me in London, circa 1964, with painting *Speaking Colours*

'I am in London.'

I bit my hand as the airport coach arrived at BOAC Terminal. I did not feel how cold the grey November afternoon was. I only felt intimidated by glass and polished surfaces.

'Am I really?'

I wanted to bite my hand again to make sure, stealthily looking to my right and left like a thief, so that no one saw me do it. Else they would think I was an idiot.

Other coaches were coming and going with people getting off or clambering in. A large but orderly crowd milled around with pieces of luggage, queuing orderly for taxis. In spite of the long Delhi-Bombay-Doha-Rome-London Air India flight, I didn't feel a tinge of tiredness. If anything, I felt 'on top' to be 'eating the refrigerated London air. It felt different. It tasted different, the air of the city of my dreams. Every good thing in India from the desirable Raleigh bicycle and the useful Singer sewing machine in well-off homes, to every car from a Mini Morris to a Maharajah's Rolls Royce was *Made in England*. Every young man from a sound background aspired to go to England to make something of himself. In my case I was coming to England to realise what was embedded in me – to be an artist. My dream.

I was going to be met by my old tutor, Mr Paul Vernon. But where was he in the hushed throng anxious to make its way out of the place? What if he forgot? My last letter to him with the news of my hurried departure and flight details was posted only a week or two ago. Maybe he didn't get it on time to write back to confirm he would be coming here to receive me.

What if he never got my letter, Indian post being what it was? And I didn't have his address on me. It didn't occur to me to take it with me while leaving home – just in case – silly, silly, silly me. All I knew was he lived in one Boundary Road, wherever that was. As I stood there idly by my suitcase, I must have looked very worried. For one of the two old English ladies who I had sat next to from Bombay to

Rome, spoke to me. They were 'old India hands' and had talked to me at length about their visit to India they 'so loved'.

'Anything wrong? You being met?'

'Yes, by my former university tutor.'

'He's late. London traffic. Awful.'

'I hope it's only that. Or …' I explained.

'Oh, dear. Here,' the kind lady said and wrote her name, address and telephone number on a piece of paper. 'I am sure your friend will turn up. But if he does not for some reason, telephone me and we will see what we can do. And what did you say your name was?'

'Balraj Khanna.' I had not mentioned my name before. 'Oh, dear. I'll never remember that. Write it down for me, will you?'

As I was writing my name, there came a shout from a six-foot-tall gentleman from behind a shuffling wall of humanity:

'Balraj!'

'Mr Vernon!'

'So sorry I'm late. Dreadful traffic.'

'There. What did I say? Telephone sometime anyway. Goodbye,' the lady said, beaming a very English smile laced with immense kindness.

Mr Vernon and I had a hearty handshake.

'How was the journey? Very long, eighteen hours.'

'I can't believe I'm here. It's thanks to you, Mr Vernon.'

'Nonsense. And it is Paul. You are no longer my student,' he laughed and divested me of my shoulder bag.

We took a No. 2 bus and sat upstairs. Boundary Road was by Swiss Cottage in London NW3 (it would house a famous art gallery owned by one Charles Saatchi one day). I had never seen a two-storey bus. Sitting on top was fun, and a privilege. We talked of this and that, mostly of the war with China which had come to an end only yesterday. My former teacher said that it was an unforgiveable betrayal of friendship by Chau en Lai. The conniving Chinaman had stabbed

trusting Nehru in the back. I was touched to hear all that from an Englishman and wanted to say thank you, Paul. But the Indian in me wouldn't permit me to call him by his first name – he had been my teacher and teachers in India are revered almost as much as parents are by their progeny.

Ten minutes later, we came to a big and busy roundabout supporting the statue of a man on a horseback slaying a vicious-looking dragon with a lance. A church with facade of tall columns stood on the right and on our left …

'Lord's Cricket Ground!'

My cricketing eyes widened to see the world's most beautiful green surface. It was a Thursday. My host had a plan. He was going home to his parents in Southampton tomorrow for a long weekend straight from King's College where he taught. Tonight, I would sleep in a very small room courtesy of his landlady. But I would have his large room from tomorrow till he came back on Monday. In the meantime, I would look for a room of my own. And a job.

After a cup of tea in his room, Mr Vernon suggested we went out to look around at the local shopping centre. The shops would be shut, it being a Thursday afternoon, but the newsagents' window would have notices for rooms etc which could be helpful. I mentioned the gift parcel I had for my chum Pat's sister with her address. My former tutor knew where that was – the Indian Consular Office, South Audley Street in the West End. Another bus ride brought us to a staggeringly beautiful building – Selfridges – bathed in a million Christmas lights in a wide street of more Christmas lights, a dreamscape. Mr Vernon's description of it placed it on top of my as-yet-unmade list of places to visit directly. We took a street almost opposite this magnificent department store. North Audley Street held another irresistible sight for me – an art gallery. And I couldn't believe what Gallery One was showing – the paintings of the painter F.N. Souza, one of the five introductions the novelist and critic Mulk Raj Anand in Chandigarh had given me.

My mentor had said I must meet all five of them soon after arriving in the city of gold! Anand's words rang out in my ears as we went in to take a look: 'They'll be kind to you.'

I did not expect to meet the famous artist within a few hours of being in London. And nor did I. I didn't even ask the man behind a desk anything about the man. But I thought the coincidence to be a good omen – I have always been prone to 'reading' into coincidences of this nature.

As it happened, Mr Vernon had heard of the artist but had never seen his paintings. I was already impressed with Souza's work when we went in Gallery One. I was even more so when we came out of it. Pat's sister's office was a mere five-minute walk from there. A shroud of dense fog had suddenly cloaked London and milk filled the air blurring the massive American Chancery on our right as we approached an equally obscured large park known as Grosvenor Square. I was used to love fog during my days in heavenly Simla, but this fog was different, special. It was the famous London fog – heavenly. I just revelled in walking through this muslin curtain.

. . .

NO NEGROES. NO INDIANS. NO IRISH said all the notices in Rooms-To-Let in the newsagents' windows. It wrenched my heart to be equated with 'Negroes'. Only one other newsagent's window did not have this kick-in-the-balls notice. It was about an Indian-owned house by one Dr G.K. Singh at No. 797, Finchley Road, a mile up the road. Thanking the notice board, I took the familiar bus 2. It dropped me about two hundred yards from No. 797. It seemed I was back in Simla. Every house around seemed to have been designed and built by the same English hand which had designed every house in Simla. The ubiquitous black beams were the familiar aspect of all these houses minus the compelling drama of Simla's vertiginous heights and its giddying gorges. I saw an Indian gentleman pottering about

in the unkempt front garden of the house. Gingerly, I made my way up to him.

'Dr Singh, I presume?' I said to the rather pleasant-looking 40 something on the heavy side and a shade darker of skin than mine. We Indians are infamously conscious of such-like things. It tells us instantly who's who, of what caste and often where from. In the case of my new island in a sea of indifference, disapproval and despise, I was to discover, happily, that all inmates of "797", as the house was referred to affectionately, were young Punjabis from the subcontinent.

'Doctor Singh I presume?' I said again respectfully.

Silly me expected him to say something like, 'Cut it out, son Stanley'. But Dr Singh gave me a long searching look instead, shook my hand limply and led me to the front door of the house which looked exactly like any back in Simla.

Across his spacious hall, Dr Singh ushered me into a small square box partitioned out of a large room. It had a door on its left and another in front which opened to a 12 foot by 6 room with a view of a lush African jungle that was its long back garden. This 1930s Simla-house was identical to rows of those on its right and left with a difference. They all had exquisitely manicured gardens.

The rent of the room with a curtain-less window was two pounds ten shillings a week to be paid in advance. It was certainly not a room with a view, nor one to die for. But it was a room all right. And it was mine, all 12 by 6 feet of it.

. . .

'I am in London'. I said to myself in the famous but nondescript Leicester Square.

'Am I really?' I asked myself in the neon lights of Piccadilly.

The Tate held me in thrall – I gaped and gaped in awe at what *They* had done before me, the *Greats*. Actually, I touched a Van Gogh

despite a watchful attendant in the room and the notice next to the painting screaming at me *Do Not Touch!*

The Indian Section at the Victoria and Albert Museum bowled me over, but it also made my blood boil – '*Oh, did the Brits not loot us? They fucked India dry.*'

I thought the Parliament was London's most beautiful building, Britain's Taj Mahal in blonde stone. The Westminster Bridge by it I had read about so fondly courtesy of William Wordsworth and could recite all the fourteen lines of his sonnet, made me feel I was I was walking history.

Half a pint of India Pale Ale in a pub where the locals sat over the *Daily Mail* and a pint on a table in front made me so want to be one of them. In the Castle one evening in Finchley Road near where I lived, I got talking to three affable Englishmen. After a while over a pint, they remarked how well-spoken I was. A little later, they were joined by three ladies in fur coats like film stars (the first English women I was to speak to), who said the same, sending me to the clouds. They talked to me at some length, making one of the men later call me 'a ladies' man', dispatching me beyond the clouds.

I came tumbling down the next day, a bitterly cold day.

I saw an advert in a tailor's shop window in the nearby Golders Green for a sales assistant. With my best foot forward, in I went to be told by a gentleman at the counter with a measurement tape around his neck like a doctor's stethoscope that the 'job was not for a Paki or a Negro'. When I protested that I was neither a Pakistani nor a Negro (couldn't the fool tell?), the manner-less fellow just waved me away. That was a palpable measure of my emerging loneliness setting in the very first few days in my Eldorado.

Among scores of Vacancies in the Evening News of the same morning, a salesmanship to sell encyclopaedias with a good wage took my fancy. I telephoned and was asked to come for an interview that very evening somewhere in Brompton Road. In my best suit (I had two) and a silk tie, I went.

On the first floor of a smart shop, half a dozen smartly dressed young men in their twenties sat around in a smart room, writing. Fellow candidates, I guessed and sat down with them. I was convinced I didn't have a chance in hell to be selected with those Englishmen around. I nearly ran. But I held on. Some ten agonising minutes later, a side door opened and a well-dressed man about twenty years older, popped his head out and beckoned me in. His office had a large black leather-covered table. He made me sit down on its other side.

'Welcome to London, Mr Khanna.'

I had told him on the phone that I had just arrived from India.

'Thank you, Mr Watson.

'You must find it frightfully cold here.'

'An understatement, sir,' I said rubbing my near frost-bitten hands.

My interlocutor laughed. A friendly chit-chat followed.

'You know a travelling salesman's job is not easy.' Then he pulled out a pen from his top pocket. 'Tell me, how will you persuade me to buy this pen, Mr Khanna?'

'First, sir, I'll say that everyone needs a pen, one that writes. Then I will draw your attention to the design and beauty of your sleek Parker pen …'

This went on for a few pleasant and hopeful minutes. Then Mr Watson became serious and posed a personal question. 'A young man like you would easily get decent work in your own country. So what made you come to England? Do you have a specific aim in mind? Further education perhaps?'

'Yes, sir. I do have a specific aim.'

'I would like to know what it is. What made you come here? What for?'

'Sir, I have come here to become an artist.'

'You seem very determined about it.'

'Sir, to be an artist, one has to be more than that. One has to be totally committed. Totally dedicated.' I realised I was lecturing. I stopped.

'So you'll be totally committed to your declared aim of becoming an artist?'

'Yes, sir. Totally.'

'But young man, we want our sales force to be totally committed to selling our encyclopaedias. You should look for work that starts late in the evening so that you can paint during the day …'

That was the end of my career as a salesman before it had even begun.

. . .

I survived on a loaf of bread, a bowl of packet soup but with no one beside me. It was no paradise. I was forlorn.

'Forlorn'!

The very word was like a bell that nightly tolled me back to 'my sole self' with a slice of cheddar and an onion in hand.

I desperately needed work. Any work. If not as a salesman, as an office man, a handy man or a door man. I had an MA dammit. An MA in English at that, which none of the 99% of the English population had. But 99% of the local population had other ideas. I looked here, there … everywhere. I walked and walked with no one to talk to – 'water, water everywhere but not a drop to drink.' I walked and the short winter days' bile-yellow streetlights walked with me till nightfall. When my legs gave out, I came back to the sanctuary of my little 60 watt light bulb room and sat down to paint how I felt. They were the desolate London street scenes with fiercely pollarded trees with stump-like leafless branches that looked hauntingly macabre. And I wrote letters home and filled sad pages of my journal. Then unstoppable tears of unbearable loneliness rolled down my cheeks. Thus, I cried myself to sleep every night asking myself in the third person: 'Why the hell did you come here?' (Later, much later, I was told the self-same stories by other young men who had sought this country chasing the self-same dream and had gone to bed every night crying

copiously). Why did you come here? I asked myself repeatedly. 'To make something of yourself, eh? What? This? At home, you were happy as happy can be. And you were never lonely.'

Had I come here to paint in such profound misery and cry myself to sleep every night?

This became so despicably desperate that one evening I took a Northern Line train to Charing Cross from my station Golders Green. From there, I walked to the bridge on the Thames I had overflowing affection for. Twenty odd feet separated me from the racing water below. In the waves dancing in the night, I saw my wailing mother, my father broken, my brothers and my sisters who held me in such lofty esteem, gutted. I saw them all at the loss of a dearly beloved son and brother. I recited Wordsworth's sonnet: 'Earth has not anything to show more fair: ..."' It made me retrace my steps to Charing Cross tube station. Back in my little room an hour later, I sat down to write a long letter to my father. Abbreviated, it said, 'Sir, I can't go through with it ... I want to come back home. Forgive me.'

I painted all day long every day and expected an equally long letter back, pleading with me to stick it out. Instead, I received a four-word telegram:

'Come straight back, son.'

I looked for a travel agent next morning. Instead of going back by Air India or BOAC, I booked my passage by sea to see a bit of the world. The only date available for that was in the first week of February 5/6 weeks away. As I came out of the shop with the provisional ticket, I saw the whole of Karnal Model Town in stitches and my University in Chandigarh rolling in laughter:

'Our Great White Hope has come crying back because he was missing his Mama. All that glitters isn't gold. It is shit. Balraj Khanna is SHIT.'

The same morning in the faceless front page of the Times full only of ads., I saw one by the London County Council, Education Department for a Play Centre Assistant.

I phoned. That four-penny call changed my life. I got an interview in the piteously-unassuming County Hall opposite the ravishing Parliament across the Thames, one a statement of sad indifference to civic architecture, the other a delectable bold statement of political power. A medical followed and I got the job as a Play Centre Assistant Class 3. Working hours were 4 to 8 in the evening on week days. The wage was seven shillings and six pence an hour. The job entailed playing with junior kids after their school from 4 to 6 till their parents got home from work. Then it was to occupy teenagers from the area till 8 pm. On Sundays it was 10 to 4 along with other Play Centre staff. It seemed like a piece of cake. It wasn't.

. . .

The following is word for word from my diary of those days:

Tuesday November 27.

… I find people of England are killingly courteous and polite. They respect you, and show genuine interest in your problems. However indifferent seemingly to each other and minding their own business, they maintain respect for each other through silence that prevails amidst an assembly of them anywhere. It is this mutual respect for each other that accounts for unity among them, and which further speaks for their success as a nation. We in India lack this to a painful extent. If we develop a similar sense of propriety, or mutual respect for and acceptance of other individuals, our nation will be better off and will advance.

One thing that I noticed from my first day here is how yellow people's teeth are here in spite of the expensive tooth pastes they use. In India, people mostly use herbal stuff, like pencil-sized twigs of the kikar and the neem trees. They munch their ends off to use as a brush. Kikar is sweet, the neem bitter. As a kid, I used kikar twigs. Only in the cities do people use chemically made toothpastes. Then again, a small percentage of them only.

. . .

I had never known it to be so cold, even in Simla at 7,000 feet during the winter months. The two thin cheap house blankets of my single bed the width of a camp bed leaked cold air. A muslin-thin bedsheet with semen stains of its earlier occupants covered its mattress. I slept with two pairs of socks, a grey long-sleeve woollen sweater Biji had knitted, over my pyjama top, gloves and a woollen scarf around my head.

The problem that I had nothing to do all day long till my Play Centre at 4 in the afternoon, morphed into a boon, reminding me of the prescient Mr Watson of Brompton Road. So I visited the Tate again and again and never tired of doing so. I could not understand Picasso's need to distort the human figures so grotesquely, but I loved his pictures inordinately. Nor could I fathom why Modigliani had to stretch his necks like an ostrich's and make mile-long nudes which pulsated with physical longing. Or why Cézanne did this to his apples or Braque that to his guitars. I felt like a child in a house of wonder and magic. Full to the brim of that magic, I came back each time to my room to work and work on themes I had started back in India. These pictures were of imagined common Indian folk with growingly abstracted features. Some also dealt with toys I had played with as a child, others with the play of light and shadows, Pollock-like as the sun streamed through leaves and branches of a dense guava tree in our garden under which I wrote in my journal.

To quote further from my diary:

> I wish to draw from life. Visited the V&A daily and made some drawings from its great sculptures. But these lifeless sculptures were uninspiring. The paintings there are fabulous. But I don't want to make copies. My paintings will be mine own entirely, throbbing with life. They will depict human suffering ... the most exalted experience ... as in a Tragedy by a Playwright. Nothing more so than in King Lear, my favourite of all literature, a must reading for all artists.

When you have nothing to do in the world's greatest metropolis, you become a moron. In my case, I became a moron with a difference. I

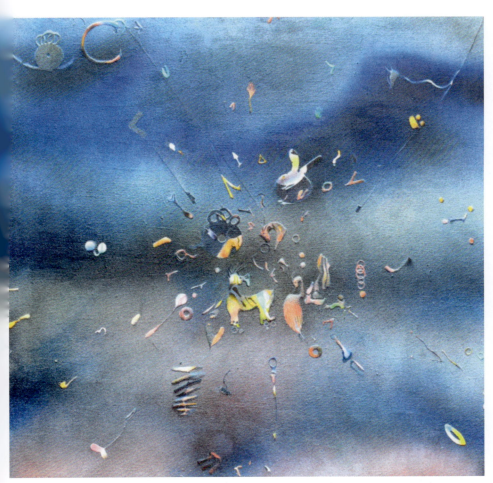

Playful Forms, 1980, acrylic on canvas, 60 x 60 in.

became a thinking moron. In that capacity, I avoided a fate worse than death – ennui. My mornings melted effortlessly into noon, painting. Noon sprinted to 3.30, painting. Then my job. By now it had already begun to grow grimly dark. The night was just around the corner, pulling a veil over the very short day. This bloody wintertime. I hated it. (I still do).

To continue with my diary:

I feel glad to insert that the first people I happen to have contact with in numbers in England are children. It is natural that children everywhere be as they are. I have ever had a strong affinity and a fondness for them. I am grateful that this is reciprocated. They become my friends straight away and I become at once popular with them. The children of our street in Karnal used to enjoy being with me and used to call out my name through their windows when they saw me passing by on the road.

And the children at my Play Centre became at once fond of me. They ran to me leaving their Miss. When I started work, I had a whole lot of them wishing to play with me, or wishing me to play with them.

My first Sunday at work. I felt enriched by a whole Pound, full twenty shillings, working with the kids I so loved. I wore a suede jacket I had brought from home. A new pupil to the centre, golden-haired Sandra about 13/14 and older than other children, had been particularly interested in games and activities I had been engaged in with my kids. She rubbed my arm up and down and asked in some amazement if it was real suede (real suede in those days here was considered posh and expensive).

"No, it is fake."

"You lie, Sir. It's real."

Sandra had been monopolising my attention by making it impossible for me to have games with other children or to play with anyone else except her. She shuffled my hair every time I showed signs of going away, or she tried to drag me to a corner of the ground floor hall and force me into a game of her own making. Today, she carried on with her performance as usual. But later in the day, I decided to

abruptly put an end to her tomfoolery when I became conscious of the prying eyes of a lady colleague, a real teacher at that school.

Shaking Sandra off, I went to the school's little staff room for our afternoon break and a cup of tea. Upon returning to the Activities Hall, I avoided her by starting to play with other kids. She passed me and jeered at me. After many repetitions of this nature, she walked up to me purposefully and told me she didn't like me. For an hour after that, she didn't come near me. I didn't dislike her. On the contrary, I liked her very much. She was an ideal teenager, bright, pleasant and good-humoured. But I had to stop it all, fearful of other Miss' suspicious glances. Yet I didn't completely ignore her. And now whenever I called Sandra to me, she refused to come, or ran away when I approached her. Just before the Home Time bell, Sandra sent me written note through a younger girl. It said:

To Sir, I HATE YOU.

I never saw her again because the County Hall sent me to another Play Centre in Holloway some way away.

. . .

With a job, which would be considered menial in India, time had come for me to leap out of my miserable little self and step into a world I had come here to be part of and thus, to realise myself, to bring out the real me residing in myself – an artist, a painter. Unknown to me, there was help at hand – those introductions Dr Mulk Raj Anand had given me before I left home.

Two of them were to the practising Indian artists Goan Francis Souza and Punjabi Avinash Chandra. Of the other three, one was the darling of the literary scene, the much lionised young poet Dom Moraes, also from Goa. Then there was the highly regarded Indian art expert and Keeper Emeritus of the Indian Section at the V&A, W.G. Archer. And lastly, the then art critic of the *Guardian*, George Butcher. Dr Anand had said they would be kind to me. I decided to call on them one by one. Only years later I realised how exceptionally

lucky I was to have introductions to those men. To continue with my diary:

Tuesday Dec 4.

Awful weather and a bitterly, bitterly cold morning. I had decided yesterday that I should call on the first of these today, the Goan Francis Souza.

As the day dawned today, I began to have second thoughts about it. For I considered it would be better if Dr Anand himself wrote to Souza introducing me. Like that, I could be assured of not being treated indifferently by the great man.

But on the spur of the moment, I got dressed to go to see the Goan artist after all. Outside, the weather was so foul that on my way to my tube station Golders Green half a mile away, I wavered about going on. Yet I continued.

It was densely foggy. One couldn't see beyond ten yards. With visibility as it was, astoundingly poor, it was hardly surprising that there was no one out and about. This made me say to myself that only a fool like me would be out and about in these weather conditions. Belsize Park where the painter lived was only the second stop on the Northern Line. His house turned out to be a good 5/600 freezing yards away in a side street. To my growing dismay, no one answered Mr Souza's door bell which I rang three times. This made me feel even colder and the street look barer. After full five minutes, I rang the bell for the last time and turned back to seek the warmth of the Belsize Tube station. Just then, a lady in a thick coat, gloves, hat and a shopping bag in hand approached from the station side of the street. She walked past me, house keys in hand. She gave me a justifiably quizzical look – who the hell was I and what was I doing there in that ungodly hour and fog? When I told her I had come to see Mr Souza, Mrs Souza demanded to know if I had an appointment.

"Mr Souza doesn't see anyone without an appointment."

Well, I hadn't one and told her so. But I made her understand that I was prepared to make an apology to Mr Souza for this inconvenience. Just then, the gentleman himself appeared at the door.

Small of stature, five foot six, Francis Newton Souza had piercing, burning glossy eyes that look so sad that they attached a peculiar sort of tragic character to his pockmarked face due to smallpox in infancy not uncommon in India. He was unshaven and unkempt. In his night clothes presumably – a pair of striped boxer shorts and a white vest (as opposed to my nightly Icelandic outfit) – Mr Souza looked ludicrous and distinctly unimpressive. He was curtly told off by the lady for coming down like that in that cold. It was nine a.m. and, obviously, my consistent bell ringing had woken him up. I was deeply, deeply sorry and profusely apologetic. Anyway, I was there, spruced up and well-turned out in total contrast. My mention of my Indian mentor's name had a visible effect on him. He let me in, muttering under his breath to his wife and I overheard, "Very difficult man, Mulk Raj. Unlike him to send anyone to anyone".

Once up in their flat on the first floor, the artist relieved his wife of the shopping bag which contained only a loaf of sliced bread. He sat me in a chair, put the electric kettle on and started making toast on a chimney charcoal fire. Tea ready, he handed me a mug and in the process he burnt the toast. It was all my fault, I felt, and offered sincerest apologies.

"Why are Indians always apologising?" Souza said, adding, "But the toast was for my wife anyway."

I felt a bit put down. However, after finishing his mug of tea, he got suitably dressed to venture out in the cold and took me to see his studio a couple of hundred yards away in the main street by a Victorian church.

His studio comprised an unfurnished whole first floor of an imposing three-storey house with an attractive staccato front he had bought recently he told me. It had been a proud purchase, prompting him to boast on the back cover of a recently published book on him by someone called Edwin Mullins – *"I make more money from my painting than the Prime Minister does from his politics"*.

The studio in the three-room flat was crammed with stacks of canvases against walls. It overlooked the street with the church on its left. The place was in a right mess with pieces of duck cloth pinned to the walls on all sides. On a table stood a classroom sort

of projector with a whole lot of rubbish around. He told me it was an epidiascope. Over another mug of tea, we settled down in front of a tall kerosene fuelled heater and talked at length about his art, Indian art in general and ART of our times in particular.

He was immensely pleased to learn I had seen his show in Delhi and at Galley One in North Audley Street on my first day on English soil. He was most anxious to know how his exhibition in Delhi only days earlier had gone down. His face lit up when I told him how refreshing I had found it, a breath of new air in constipated Delhi, even though the few critics who had noticed it were rather unkind, I said, thinking his work to be too pornographic to be of any value.

To defend the charge of pornography levelled at him during his show that I saw in Delhi, he mentioned the explicitly erotic temple sculptures of Khajuraho in India he drew his inspiration from. Souza staunchly held that his work depicted sex not as something dirty and to be ashamed of as understood in the modern society whose values were rooted in decadent Victorian thinking and understanding. Then he pointed out the ever-prevalent paranoia and threat of a nuclear holocaust the world had just managed to avoid only a few days previously over the Cuban Crisis, insisting that it was over only for the moment. But it is not how but when that it would certainly happen, taking the world back to the stone age. "Hence my Prophets of Doom. The deformed human beings that populate my paintings are intended to suggest and warn against those extreme horrors to visit upon the human body sooner than later. History's worst gift to mankind is atomic radiation".

His seemingly endless energy, passionate and forceful expression might have induced others to think of him mad, and many did, as I was to discover later. But it was just that very aspect of his demeanour which won me over. In those two hours, we struck up a friendship that would prove to be so very inspirational for me for the foreseeable future. And helpful. On the whole I thought of him as a humble being devoid of conceit or ostentation in spite of his success.

When Souza learned where I was living and painting – in a cardboard box – he said I could work in his studio, starting from tomorrow.

This was amazing luck. I told him so and said I would buy him a beer to celebrate. He laughed – he had a most charming laugh, at once childlike and so instantly endearing – and said he was a strict teetotaller, surprising me.

"A total teetotaller. But I was an addict once, A certified alcoholic." That made me laugh for I thought he was joking. But he wasn't. I asked him if he knew the other four individuals on my list.

"Butcher is a good man, a good balanced critic and a good friend of India. Dom Moraes? He is cynical and too much in love with himself to be of use to anyone else. He is a middle order poet who won the Hawthornden Prize for Poetry earlier this year and who thinks that the Nobel is half in his pocket. The former ICS officer W.G. Archer basically loathes Indians and is convinced he was born at the beginning of the 20th century to educate us illiterate natives totally ignorant of our 40-centuries of art, and we bloody fool Indians are lapping up his High Priestly sermons with no questions asked. That leaves the Punjabi Mr Avinash Chandra, a God's gift to us all. He can't paint, only pretty, pretty watercolours which are neither here nor there, but can sell because they are pretty and decorative. The mountain of a man has a head bigger than the mythical Mount Olympus. Oh, please forgive me if I sound dismissive, pomposity never planted itself more firmly on any other man than on Mr Chandra. Nor vanity. Go and see and you'll know what I mean."

Then my great new friend I had much to learn from, gave me a copy of the book on him by the afore mentioned Edwin Mullins. He gave me another tome, a slim paperback on himself by himself, *Words and Lines*. He inscribed them both to me. It was an honour – an author giving me his books!

. . .

From the spine-chilling cold and blinding dense fog emerged the unheard-of something called yellow smog courtesy of a million coal fires Londoners burnt in the vain hope to keep the cold at bay. It was followed by arctic ice on the road which turned into black ice.

This infernal weather had a certain benign effect on my new abode, 797 Finchley Road. Its inmates, all of them Punjabi were recent arrivals in the UK after the passing of the Immigration Act earlier that year allowing them to come. They were mostly employed in the service industry. Unable to report for work in the forbidding weather, they had nothing to do except cook, eat and watch the telly. It brought us all together.

Billa, a clean-shaven Sikh some 4/5 years older than me and working as a cashier at the Bank of Baroda for £7.10s. a week became a best friend. He cooked the most magnificent lamb trotters west of Amritsar he hailed from. Saeed, a Muslim, from Lahore in the room next to mine and working as a mechanic at a garage nearby, made a finger-licking biryani. Nadim knew how to toss an aloo paratha as no other in the business. Lanky Sehgal did a rogan josh Moti Mahal of Delhi would have been proud of, and not to be forgotten or ignored was our landlord, the amiable Dr Singh, the non-practising medic who could cook anything and everything to amiable perfection. To add icing to the cake, he loved entertaining which we all benefitted much from.

With him as an undeclared leader, we went out in snow and ice and spent our evenings in the Old Bull and Bush half a mile away, eyeing lustily young ladies from the Nursery Nurses College nearby. Some of us chatted up some of them, but no one ever made a much-longed-for kill. If I fared better than then the others at least in talking, it was not held against me. Not only not-bad looking, I was the best educated.

And so was Dr Singh, the bachelor non-medic medic. He had qualified from Burma where his family had moved to before the war when he was a child. The double-chinned, mild-mannered man with a generous midriff loved the Old Bull and Bush, though he sat through a whole evening with a half pint of Pale Ale. He loved having parties. To attract young ladies he soon began to use me as bait. Almost all of these were mouth-watering au pair girls from the continent who

flocked to the cafés and dance rooms in the heavily Jewish, and therefore well-off, Golders Green NW11, called by '797' the *Aupair Land*. That was my hopeful friends' hunting fields where they went 'a-plucking' routinely. This always included the not-so-young, but indefatigable Dr Singh. He never succeeded in 'plucking' like most of the others. But the ever-optimistic nut never gave up.

. . .

My next port of call was to meet Avinash Chandra. He also lived in Golders Green by Hendon Way. He and his wife Prem, also a painter, had a small terraced house in Wessex Gardens.

'Ah, Hardy country,' I said upon arrival one ice-laden evening.

He did not get it and replied, 'You mean cold country?'

Avinash Chandra was nearly as tall as I was, 5 ft 11 in. with a voice to match – resounding. He would have made a great Othello on stage as I was to tell him later one day. He looked you straight in the eye when he spoke – every word articulated with clarity. His wife was away in India at the time, visiting family. He helped me with my coat and gave me what he himself was drinking – Scotch. He said he had high regard for Mulk Raj Anand and that he must have seen something in me to send me to him. That set the tone of our conversation. He turned out to be not just an accomplished painter, but also the most superb cook as I discovered at our very first meeting.

He had prepared a meal – we Punjabis are great ones for food and our best chefs are invariably male. They specialise in making meat dishes, leaving the mundane business of making bread – chapati – to our women folk. My host had cooked a rollicking lamb curry and boiled basmati rice, a rarity in those days. His two ground floor rooms were littered with pictures, unframed drawings mostly and many others rolled up. He let me have a good look around. He could tell I was bowled over. I did not think they were 'pretty, pretty' pictures as Souza had described them. In fact, I found them lyrical, poetic. And

I told him so. This went down rather well and he poured me another two-inch 'Patiala peg' so named after the Maharajah of Patiala who loved strong stuff.

'Bus, bus, bus. Avinash ji,' I protested – I had had enough.

'We are Punjabi, dammit. No bus-shus here. So what did you make of our friend in Belsize Park?'

'Great painter.'

'You mean a great talker? Souza can't paint for toffee. Not paint, but shit oozes out of his paint tubes. The Goan Catholic has made a harlot of his religion. He uses paint brushes as if they were lavatory brushes, only slimmer with long handles. He would sell his mother to woo an art critic, to get a mention here or there, the wanker would.'

I thought it was very unkind of him to speak thus of the only other Indian artist who had any standing in the London art world. But I kept quiet. I was a guest there. And back home you didn't argue with your host. But these two meetings with AC and FNS were to establish the pattern of my resulting relationship with them. I was never to meet the two of them at the same time at the same place. As chance would have it, a postcard came from Dr Anand, saying he would be passing through London that week and staying with his old friend W.G. Archer. I should come and see him.

This was a hugely welcome piece of news. Now I wouldn't have to go on the phone, asking a stranger for a meeting, always an awkward exercise. Archer lived only a stop after Belsize Park in Chalk Farm in the well-off Provost Road.

The Archers had another couple of Indian visitors, journalists both. They were drinking red wine. I bent down to touch my mentor's feet in the time honoured Indian tradition.

'No, Balraj. This is England. Not India.' The teacher raised a toast to the pupil. Mr Archer, a very tall man, extended a glass towards me. As a pupil would not accept an alcoholic beverage in the presence of his teacher or father, I declined.

'Good lad. Good lad,' opined Mr Archer and I was offered a soft drink by a very motherly Mrs Archer half as tall as him.

'So how are you getting on, young man? Broken a few hearts as yet? This rascal was quite a hit with the girls at the campus I heard,' said Dr Anand, killing me with embarrassment.

I drank my drink, listened to the men talk of world affairs and took my leave, bending down to touch my mentor's feet again with the same response from him. As he was leaving the next day, I didn't see him again, not for another four plus years. But meeting him here had been a great help. I had met the great critic W.G. Archer. It would serve me well in time.

. . .

Now began a chapter in my life which was full of just two main activities beside the Play Centre. Both were equally pleasurable. One was girls, girls, girls. The other was painting. I persuaded my landlord Dr Singh to dismantle the partitions dividing his ex-large room to make a good 20-foot-square studio-cum-living/bedroom for me. This made it unnecessary for me to travel in the initially very cold weather to work in Francis Souza's studio in Belsize Park. Yet I saw a great deal of Francis. I had learnt to do elementary cooking. But he couldn't fry an egg to save his life, just like me before I left home where I was spoiled to the bone marrow. So often I cooked for him. Or rather, I bought two legs of chicken at a half-crown each from a supermarket and curried them in the only saucepan I had managed to acquire, an aluminium receptacle and lid. I learned to my amazement that chicken here was nearly half the price it was back in India.

Chicken here was commonplace. Not so in India where, being expensive, it made a rare appearance in an average household. It was eaten on special days to celebrate an occasion – like birthdays, a wedding feast and other similar events. We kept chickens at home, a good many of them. They ran around our garden all day long and were

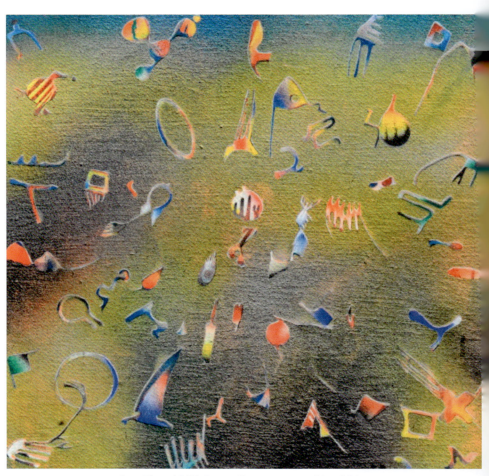

In a Flux, 1987–8, acrylic on canvas, 30 x 30 in.

fed corn and wheat. They clucked back to their pen in the evening by a clock of their own. My eldest brother slaughtered one every Sunday for a family feast.

My repertoire did not extend beyond this one dish – chicken curry. So it was chicken today and chicken tomorrow and chicken the day after. Souza loved my chicken curries. But more often, we went out for lunch. He adored fish and chips, something I completely failed to understand let alone endorse. What was there to find tasteful about a piece of cod with a thick coat of batter and then relegated to boiling oil for ten minutes? It had no taste to recommend even to a total non-cognizant. And a conical old newsprint container to contain half a pound of thick potato chips that were equally devoid of personality, being totally tasteless – they could have been made of edible rubber or blotting paper and my new and only friend wouldn't have known the difference. Even when they had been hosed with squirts of malt vinegar, they remained what they basically were for me – tasteless. When I asked, 'What do you find so great about them, Francis?' How could he extol fish and chips of totally non-existent taste?

Whenever I said to him that as an Indian the love of good food must be in his blood, part of his DNA, the great painter laughed and maintained I did not know what I was missing. I said that I had to agree with him.

At an average fish and chips street stall the other thing he demanded was a fish roe cake, a three-inch diameter of compressed fish eggs stuck together with batter and fried mercilessly. He often said he would go a long way to get that master culinary concoction, informing me through fits of laughter that it was poor man's caviar. Over such lunches, we talked and talked, but mainly of the same subject matter – the ugly little man's conquests.

'They love me. So what do I do? So I give it to them.'

'And no kidding, Francis?'

'And no kidding, Balraj.' My mentor believed in himself.

While I was still working in his studio, now with diminishing regularity, a Dutch artist friend and his young wife came to visit him. He gave the very friendly couple a room in his big Belsize house and I got to know them well. I arrived one morning unannounced and what do I find? The Dutch Delight in the nude laid out on a chaise longue with my friend similarly divested of his apparel on top of her by an easel. Where was the hubby of lady, I asked him at a Chippy's later.

'The Dutch man said he was flying to see someone important.'

'Don't you have any shame, any sense of loyalty to a friend, Francis? Where is your Catholic upbringing?'

'Balraj, don't give me your high-horse shit. She had been asking for it ever since they came here, giving me those saucy come-on looks. So what was I to do? I'm no Saint Francis.'

'No, you certainly are not. You are the Sinner Francis. You'll burn in hell, Francis.'

'It was all for Art's sake anyway. What do you think Picasso has been up to all his life? Or Modigliani for that matter? See what we all have to do for the sake of art.'

'It was all for art's sake', said the artist's first wife, the loveable gentle golden sparrow Maria Souza thirty years later. With Robert Skelton, one of the truly conscionable devotees of Indian art and Keeper of the Indian Section at the Victoria and Albert Museum, I had interviewed her on tape for no other reason than to record the life and times of Francis Souza. Maria, the well-known beauty in Bombay's Goan circles of the 1940s and 50s had devoted her life to him and worked as an alterations' lady at a women's clothes shop in London to keep the wolf away from the door from 1949 onward. When at last success came, the painter with a pock-marked face hardly known for his looks, had discarded her for a nondescript singer/actress.

I did my work and helped him with his. That was mainly to do the preliminary work by which I learned how to prepare a canvas. Stretch

a piece of calico from a roll of it he had, and priming it with a couple of coats of white emulsion.

Souza had a classroom overhead projector. Upon it he laid a transparent acetate sheet. He then drew on it in black ink, and projected the drawing on a large piece of prepared canvas I had made ready and stretched with drawing pins on a wall. He would do the outline in charcoal, partly filling the drawing with paint brushes or palette knives and let me complete the painting, issuing instructions as the work progressed.

Francis had a collection of girlie magazines with lewd and nude pictures in black and white. He simply laid the acetate on top of a selected picture and drew out the outline. He then projected it into a large figure on the canvas pinned to a wall, distorting the figure, making beautiful ladies ugly, beastly, repulsive and vulgarly sexual. He would start painting it and let me take the work to conclusion which he then encapsulated in bold outlines and signed with a bold flourish in black. Thus, I painted quite a few of his paintings and took pride in being his student-cum-assistant.

It made me feel self-assured while working on my own in my room. In the big, wide world outside, I was cutting an amiable figure, making friends and attracting girls right, left and centre, continental girls all. Au pairs.

. . .

Of all the London Museums, the V&A in South Kensington was my favourite. I went there regularly to draw from plaster-casts. I allowed myself half an hour for lunch between sessions.

There was a self-catering café doing snacks, but being the son of my father, I preferred to eat at the museum restaurant separated from it by a mere rope by the side of the café cashier. Minutes into my lunch one inhumanly cold but sunny afternoon, a bearded Indian chap ten years older than me hailed me from the cashier's till on the other side

of the rope. A co-Indian, he addressed me as if he knew me. I asked him to join me. A paper cup of tea in his hand, he did.

He turned out to be someone I had heard of, Ghulam Sheikh, a painter from the famous Baroda art school in India doing a British Council scholarship post-grad at the Royal College of Art adjoining the V&A in posh SW7. Over a cuppa, we became friends as we would have done back home like all easy-going Indians. He took me to see his work in his studio in the Royal College building. He was figurative with a total command of his medium, (oils) and subject matter; supremely figurative with a hint of a personal brand of surrealism. Hugely impressed, I humbly and respectfully invited the accomplished artist to visit my grotty studio room in uninspiring NW11 where I cooked and ate and painted and slept – with girls.

If I had been impressed by the work of the Royal College Postgraduate Ghulam Sheikh of some renown, he in turn was no less so by the efforts of an untrained somebody totally unknown. I was then working on large scale canvases I had learned to make from Souza. They were filled with tortured female forms in bold colours and black outlines like Souza's. Sheikh declared my work to be striking and said I had promise. I said come again.

He did soon after in the company of two other mid-thirties' Indian artists. One of them was none other than my Goan mentor's half-brother Lancelot Ribeiro who I had met with Francis in Swiss Cottage Centre a few days previously. And the other artist, Ibrahim Wagh from Bombay, was a graduate of the reputable Central School. Mugs of my favourite brand of tea, Typhoo, in hand, they looked around with critical eyes, nodding to each other in silence, dispelling an air of foreboding. Then, finally, the older and more self-assured of the two, Ribeiro, spoke and said they had just founded a group, *The Indian Painters Collective*. It had three other members and was a unique new setup, the only one of its kind in the UK and the whole of Europe. They would like me to join it.

I was flattered. But impressive as it sounded, the IPC seemed not have anything substantive to offer the world. I asked about their manifesto.

They had none as such. All they wanted was to exhibit as professional artists and be seen and recognised as such. But the British art world was hermetically sealed, galleries et al. It dismissed out of hand all non-white artists as being of no artistic merit whatsoever. As individuals, IPC members had no hope of making a mark. As a group they could perhaps succeed like many artists' groups in Europe before them. They had made a good start. India House, Indian High Commission's London's Head Quarters where famous Souza had his first one man show in London back in 1949, was being very helpful.

What about him and Chandra? How did IPC explain their success, critical and commercial?

Oh, they were just two odd ones, extremely lucky 'oddities' though highly talented. Penury-blighted members of the IPC were just as talented, the IPC spokesman Ribeiro said. They were biding their time and waiting for a chance to make it.

Wasn't that the plight of artists the world over? In Paris, for instance, the home of Modern Art, they were starving and craving attention.

True. But at least the open-minded French were not so discriminatory. Nor so dismissive as their barbed-wire enclosed Brits, who thought Indians as 'Inferior' in every sphere of human existence, including the most elemental and most elevating being that of arts. But then that was how things were – incalculably superior attitudes versus unfathomably the lowest as measured and determined by the former. It was as simple as that.

Why didn't IPC locate itself in the French capital then which was more egalitarian and, among other things, teeming with yum, yum les d'moiselles de Paris, eh?

Laughter! Would love to. But. But we don't know a word of French other than oui and non to catch a mademoiselle de Paris.

Would Ghulam also join the IPC? A distinguished product of the Royal College?

He simply couldn't. He had finished his post-grad and his visa was expiring. Besides, it was the bloody weather here. He couldn't wait a moment longer to get back to sunny Baroda.

'But you must join, Balraj. You've got everything going for you. Talents. Looks. Perfect English. You'll be an asset and it will help you in your career.'

Thus, I became a member of the Indian Painters Collective. And talking of yum, yum ladies, I ran into them wherever I went – pubs, cafes, shops, parks … I picked them up from tube station platforms, continental au pair beauties all. They began to pass through my new habitation with abundant regularity. Being European, they carried art in their blood – they loved my art. They had no inhibitions in taking their clothes off to pose for me.

Naturally enough, I loved it and loved them for it. I partied, I entertained helped by the master chef-in-residence Dr Singh. And I painted till the wee hours. And I attended IPC meetings held at the palatial 1930s India House. Negotiations were in progress for an exhibition of the group there. A young diplomat, the immensely charming, outstandingly promising and bright Cambridge-educated Salman Haidar, was in-charge. He was so unlike the senior run of the mill dukandar-type higher officials who would look more plausible sitting cross-legged on a dhuree in a bazaar shop back home than in a high office chrome chair in the world's greatest city. (Haidar would come back to India House as the Indian High Commissioner three decades later). When we met, he gave us a drink and apprised us of the state of play. Things had begun to look good. But a lot had yet to be done.

Charmer Salman visited our studios one by one and was more than convinced that the IPC deserved to be launched at India House by a high-profile exhibition.

. . .

About my two new-found mentors, Souza and Chandra, while there was always something grand about the latter, there was hardly anything noticeable physically about the former except his pock-marked face. But the main difference between the two men most important at that crucial stage in my career as an aspiring artist was that while the Goan FNS was an intellectual – his *Words and Lines* is as fine a piece of writing – concise, analytical and profound – as any written by an artist of his generation, the Punjab-born AC was basically a Punjabi peasant, to be summed up with just one word – bluff. He had probably never read a book in his entire life. But he exuded immense self-confidence, a typically Punjabi trait which I, a fellow Punjabi but with an MA in Eng Lit obviously unconsciously shared unknown to me, but that which people would begin to notice and comment on later.

'What makes you so, Mr Khanna? When you speak, everyone in the staff room listens,' remarked a fellow Indian teacher at Rutherford School for boys where I began to teach a few years later. The ever-alert and ever-ready with an opinion, diminutive Mr Biswas who taught 'shit' (Physics)to labs-full of 'hooligans' (as he called everybody in that school) befriended me there from day one as a 'fellow sufferer'. 'You must have been a top favourite of your mother's ten to fill you with such an over-flowing but pleasant demeanour.' But it was nothing of the sort. It was just me, one of my mother's ten.

I loved Chandra so much that I could have done anything for him – I cut the grass of his small garden a couple of times in Wessex Gardens, the Hardy country. He was also generous of heart. He ate selectively – unlike Francis who ate anything when his tummy demanded an intake. Avinash, an excellent cook, entertained well and was well-known for keeping a well-laid table. The physically big man loved his drink and could drink anybody under the table.

He and his wife Prem were both art graduates from Delhi. But it was Prem who had won a British Council post-grad scholarship to a London art school and Avinash had come in tow. However, he made

it because of his superior talent and towering personality, while Prem remained merely the great artist's wife. I was welcome in their house with Prem treating me like a little brother.

Not so Francis Newton Souza, who didn't treat even his own half-brother Lancelot Ribeiro as such. Nor kept any table to speak of (Victor Musgrave of Gallery One that launched him in the 1950s, many years later confessed to me that 'one was lucky to get a cup of tea at Souza's') though he too was generous of spirit. With the former, one ate and drank. With the latter, one only talked – of art and artists, the Bible the and the Upanishads. AND HIS CONQUESTS.

As I went through all this, I also watched the art world leapfrog from one ism to another. Paris had fallen and Swinging London of the 1960s was the emerging new capital of the Art World. New York had yet to occupy a resonant voice which it would begin to roar with in the late 1960s and the advent of the 1970s with the rise and rise of Jackson Pollock and his ilk. Experimentation on a monumental scale was afoot with me between its twitchy toes.

In the beginning were Mods and Rockers followed by Skinheads. Then came the divine Carnaby Street of flared satin trousers, long sideburns, long lapels and long shirt collars. Once upon a time colour-shy England had now sworn never to be the same one-legged nation again. Intercourse got 'discovered' soon after, in 1963, to universal delight. Love, reborn, was hoisted to unimaginable heights with Kama Sutra abandon. It was exciting. It was exhilarating. It was liberating. Above all, it was fun and a good time to be alive, though I did not know how I fitted to it all. Good looking and well-spoken that I was, I was still a brown-skinned Indian to be kept out of it all by a silent, unspoken but universal attitude. It hurt. I bore it with a semblance of equanimity and deflected it with the natural armour I had forged to mould me – determination.

Chin up, as my mentor back at home Mulk Raj Anand had advised, I kept my wits about me and watched the world 'twist' (the name of

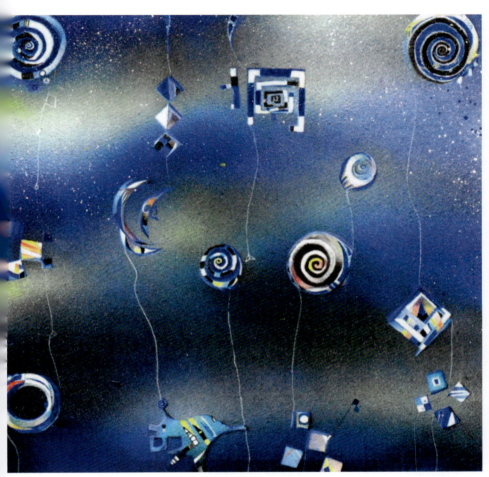

A Sacred Play of Forms, 2019, acrylic on canvas, 36 x 36 in.

the dance that defined the era) and turn – History paddling on. It was enjoying a new dawn post-Cuban Missile Crisis of October 1962 with a handsome young and bold new American President infusing it with new vigour that was percolating meaningfully and excitingly down into the arts of the time. London was coming into its own as it had not for a long time, if ever.

New galleries leapt out of the groin of the war-torn Britain, offering a new dawn and pastures new of a new growth artistically. To name a leading few, imaginative John Kasmin flourished in the ever-fashionable Bond Street. He shot to fame the young Royal College product, David Hockney. Close by, Cork Street came into its own with galleries like the Redfern show-casing new art and artists. As indeed was an experimental new gallery by Marble Arch called the New Vision Centre where the redoubtable Peter Blake had his first one man show as, indeed, did I not long after.

On the money side, reputable auction houses like Sotheby's and Christie's began to attract buyers from as far afield as Japan, now making purchasing pilgrimages to acquire the works of up and coming British artists. The great modern temple of International Art, the Hayward Gallery would rise in 1967 on the South Bank with a definitive retrospective of Matisse to heart-felt national applause. It was an exhibition master-minded by the Hayward's first Director, the charismatic Joanna Drew and her team led by the affably perceptive and soft-spoken Andrew Dempsey, one of the most likeable exhibitions' selectors and organisers with an eye for excellence. To their good fortune, they were strengthened by the younger, insightful and ravishing Caroline Collier, Isobel Johnston and an excellent draftsman himself, Roger Malbert. The great new gallery's Exhibitions Committee prided itself in having among its 30 odd members the country's foremost art critics David Sylvester and Richard Cork.

As an aside, years later I had the rare honour of serving on the ACGB and Hayward's Exhibitions' Committee for an instructive decade,

selecting with fellow members some of the greatest 20th century artists. This list included a controversial but seminal exhibition entitled, *The Other Story* in 1989 that showcased 24 post-war non-white artists from around the world who had made Britain their home. I was invited to take part in its selection-process and to participate in it.

I must say here that this historic exhibition's proposal by Pakistani-born sculptor Rasheed Araeen would not have gone anywhere without the explicit support of the Committee's President David Thompson, the art critic Richard Cork, ACGB's Joanna Drew and, of course, without my passionate argument for it. This was in staggering and inexplicable opposition to the proposal. The fact was that the majority of the committee did not want an exhibition of this nature proposed by a Pakistani to take place in the country's topmost public gallery. Crudely put, they didn't want the 'wogs' in. But that was the politics of the time for you, reflecting the universally held view in Britain that artists from outside the Western matrix could not be regarded as artists, being of no aesthetic substance, a prerogative of that matrix. The couple of artists, namely Francis Souza and Avinash Chandra did succeed, but only to an extent, and for far too short a time. They were never included in the Great Debate of Modern Art. They had no place in it till four decades later in 2019 when an exhibition of Figurative Painting in Post-War British Art took place at Tate Britain that included Souza with other Modern Masters.

. . .

I was talking of me, the pilgrim and his progress. My life had taken a scrumptious turn as my friends saw it – ladies galore. But the more I dallied with them, the more I felt lonely inside. They bore a hole in me, a hole not one of these attractive girls had been able to fill in terms of reaching my inner most self, my soul. They left me empty. My friends thought I was having a great time. I was not. I was an empty vessel who was able to make noise to deafen my inner being.

These girls came from all corners of Europe to London to learn English. To my young friends' endless joy, they all lived within a cricket ball's throw away in our own Golders Green. They were mostly with Jewish families as family members, but earned their keep by doing all the housework for which they were paid the princely sum of two pounds a week.

They attended a local language school for English in the morning and were free for the rest of time. Beside the families they lived with, they had little contact outside. They knew no English people, young or old. In fact they were shunned by them – no one seemed to want to know them other than those they worked for and lived with. They knew only each other. They wanted to meet other people, boys.

We young subcontinentals in Dr Singh's house had similar problems. No one wanted to know us either. The English were all around us, but they passed us by as if we were invisible to them. None of us had friends among the locals. We longed to be befriended by them, but were kept at a long arm's length. So we stuck to each other, spending our spare time in GG cafés and pubs. The homesick lonesome beauties from far off places in Europe sort of fell in the laps of us lonesome chaps from the very distant subcontinent.

Where my friends were concerned, it was manna from above. Not where I was concerned. I went through it all as a matter of course, but I was looking through them. I was looking and I kept looking.

I painted by day and slept at night in the arms of luscious young things. They were impressed by what I was doing. Everybody was. But I was not. Far from it, I was deeply aware that I was painting rubbish, that I couldn't draw nor paint. Page after page of my diary of 1963 paints this dismal picture of my lack of talent. I keep telling myself page after page I must draw better and paint better, evolve my own expression, my own style, my own technique. Yet I was prolific. Which is to say, I amassed a whole body of work which at a glance looked painterly because I was using thick impasto oils on canvas and

board with brushes and palette knives in bold black outlines like my friend Francis. I longed for someone like Mulk Raj, the critic, to see my work and help me in my quest to express myself.

But I knew no one in the art world other than the members of the IPC who all lived in their own little worlds like me in isolation (it was not splendid). I regularly went to see shows in the commercial galleries and tried to make contacts. I always ended up with the wrong, but a delectable sort, a continental kill. At my request, Avinash brought Archer to see my stuff. The frank, no-nonsense Englishman cut me down to size by declaring that it had been painted under too strong an influence of Souza. He said I must carry on and on, but I had to stop looking at too many Souzas and start looking into my own inner self.

But, frankly, I did not know how to do that. I tried. I ordered myself to go into my inner self. I did so loudly in our local park, like one ordered a dog. Or like an army sergeant barking an order at a parade. To no avail.

Early one evening, I gate-crashed a private view party at the New Vision Centre gallery. I was taking a short cut to to Edgeware Road to meet pal Billa to see a film. I saw a large crowd at the gallery's door and I just went in. I knew no one there, nor did anyone accost me. After a quick look at the paintings on the walls, which I thought nowhere as good as mine, I turned to leave when someone did stop me. He turned out to be the gallery owner, Denis Bowen, a smiling mid-forties man, the sort you like at first sight. After a chit chat over half a glass of red wine, I invited the affable gallery owner and art critic to come to see my paintings. He came one day with someone, his co-gallery owner and well-known critic Kenneth Coutts-Smith. Wow! I thought I was on my way. Just by their coming to my studio-drawing/dining/room-bedroom-kitchen gave me this feeling. The two spent a good half hour looking at everything in my room. Then they said I needed to mature and suggested that I saw them again in 10–12 months.

'We noticed how the girls in the gallery were looking at you,' Denis Bowen said with a wink.'

'How? May I ask?'

'Take full advantage, young man. Undress them and paint them daily.'

'Is it an order or advice?'

They laughed in answer while leaving.

. . .

Was that advice or an order? Whatever it was and what W.G. Archer had said, I could not act upon. I was depressed. I carried on like a demented pearl diver hoping to grab a jewel-enclosing oyster. Or like an incorrigible optimistic poker player whose next game had to fetch him a winning hand. Depressed beyond bearing, I withdrew into myself and stopped all my extra-curricular activities. It was noticed. To get me out of my woebegone self, Dr Singh decided to throw a mother of all parties. Billa took me out for coffee a day before at the charming Swiss Tea rooms Lindy's opposite the WW1 Memorial Clock Tower in Golders Green. The popular haunt of the young, Lindy's was not busy that day. At a table for four along a wall by the entrance there sat a very young and very lovely girl. By the cut of her elegant raincoat, I knew she was French.

The summer of 1963 was host to an unproductive talk between Britain and France of building a tunnel under the English Channel. Billa had a copy of that day's *Evening Standard*. Its centre spread carried a large cartoon of the Channel with Napoleon on one side and the British Prime Minister Harold Macmillan on the other with a bold caption above them in French. Usually, bold and self-confident, I felt all that ebb out of me and a certain hesitancy or fear even, invade me as I considered initiating a conversation with the elegant French girl. Yet I couldn't resist asking the young mademoiselle to kindly translate that caption for us.

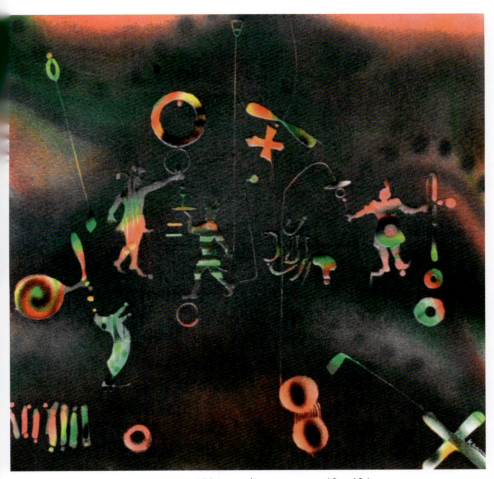

Green Waiter, 1991, acrylic on canvas, 40 x 40 in.

Looking me up and down for a long moment, she did. Her English was beautifully broken, her accent delightfully delicious, her lips full like Botticelli's Venus. During a chit chat that followed, she told us in her edible English she lived nearby in Golders Green with a Jewish family. Billa told her in his Punjabi English that we also lived nearby, a prelude to throwing an invitation.

(When most Brits speak French, they sound positively parochial. When the French speak English, especially French women, they sound mouth-wateringly sexy.)

Dr Singh had said to us all in No. 797 earlier that we could invite whoever we liked. After a few minutes of sampling that vocal heaven, I did just that and wrote down the address for the next evening, sure in the knowledge that she would throw away the chit I had written *797 Finchley Road 7 PM* the moment we were out of sight. But I wished with all my heart that she wouldn't. One met so many girls those vacuous days and we threw invitations right and left. Only an odd one or two of them ever turned up. We never took it personally if others didn't. We never paid much, if any, attention to these sort of obligatory invitations – you met a girl, you felt it was compulsory to ask her. It was, therefore, a foregone conclusion that I would be forgotten the moment my friend and I were out of Lindy's door. Yet I couldn't get those demure brown eyes and those Botticelli lips out of my head. I called myself a damn fool for even thinking about her, a passing vision of half a moment's duration and I had fallen in love with her, foolish me. Then, mercifully, I forgot all about it.

The party was to be held in Dr Singh's spacious flat on the top floor. I didn't really want to go – oh no, – another of incorrigibly hopeful Dr Singh's silly do's! But I turned up all the same with the statutory bottle, a Rioja that cost seven and six which we all loved. With a feeling of obligation more than that of any other sort – my heart was not in the party – I intended to quit no later than my Rioja was drunk, and thus was grumpy. In that mood, I went and stood

by the window that overlooked our undignified front garden. After a couple of glasses, just as I was about to turn around to go, what did I see – that Lindy's blinding beauty in a midnight-blue polka dot frock walking up our garden!

They say there are certain moments in one's life that can change it for ever. It was that moment in my life.

I dashed down and brought the 19-year Francine Meunier upstairs to the party. She didn't drink. So after half a glass of schweppes tonic water, and twenty minutes talking, our eyes deep into each other's, she said she would like to see my paintings one day. I said would she care to look at them today, now, my studio is on the ground floor? Why not? She mused with her deep brown eyes on mine. We took to the stairs and did not return to the party. I never looked at another lady in my life after that.

. . .

Soon after, the country found itself at the stage set for a political drama of the utmost titillating kind, resulting in the most delicious scandal of the century. It was delivered in daily portions at every breakfast table of the highest and the lowest of country in the summer and autumn of 1963, uniting it in the truest form of democracy – laughter.

It involved a respected minister of state in the Macmillan Government, a handsome Russian Diplomat-Spy, a well-connected society Osteopath and a beautiful call girl of 22. Every day, more and more salivating details of the seismic affair came out courtesy of a deeply devoted Press, making the insatiable country asking for yet more and more.

It came out that the British Government Minister and the Russian 'diplomat' were both screwing the same young English girl Christine Keeler in the Country House of Lord So & So as arranged by her hobnobbing-with-nobility pimp, the Society osteopath Stephen Ward. Prime Minister Harold Macmillan was deeply embarrassed. When he

accosted his minister John Profumo of Italian extraction, the minister denied point blank any wrong-doing whatsoever. That did not satisfy the Parliament. It wanted to hear the same from the randy Profumo. So the fellow repeated the same under oath, a white lie. The fool was administered treatment accorded to a member of the Parliament for lying to the House. He was not only ostracised and disgraced beyond repair, he also had to serve time.

Cutting a long but belly-achingly delicious story short – oh, how the world loves schadenfreude – dear old grandpa Macmillan had to resign. This led to the resignation of his entire cabinet, the expelling of the Russian spy, the Osteopath taking an overdose, and nine months inside for the beauty queen whose only fault was being starry-eyed in high society for a while and for being what she was born to be, a practitioner of the world's oldest profession. Britain had a new Prime Minster, the namby-pamby Lord Alec Douglas Home who had to surrender his lordly fleece and enter No. 10 Downing Street as a mere Sir ADH. In these pulse-racing febrile days, a General Election was all but inevitable, much to the chagrin of the Tories. It took place a few months later in August 1964 and Great Britain had a first Labour Prime Minister and a Labour government, if only by the skin of its teeth – by a majority of a mere six seats in the Lower House, after having been in wilderness for thirteen long years.

I was talking about myself. I'll move on.

. . .

I was back at work. Francine and I met twice a week – her day off on Thursdays and Saturdays pm – in my room between the sheets. We treated ourselves to soup out of a packet, an occasional chicken curry of sorts that I concocted accompanied by a loaf of the delicious Jewish holler bread, an apple and a sizeable triangle of cheesecake from our Lindy's that made her say, 'I have too much eaten.' I loved to hear her say that and kissed her from here to the yonder clouds and beyond.

That became our lovely routine, taking in a visit to a gallery in town or a major exhibition at the Royal Academy. I was happy like a pig in a pool of mud. And full to the brim of myself – who wouldn't be? It sent me soaring in the sky to see that she was too. It was love in whichever way we looked.

With work in full swing at the same time – looking and finding and delving deeper, my life was complete. I had never been happier.

Francine had to move to Eltham Well Hall in the depths of south London to work as a secretary for a doctor. Twice a week – on her day off on Thursdays and Saturdays – she came all the way, poor girl, on British Rail to Charing Cross and then on the Misery, Northern Line to Golders Green in the north, an hour each way, to be with me! First was an hour between the sheets for travellers in a desert who had suddenly come upon an oasis. Then lunch of soup from a packet and a loaf of the heavenly Jewish holler.

No man on earth was luckier. Nor more grateful – she was beautifully innocent and deliciously devoid of pretence and the airs of young women of beauty. What you saw was what you got – an unbelievable work of God. And it was mine.

But I nearly lost it all.

Dr Singh invited me one Thursday to a game of tennis at the public courts in our local park. Never being one for tennis, yet foolishly I accepted. I left a note for my love, saying come and join me at the nets, never doubting that she would not. Being a spoilt brat, I had taken it for granted that she would come like any other girl would have. But Francine Meunier was not just any other girl. Having come all the way from Eltham Well Hall a million miles down south, the fiery French responded in the fiery French way saying something like go to hell. "What do you think I am, a door mat?" she wrote in response to my epistle. Imagine my innocent self-injured state of mind when she refused to talk to me on the telephone, or even acknowledge my messages. Life suddenly changed from total delight to utter misery. After

a grovelling long letter twinkling with quotes from my copy of the Golden Treasury, she agreed to meet. I started to breathe again. And the country too for its own good reason.

. . .

With the pipe-smoking avuncular Harold Wilson in No. 10 Downing Street, the country acquired a distinctly more 'welfare state' look. But the Profumo affair lived on in tabloids with pictures of Miss Keeler in a revealing swimsuit reclining languidly on a poolside garden bed. And pub lounges continued to resound with laughter. A change was afoot in our lives. The bowler-hats and pin-stripe suits of 'squares' were being replaced by flared trousers and long sideburns. Chaps took to the 'weed' and young women to ethnic chic. Carnaby Street was just around the corner to broaden England's horizons further, and Kama Sutra turned tables on everything traditionally queasy and prurient at every dinner table by being openly discussed. Suddenly the lid began to come off a tightly packed jam jar. The country was beginning to have fun. Intercourse was born, as a philosopher later said. It was a great time to be alive.

Francine came one fine day and announced with a sparkling smile that her mother was coming over from France for a long weekend. I was happy for her, but not for myself – would she like me, a brown Indian? Thus far, I lived in the belief that ladies generally liked me. I had been told time and again that I had all that a girl found attractive in a man. This, to the extent that many of my male contemporaries back in Karnal were prepared to kill me for my looks. But that was different and I didn't take much notice of it all. Now I feared, what if Madame Meunier found me unbearable to look at?

As it happened, Madame Meunier had to have just one look and that put all my fears to flight.

She turned out to be a carbon copy of her daughter – in looks and mannerism. It was the other way around but that was how it had

looked to me at the time. It was early evening when I met them at Oxford Street station. We had a coffee nearby. A young Indian woman next to our table tried to initiate a conversation with me much to the annoyance of my love and disapproval of her Mum. But I had nothing to do with that and managed to see off the nameless woman with practised ease.

Francine's Mum wanted to see my paintings. She was impressed by what she saw. It was 7 pm. She succumbed to my invitation to dinner at an Indian restaurant two hundred yards from my place. She had never had "currie". She liked it. She didn't speak a word of English. I didn't speak a word of French. But we got on famously well, dispatching her daughter over the moon. Her Mum insisted on settling the bill, just what my mother would have done. But was not allowed to do so. I had winked at the Bengali waiter. He had understood. He refused to let her take the bill.

. . .

India greatly welcomed the re-arrival of a Labour Prime Minster on the scene. For after all, it was a Labour Prime Minister, Clement Attlee who had given India its Independence within everybody's living memory. The world's newest independent country celebrated its sweet seventeenth birthday with a grand party in the elegant house of its ageing High Commissioner Jeevraj Mehta at 9 Kensington Palace Gardens W8. All six young members of the Indian Painters Collective were invited, thanks to our patron-saint, the ever-charming Salman Haidar. Indian Government being dry, it was to be a tea and samosa do. Present there were some two hundred Indian big wigs, including several leading Labour lights. With glad-to-be-here faces, the young Indian artists mingled with ladies in colourful saris and gentlemen in sparkling white khadi kurta-pajamas or in boot-shoot, tie-shie and whatnot on a fragrant, freshly mown lawn – alcohol-free parties can be fun too.

I recalled with great awe a similar but immeasurably grander garden party with a lot more people a few years earlier on the lawns in New Delhi of the Indian President Dr Rajendra Prasad no less. It was there that among the high and mighty I met Prince Philip, of all people in the world. It was his first visit to India in Jan/Feb 1959. He had come on his own, leaving the missus behind to mind the house. How I got there is another story. Simply put, my newlywed sister Raj's young brother-in-law Captain Vij was stationed in the Presidential Palace with his regiment, the famous 4th Guards. Raj and her hubby of Chandigarh were invited to the Mega reception courtesy of Captain Vij. I happened to be in Delhi. I just tagged along and met HRH in the throng, agog.

I was a little less so on our High Commissioner's lawn that morning. At 11, the HC hoisted the tricolour with the Ashoka Wheel of Law in its middle. Rose petals rained down as it unfurled and the colourful congregation burst out in one voice Tagore's famous song, 'Jann Gann Mann abhi nayak jayo hey, Bharat Bhagya Vidhata …' our National Anthem. Then thunderous clapping and pandemonium because tea and samosas appeared. Indians by nature are an unruly lot when they get together in large numbers. On occasions such as weddings, they take leave of all manner of decorum. In that halla gulla, someone was urgently making his way to us – Salman Haidar.

'I have some news for you chaps.'

'WHAT, Salman, WHAT?' We cried, our hearts missing several important beats. For we were waiting desperately for news.

'Your show is on at India House.'

One by one we hugged the man. Again and again, we hugged him. It caused tea-drinkers to hold their cups mid-air, stop munching their samosas and stare in consternation at the six nutters grouped around a nonplussed man. And all the man wanted to do was to find a bush to hide behind.

'Meeting at India House with the High Commissioner at 11.30 on Monday morning. Hope you chaps can make it,' said the young

diplomat with an arcane sense of humour, addressing his words to me, the only well-read around beside himself.

'Rather busy, I'm afraid. But we'll do our best. What do you think, chaps?' I replied in the same vein.

Then the Indian Painters Collective embraced Salman again collectively in a volley of laughter, stupefying the onlookers further. Salman now introduced me to someone called Lali. Lali was a schoolteacher. When told that I had an MA like him, Lali said why didn't I become one too? He even told me how to go about it.

'Go to the Education Department of County Hall with your BA and MA degrees tomorrow and apply. It will take a while as they check your MA degree with your Uni back home. Then an interview and then a medical then you are Mister Khanna Sir at a London comprehensive. Simple as that …' I hugged Lali in thanks and my five friends and I hugged Salman again a couple of times before parting.

There was a pub on the main road by the side of the gated Kensington Palace Gardens in Notting Hill. As my mates made a dash to it after the HC's interminable speech to get pissed in celebration, I surprised them by abandoning them. I made a dash to get to Charing Cross station by one. I was meeting Francine's train from Eltham Well Hall. She arrived on time, but instead of her usually bubbly self, she looked glum. Something was the matter. From my station Golders Green we did not go straight to my room as always to leap into my bed. We stopped at the big park half way to it. I lay out on the lush grass by the tennis courts there, my head in her lap. She remained sitting upright in alarming silence.

'What is it, darling?'

Her answer was the pearl of a tear drop that fell on my cheek.

'WHAT IS IT?'

'My period.'

More pearls.

'Are you sure?'

Then a stream of tears. It broke my heart to see her cry so.

'What am I going to do?'

'Nothing.'

Hiccups and a flood and silence.

'I'll tell you what we are going to do?'

'What?'

'We are going to get married. Write to your Maman to tell her.'

'She'll say what will we live on?'

'Air and water. We'll go to France, get married there and I will paint there.'

'You are dreaming.'

'My prerogative. I'm going to take a full-time teacher's job …'

'Think. It is serious. Please think.'

'I have done all the thinking.'

'What, just like that?'

'Yes. Just like that. You'll be Mrs Khanna soon. Our darling baby will be the apple of our eyes. And your Mum's.'

'As simple as that?'

'Yes, as simple as that.'

I did what Salman's friend had told me to do. After an Interview and a Medical, I became a qualified teacher.

. . .

Our benefactor-friend, the young Indian diplomat, Salman Haidar, not only got us a date for our exhibition at the elegant 1933's India House in Aldwych, India's High Commission in central London, he did something magical, Prospero-like. He pulled off the diplomatic coup of the century. With the blessings of our distinguished-looking High Commissioner white-haired Jeevraj Mehta, he managed to charm Britain's first-ever Arts Minister, Motherly Jenny Lee, a doyen of the Labour Party, to inaugurate our show!

This was too good to be true that a minister of Her Majesty's Government was opening an exhibition of six very young unknown Indian

artists. Four of them were barely out of art school and the oldest was in his early 30s.

The 9th of November 1964, a Monday, was nominated for the opening of our show. We were given a very large room on the first floor of India House to hang our paintings. It was by a circular marble balcony looking down at the ground floor, like a well. The two-foot marble walls circling the big hole in the floor were perforated with exquisitely carved Indian motifs. We took the weekend to hang the show. The private view took place in that room. With the famous Indian hospitality, it got packed with dignitaries and non-dignitaries in no time at all because alcoholic drinks were on offer that evening.

Francine, now two-months gone, and I arrived late – London Transport. The Minister was well into her speech when we turned up. I just caught its last sentence:

"None other than Indian hands could have produced such striking works of art …"

We met everybody. They were struck by the *French girl's* striking looks. I beamed with pride because she was my girl. I was a bit afraid that she might get flustered by it all. But she was nothing of the sort. Ever unselfconscious, she took it all with her natural innocence and charm. People praised my paintings profusely which did me no harm at all.

There were a few Indian journalists, and many men and women from the art world. Among them was an old couple. The lady was an actress, by the name of Tallulah Bankhead, I was told. It was whispered to me that she was very famous. I had never met an actress famous or infamous. Sixty plus, she was white-haired and handsome. She held a long conversation with me which I found much to my liking. But being accustomed to female attention, I did not feel unduly flattered. Yet I did feel flattered by her comment about a very large painting of mine. It depicted a number of female forms in turmoil, as if in torment. The actress said something which I remember to this

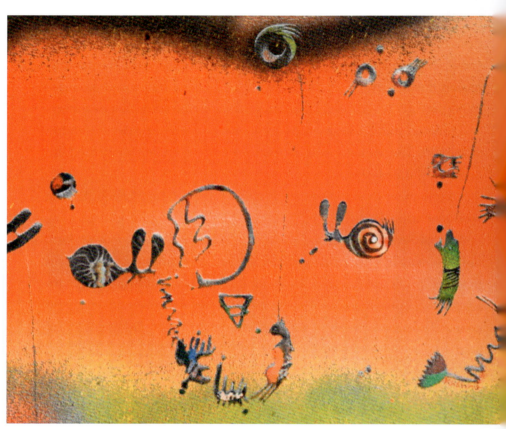

Play at Dawn, 2005, acrylic on canvas, 16 x 24 in.

day. She said that a long red painting of tortured figures reminded her of the Rape of the Sabines I had never heard of.

I made a life-long friend that evening. In his 60s and white-haired, tall and imposing, Eric White was the Secretary of the Arts Council (a post abolished after him). A poet and the Director of Literature at the Arts Council, he enthused about my work. We had a good long chat. Before parting company, he gave me his card, suggesting I gave him a ring to meet up sometime.

Among other interesting people – everybody there seemed to be interesting – were the two art critics Denis Bowen and Kenneth Coutts-Smith of the pioneering New Vision Centre gallery I had met before. They liked my paintings. Upon being told of my plans to go to France to get married and to paint, they asked me to come and see them with my new work when I got back.

As it happened, while I was waiting for Francine's train from Eltham Well Hall one afternoon, who should I bump into, but Eric White, the literary giant of the Arts Council? He was waiting for the same train now southbound. We made a date. I called on him at the ACGB's offices in St James' Square behind Piccadilly. He took me to an Italian restaurant in a smart side street. He ordered prawn cocktails as starters. I held up a hand and said I didn't drink on Tuesdays. He laughed in a fatherly way. I felt a bit foolish to learn that this cocktail was not made of alcohol. I had my first taste of the mango-shaped green avocado pear (we don't grow them in India for some reason). He invited me and Francine to dinner and to meet his wife Dodo at his sumptuous house in Canonbury. We would have many such meals together.

. . .

Things moved fast from there on. I got a job as a Supply Teacher going from school to school like a nomad with an MA instead of a camel. Francine spilled the beans about her being pregnant to her mother and told her we were going to get married. She had also told me that

her 28-year old sister doctor Claudine had a *'mal character'*, meaning she had a very bad temper. I feared the worst. I had never expected her family to respond in any other way than the most inflammatory to her double seismic announcement. But demolishing all our shudders Francine's Maman was jubilant, so utterly unlike an Indian mother. We could have tied the knot in a registry office here in London. But no. We had to get married in France, in Metz, Maman insisted. At her Maman's expense. I had just started teaching but I was still penniless.

On the first of December of that year, in 1964 that is, Francine went back home first. Then a couple of days later I undertook the long, very long train, boat, and train journey to Metz. My heart was in my throat – how would I be treated, me, a total outsider – neither French, nor even a white European, but a brown, though light brown, bloody Indian however good looking? In India, the brothers of the girl would beat up black and blue, even kill the man who had put their sister in that condition, bringing unspeakable shame to her family. They would kill her too to save the family honour.

It was about eight in the evening when I arrived at the heavily Germanic Metz station. Francine had come with her sister Claudine in her white Simca car to receive me. Their mother awaited us at home. It became clear straight away that no knives awaited me. What did await me, however, was a glass of champagne as aperitif and a finger-licking *coq au vin* meal. Instead of any reproach or dirty looks, warm welcome laced the air I breathed. The dinner table sparkled with smiles. From that moment on, I felt I had come home, become one of the very small family. The date for the nuptials was the 5th, only four days away. I had not yet informed my family in India. While leaving home in Karnal, Punjab, on the 21st of November three years previously, my mother had extracted a promise from me that I would not marry an English girl. Even though I had not reneged on that promise – I was marrying a French girl – I would write to my Dad explaining it all properly and respectfully when we got back to London.

Francine had told me about her sister Claudine's bad temper (*'mal character'*). But how bad, she had not. No sooner was the meal over, I found out. The sisters had an argument of some sort. It got out of hand and a shouting match began. Their mother not being an authoritarian, referee, couldn't stop it from getting *worse*. Loud hysterics got louder. I looked on in utter disbelief. I had never seen anything like that back home. Sisters there too were known to quarrel, but like this? Never. A shout from their father would put an abrupt end to their unladylike behaviour. But these sisters did not have a father. He had died when Francine was four and Claudine twelve. Exhausted, they finally shut up.

It was bed time.

Since Francine and I were not yet married, decorum hypocritically said we still slept separately. I was given the long sofa bed in the lounge and Francine retired to the spare room. Needless to say how I passed the night, convinced without recourse to any alleviating thought that our marriage was off. I had been told that there was a train every morning to Lille and Calais. We would catch it and get back to the calm of London. Tossing and turning, I waited for the day to dawn. When it did, I got changed quickly, packed my suitcase and brought it down to ask Francine to get ready to go to the station. I nearly fell in the doorway at what I saw – the two sisters twittering away like birds amidst giggles as if nothing at all had happened last night!

This pattern would repeat itself time and again. And I discovered that Francine's nickname was Bibish, which is the word for a young she-deer. I loved it and have called her Bibish ever since.

The marriage ceremony took place in the modest-looking red stone edifice, the *Mayorie*, opposite the great and grand medieval cathedral which had somehow avoided the Nazi air-raids (a sister cathedral not far off had not). The cathedral-sized Mayor of Metz himself wearing a colourful sash around him like a chocolate box intoned the marriage

mantras. A translator hired for the job translated. His English was so French, I understood not a word. When the punishment was over, we all drove back to Francine's sister's spacious flat for champagne. Moët et Chandon became my most favoured divine lemonade from that day on. Most of the guests were Claudine and Maman's friend – none of my friends in London came because could not afford the train fares to Metz and back. They included two young and very pretty doctors, Penelope Mangin and Francine Jardine, my *belle soeur's* mates from her medical schooldays. They paid me an unforgettable compliment. They called me 'Pin Up Boy.'

Well, well, well. I said and laughed. I had been told all kinds of things about my looks ever since I could remember – from my primary school days in the old Mughal-Princely Lahore till university in the ultra-modern Le Corbusier-designed Chandigarh, and after. But this topped them all.

A few bottles down, we moved to La Pergola on the town's outskirts, a posh restaurant-cum hotel by the Moselle flowing by. A long table by a raging *cheminée*, as the French call a fireplace, was laid out for sixteen of us. A spit by it had a whole lamb above gentle coals, revolving impassively. I sat in the middle of one side with my new wife opposite me in a gorgeous pink silk *robe*, as the French call a dress, looking at once edible. On my right sat apparitional Claudine elegant in a long black silk couture masterpiece with a frilly collar, on my left the supremely elegant (as only the French women can be effortlessly) Madame Schmidt, 40. First came a massive salmon on the table.

'Ah, Salmon! Delicious,' cried Mme Schmidt.

'Just like my salmon,' I replied, pointing to Francine in her pink dress. 'Delicious.'

The dinner comprised of more champagne and three different kinds of wine. Maman had reserved a room for the newly-weds. It was a mind-blowing evening. I didn't want it to end soon. But it ended

as it had to around midnight. I was dying to rush to the Presidential Suite on the first floor of the inn and light the flame of my life. Or hose down the fire that had engulfed the President's Suite. It resulted in guess what – a President de Gaulle of all hangovers. It was richly deserved, thanks to the swimming pool of the grape juice of bubbles imbibed. Yet I had delivered.

'Not bad,' I was told.

France was a dream. Or rather, a dream come true.

. . .

Back to reality in London and the nomadic grind of Supply Teaching (where the kids called me Jack the Pak), but that which paid me five quid a day, I had to put up and shut up. I found a spacious bedsit in Howitt Road opposite the Belsize Park station I knew so well. With chum Billa's help, I stored all my hundred plus paintings – two whole years of work – in Dr Singh's moist basement to reclaim them when I had my own castle or a flat. Here in the bedsit, we cooked – there was a small gas fire and a mini oven – and made love, slept and I painted till late at night. Here we could even have a friend or two for a meal. Our first dinner guests were Eric White and his charming wife, Dodo, a fine and proper English lady of the old school as was Eric a gentleman. The two made an exemplary couple. A mutual friend, the poet Alan Ross said to me one day – that Eric spoke to his wife as if he was addressing a meeting. Francine made roast chicken, roast potatoes and green beans. They invited us back to a more lavish supper. There I had to sign a visitors' book, which made me want to laugh.

The next morning there arrived in the post a letter I had been dreading to receive. The news it contained removed the floor from underneath my feet – my father was no more. The family had gone to Delhi for the wedding of his sister's son Satish, a contemporary of mine and a good friend. He was in good spirits and had danced the bhangra all evening. That night he had succumbed to a massive heart attack.

The letter ended with the words: 'He loved you much, Balli.' I wished he knew how much I loved him. When I think of him, I want to cry even today as I write this. My poor mother. I wished I could hold her in my arms in that moment. I couldn't even talk to her, not having a telephone of my own. Nor could any member of my family speak to me for that reason. I felt deeply alone in my grief. Francine tried her best to console me. Dr Singh, Billa and other friends came with profound condolences writ large on their faces. But all I wanted was to be with my mother and my brothers and my sisters. I needed to feel and touch someone of my own flesh and blood. That was not to be. I wept and wept and wept.

. . .

There lived on the ground floor of our new abode in Howitt Road, supposedly next door to where once lived a former British Prime Minister, (rather a humble joint for a PM I thought), two young Scottish brothers. One of them owned a Vespa scooter. We became friendly. He showed me how easy it was to ride a scooter. He let me try it one day. Off I went, picking up speed. Suddenly, I realised I could not slow down. Nor stop. In panic sheer and total, I tried this. I tried that. The more I tried, the faster I went. Now the only thought in my head was that I must not run into someone in the street and kill them.

The next thing I knew was that I was in a hospital and in excruciating pain – I had collided with the gate of the entrance to a block of flats at the bottom of Howitt Road. I had done some dreadful damage to my right leg above the ankle and cut some tendons inside it. That could have been the end of me.

I spent twelve days in St Mary's, then in Harrow Road, thanking Krishna every moment for saving my life. And feeling grateful to our wonderful and unique-in-the-world NHS for the free medical treatment it gave me – from the ambulance service to 12 days under care in a hospital towards which I had not yet contributed a penny.

My leg in plaster from the knee down, pregnant Francine made arrangements for me to be taken to France to be cared for by her Maman and doctor sister Claudine in Metz. I knew them but only a little. The few days I spent with them after the wedding celebrations hardly entitled me to a place in their hearts. Yet there I was, being treated by them as if I was a member of the family. This was beyond all my expectations. But it brought me galactic relief. They literally took me their bosom. Madame Meunier treated me like a son she never had. And Claudine became my sister Raj. Their love and affection made it a home from home for me. Never did the invalid that I was for once feel I was a stranger among them. This in spite of the fact I did not speak a word of French except *bonjour* and *bonsoir*. Yet I managed to communicate with them with perfect ease. And vice versa.

It was a feeling suitably enhanced by the fact that Claudine's fiancé, Jean, also displayed the same regard for me to the letter. The divorcee lived in his house separately in Borny, an old suburb of Metz. Claudine had a spacious flat of her own which also served as her surgery. That was where I had stayed on my first visit to Metz. Maman inhabited a small flat in a neighbouring post-war urban development called the Zup. Jean's business was wholesaling meat and he had a large house with a large garden a kilometre away. He also had a long plot of land by the side of his maison in which he had an immense purpose-built cold storage. A large man with a large heart, he generously let us have his house and he went to live with Claudine. Beside his meat business, Jean was also constructing a big restaurant in the middle of le Foret de St Bernard fifteen miles away near a small picture postcard village called St Bernard. Chickens clucked in its timeless streets and pigs brushed past people as they went about their leisurely life.

This would be of incalculable value to my work. For we all regularly went to the forest for a day out in the country. This was the first time since I left India that I came in contact with the real mother earth. In London, one had to take a bus to go to a park and feel the

earth and grass under one's feet. Here, all earth was mine. My leg still in plaster, I would lie down flat on the grass and stare in awe at the drama above me of light and shadows conversing with each other. I felt as if I had never seen trees before in all my existence. The branches and leaves played magical games of light and movement as the sun's rays filtered through them, and the birds – sparrows, starlings et al flapped their wings, flitting from branch to branch and tree to tree. Being surrounded by foliage all day long in the silence of the wild made my heart sing. Back in Jean's house in Borny, working in my dimly-lit make-shift studio, his garage in fact, I made drawings on paper of what I had seen in the forest in daylight. I found a new force in me. It was dragging me away from my usual semi-figurative stuff to the semi-abstract, a new-found abstraction that captured or rather expressed my feelings for nature. Came the day when Claudine took Francine and me to the Bell Isle Hospital in town where a surgeon cut the plaster off my leg.

Back on my feet, I began to go to town, buying materials to paint on canvas as dictated by how I felt. I had to devise new methods and invent techniques of my own. I made my own canvases as I had learnt from Souza – thick calico primed well with white emulsion and given a very light coat of white gloss, light enough so as not to kill the grain of the canvas, and voila! I had canvas to paint on. I drew on it with pen and ink, large swirls enclosing smaller swirls, geometric shapes, and those derived from the theatre of the natural world becoming organic shapes.

I coloured selected ones in acrylics. When dry, I went over the entire surface in one or two light-coloured glazes. When nearly dry, I liberated selected shapes with bits of cloth touched with turps and went over the entire remaining coloured parts of the canvas with artists' oil paints. This, then, was how I came to evolve a technique which matured further with more experimentation. A single colour often dominated much of the finished painting.

Experimentation was the order of the scheme of things as I went on. It was heartbreak for much of the time as I aimed for oft-elusive perfection. But also joyous at others. On the whole, fulfilling, a revelation.

Spring had sprung. It began to get warmer. Jean's rose bushes burst out in smiles. There was a hoary weeping willow in the garden. Sometimes we lunched under it. I could cook Indian food reasonably well now. My soon to be brother-in-law Jean loved whatever concoction I came up with as long as it was hot – the hotter the better. No respectable Indian would have taken a second look at what I produced. But it didn't matter.

Francine got bigger and bigger. Then late one morning, she said it was time. It was Sunday, the 30th of May. Maman and Jean's ample mum Madame Kieffer, a legendary cook, were busy in the kitchen for a fiesta – four Kieffers, two Meuniers and two Khannas. The mouth-dribbling star of the menu was my favourite sweetbreads that Mme Kieffer had cooked for us previously. By one o'clock, it became clear that Bibish had to be taken to the Belle Isle that very moment. Claudine and I hurried her there. False alarm – her labour had subsided. Yet she had to remain in her hospital bed. Sadly, we had to leave her, sadly because she was so looking forward to what promised to be the lunch of the century. The hospital said they would telephone Dr Claudine to come back when it was time. Thus my wife missed that glorious repast – she complains to this day and says how sorry she was to have to forgo it. As the whole world knows, French lunches can last a long time; when the French eat, they eat. Something in common with Indians.

We were still at it when around 3.30, the telephone call came and Claudine and I raced back to Belle Isle to be there for the birth. As I ran down the corridor to the room Bibish was ensconced in, I heard a baby cry out loudly. I knew from the tenor of it that it was a Khanna.

The world's most beautiful baby, Nathalie Rani Khanna had arrived.

Soon it was time for the Khannas to return to London. The plan was I would go first with my paintings, start teaching and find a flat.

Bibish would follow me on her own. When we had settled in, Maman would bring baby Nathalie by air, flying from Luxemburg forty kilometres from Metz. Being hard working, I had a body of work ready to take back. But before that endless train journey from Metz to London via Calais and Dover, I had another of a mere three hours to undertake, to Paris to look for a gallery. My old university chum Pat had given me the number of a friend of his by the name of Ravi Kumar living in glamorous Paris 16eme. He turned out to be the brother of the chap who owned the Kumar Gallery in Delhi where I had first seen my friend Souza's paintings just before leaving India. Ravi Kumar also knew Souza. Besides, he had a French girlfriend he lived with and knew Paris well. All this helped to create a telephonic friendship. He told me where to go.

'Around Montparnasse. Get off at Vavin. Loads of galleries there. And let me know how you get on,' he said, after a good long warm friendly chat. I said I would let him know.

So early one morning, I took the train to the French capital with a roll of ten canvases under my arm like a carpet seller back home. Arriving there from Gare de l'Est station, I took the Metro to Vavin near where Bd Montparnasse crossed Bd Raspail. I found myself looking up to an immense statue of the literary giant Balzac by the great sculptor Rodin at the crossroads. By its side a few yards away was a large-fronted shop with **Galerie Transposition** emblazoned above its entrance. I went in. A lady who could have been a twin of my Dad's elder sister looked me up and down, deducing who I was – a very young painter in search of a patron.

'*Bonjour, madame*, do you speak English?'

'*Oui, monsieur, un petit peu*. I do. You have something to show me, no?' she said in beautiful French-English.

Like a carpet-seller back home, I unrolled my paintings on the carpeted gallery floor with a hushed flourish. She looked and looked at my paintings and then at me.

'Are these the landscape of what you have seen in Alsace or of your mind?'

I nodded.

'Humm.'

I nodded again.

'Humm,' she muttered again. She wanted to know all about me, the A to Z of my life in India, London and Metz, Madame Capitaine did. 'I'll give you a show but I am booked up till next year. Write to me from London …'

It took all of an hour.

On my way back to Gare de l'Est, I telephoned Ravi Kumar from a public booth. He asked me over for a coffee and told me how to get to his apartment in the fashionable 16eme. Instead of coffee, the handsome 30 year old and his beautiful young wife Françoise cracked open a bottle of champagne. It was the beginning of a long and beautiful friendship. After that, they dropped me back at Gare de l'Est. I was in Metz just in time for dinner with Maman's speciality and TDF garlic snails as starters – I could smell them from the station. Ten days later, a Saturday, I was in London at 8 pm, eating with Billa his speciality, a sausage curry. I shared his room, sleeping on a mattress on the floor, no problem.

. . .

I was sent to a convent in Archway to replace an English teacher on maternity leave. In 5C, I had a score of 16–17-old lovely beings in viridian-green uniforms. They were staring at me as if they had never seen a man before. I had never seen so many beauties before either. Salivating as I was, I was also terrified. I wanted to run, climb over the twelve-foot convent wall and dissolve in the air. The girls sitting in the front row facing me did not know what buttons of their green blazers and white shirts were meant for. They were doing the Romantic Poets, Keats' 'Ode to A Nightingale'. I loved Keats. I could recite

his ode by heart. After the register, I began my first lesson ever as a teacher reciting:

'My heart aches and a drowsy numbness pains my sense as though I had drunk some opiate, or ...'

That seemed to be a good start, though my knees were trembling. While doing the register, I got to know the names of a couple of the girls in the front row. Then I devoted about ten minutes of word-foreplay about the young poet's sad love life and tragic untimely death. After that I stood up to start reciting the rest of the famous ode without looking at the book in hand. I was interrupted.

'Are you married, Sir?'

'And Keats lived just a mile away from here in Hampstead.'

'Are you, Sir?

'Shut up, Rachel. Sir is trying to teach us.'

'Only asked a simple question.'

'A silly question. Sir is too young to be married.'

'Keats was only a few years older than you all when he wrote this ode.'

'What is an ode, Sir?'

Before I could answer, in walked an apparition – a nun with a beautiful face and in her all-black habit. The girls stood up, pulling their green blazers over their breasts and buttoning themselves up in seconds. All that was noticed.

'How are we getting on, Mr Khanna? I was passing by and thought I would just look in to see how you were getting on. Everything all right?'

'Yes, Sister Inez. Perfectly all right.'

'Sit you down, girls. Sit, sit, sit. And what's the matter with your dress sense, Rachel?'

I could write a whole book about my two weeks at the convent. But I shall desist and move on with my own story.

. . .

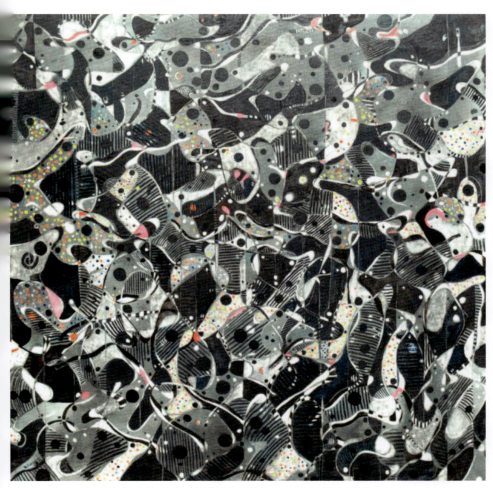

Nairobi Night, 1970–71, oil on canvas, 152 x 152 cm

Next came flat hunting. I got telephone numbers galore from the ads in the newsagents' windows. My interlocutors, landladies, landlords, caretakers et al were warmly friendly and said come take a look. But when I turned up in my best suit and polished shoes I was told, with utmost politeness of which only the English are capable, that the flat had been taken. It went only a few minutes ago. My former tutor Paul Vernon was apologetic on behalf of his race. But Dr Singh and Billa said:

'Develop a thick skin and carry on. You'll get there.'

I did. Or rather, it was cricket that did it.

I got the number of an agency in Hampstead. West Indies were playing at Lord's for their second Test. The person who answered, a man, was obviously a cricketer – he was listening to the cricket commentary on his wireless. I couldn't resist asking him about the state of play. Now when two cricketers get together even on the telephone, what do they talk about? Cricket, lovely cricket.

A two-bedroom semi-furnished flat was going in a side street off Finchley Road half a mile from Golders Green at 30 quid a month. If I was interested, estate agent Jamie Ferguson would be 'awfully pleased' to meet me there, say, at four that afternoon.

We met. I was awfully pleased to meet him, I said over a good handshake. And I really was. The flat was a bit basic, but it had all the bare necessities of life, including the all-important telephone. For euphoric me, my new flat was my castle and I its lord, awaiting the imminent arrival of his lady.

Bibish arrived very early that Saturday morning after a 12-hour rail-ferry-rail journey with a French baguette sticking out of her shoulder bag. She hadn't slept a wink. But the French, very French girl looked fresh as the morning dew. Reaching our new home, we went straight from the taxi to my unkempt bed, two desperately hungry wanderers in the Sahara had spotted an oasis. Our thirst quenched, at least for the moment, we slept an hour in each other's arms.

The young, very young French wife of mine had a long shopping list. Top of this list were new bed linen and cleaning agents. A jar of coffee and one of Bonne Maman jam she had brought with her and the baguette for our breakfast. Tired as she was, yet she wouldn't rest till the lino of the floors was scrubbed to French standards – spotlessly clean. At one, we took a No. 2 bus to Lindy's for lunch, full to the brim with puppy love. We would look for bed linen later.

. . .

Maman brought baby Nathalie over. I went to the BOAC terminal by Victoria to receive them and bring them home. Maman stayed with us under a week; she had to get back to work in Metz. It was a week of culinary delights dreams are made of. I ate like a grand Seigneur and was sorry as a clochard when I took her back to the Air Terminal and saw her coach off. Time had come for me to retrieve my paintings from Dr Singh's basement – I had room for them now in my dacha. I hired a driver-van and turned up at 797 Finchley Road. But where were my paintings? Not where I had left them in my friend and ex-landlord's moist basement. The damned place had got flooded while I was lapping up my mum-in-law's matchless cuisine in France. It never occurred to my former landlord to move them to somewhere dry. Whatever the weather couldn't claim was taken away by the landlord's itinerant tenants, people coming and going from rented rooms. The impressive body of work that I had produced in those two years had just disappeared. I never saw any of it ever again. Paintings of those two years of my life went up just like that not in smoke, but in the fumes of Indian indifference to modern art (Picasso? Rubbish. Braque? Who he?). Not the end of the story, though. For when I went to India House to reclaim my six or eight paintings exhibited there during the IPC's acclaimed show of November 1964, not a single employee of the 2,000 strong work force of India House knew what had happened to any of my paintings. Not even my wonderful friend

Salman Haidar. Someone somewhere in this beautiful country is sitting on those eight beautiful paintings, one of which had caught the eye of a beautiful lady by the name of Tallulah Bankhead.

At least I had brought back with me from France all those I had painted in the last six months. So I had something to show to that duo of critics, Denis Bowen and Kenneth Coutts-Smith. My fellow artists of the IPC had told me that the New Vision Centre run by those two important art critics had a very good reputation for that reason. I knew the gallery well. I had once gate-crashed a party there. In Seymour Place behind Marble Arch in central London, it was easy to get to.

I made a hefty roll of a dozen plus paintings and just turned up there one fine morning at 10. The gallery was firmly shut. As all the surrounding businesses were open, I concluded that its owners would soon turn up. I walked up the street, then down a couple of times. I was spotted from a first-floor window where apparently the two gents lived. One of them, Denis Bowen, having recognised me, came down and let me in. He was followed shortly after by his friend. My heart got jammed in my throat as they inspected my wares one after the other – 'will they, won't they like what I had offered?' They did not utter a word for the next ten minutes. Realising that I was half in the grave of suspense, Denis Bowen broke the ice,

'Let's go grab a coffee and talk.'

I could have kissed his several days' designer stubble. We left the paintings where I had laid them out and went to a café next door. We talked. They gave me a date in October, asking if that was too early? Did I need more time? No, I did not need more time, having enough work to exhibit tomorrow. I would have the downstairs' gallery – an Italian, a senior artist Luciano Latanzi had been promised the upstairs one. Coffee drunk, deal done, we ambled back to the New Vision Centre for me to take a look. My space was the stairs leading to the basement, a tiny hall and a room measuring all of 15 ft by 15 ft. For me it was like having a room all to myself in the Tate.

'Small is beautiful as they say,' said Denis with a naughty smile. 'But don't worry. For you are going to have a much larger space very soon.'

Then he explained what he meant.

'We are organising the 2nd Commonwealth Biennale of Abstract Art to take place shortly in London. It will be held at the Commonwealth Institute's huge Gallery soon after your opening. We think you should be representing India along with Rama Rao another artist from your IPC. How do you like that?'

'Now go home and start painting for that. Bigger the better,' Kenneth said.

'That's a challenge for you, young man.'

'I like nothing more than a challenge, Denis.'

'That's the spirit.'

. . .

Reaching home, I picked up baby Nathalie from her pram, gathered Bibish in my arms and kissed them and kissed them and kissed them till Nathalie baby started to protest with a long howl. The first person I rang after that was Francis. He was absolutely delighted to get the news.

'I knew you'd be all right'.

Then I phoned Avinash. He morosely just said 'good for you'. I loved him so much, I could have done anything for him and he only said 'good for you' in response to the biggest news of my just-begun career. Suddenly, it dawned upon me that he was not the sort of person who likes to hear of anyone else succeeding. The realisation gutted me – I had placed him on the highest pedestal. Next, I spoke to Billa, Dr Singh and the other old friends at 797. Jubilant for me, passing a bottle of Rioja around, they danced the Bhangra with me in the middle when I went to 797.

I had learnt how to prepare canvases to paint on from Francis. With a bit of self-taught carpentry, I began to assemble large canvases and

realised how I loved working on large scale. The sensation reverberated in me.

My preoccupation still was landscape as I had painted in Metz. Trees fascinated me and looking up at the foliage through sunlight and falling rain and water and the mother earth upon which I stood, entranced, surveying all that I beheld. But since the death of my father, there had seeped into my palette a certain change. At first, it was sombre, but soon, without my being aware, it became dark. Suddenly, I was painting rather stark pictures.

My show at NVC opened to a full house plus. The 15 ft by 15 ft room could contain only so many people. The others had to remain crushed in the small hall outside it and the stairs. By contrast the large ground floor gallery which the rather dour Italian artist Luciano Latanzi had was strikingly bare and just as 'spiritless' as Souza described his paintings. There was hardly anyone there. Everybody was rushing downstairs. Wine there was a-plenty, the noise, therefore, deafening. Yet everyone seemed to know exactly what they were talking about – the famed cocktail-party-syndrome functioning handsomely.

With the exception of Avinash, everybody I knew came and many more whom I did not know. Grand old Eric White came looking as distinguished as ever.

And surprise, surprise, the difficult art critic W.G. Archer (or Bill Archer) turned up against all expectations and said something staggering:

'You are not the artist I saw with Avinash. You have matured phenomenally and in so short a time. Well done, Balraj. I like your new palette.'

Paul Vernon came with three friends from King's College where he had been teaching ever since he left my university in India. ACGB's Hugh Shaw came with the painter and graphics designer Gordon House. With Hugh was his charming secretary Patricia Claussen-Theu (she bought a blue painting for £40). All my IPC fellows came too

… and my mentor Francis Souza. He was accompanied by an electrifying very young, almost teenager blonde, Barbara 17, he had just got married to. The lady killer had not uncharacteristically ditched the lady I had met at his doorstep one bitterly cold foggy-smoggy morning all that time ago. But gallantly, the gentleman rake had given her and their three primary-school daughters the garden flat of his big house in Belsize Park overlooking the church he had painted so many times. He had taken over the upper two floors of the same house for himself, his studio and his new bride.

It was a fun evening, an evening to remember. And it was long, deliciously long. Finally, when it was over, Francis invited all present to his studio in Belsize Park to continue the party. Except seniors like Eric White and Bill Archer, we all – artists, critics and the humdrum trooped across from W1 to NW3 by bus, car, and taxi.

Himself a total teetotaller, my friend had laid on a pre-bought supply of booze and music. Barbara came and sat down with Francine. The two girls talked. Then they drifted away. As I took it all in my stride sitting down on my own and watching the revellers Twist, the dance of the decade, a young woman came and sat in my lap, an electric shock. She put her arms around my neck and declared I was the best looking of all the men in the party. Though music to my ears as it would have been to any man's, I pretended not be too flattered.

'What about him?' I said, pointing to Francis.

'Urrgghh! He's ugly, you are the handsomest in the party.'

'And you are the prettiest,' I lied.

'Can we go somewhere after this?'

'I'm afraid not. I'm married.'

'So am I.'

I disentangled myself and rose. Francine had come back and I took her to the floor. Ten minutes later, I saw the same woman sitting in the lap of the Italian artist, her arms around his neck. Soon it was time for us to go.

'Not going, are you, Balraj, just when things are hotting up?' Francis shouted across the room.

'We have a baby-sitter to relieve, Francis.'

. . .

The Commonwealth Biennale was largely a white Commonwealth affair, consisting of artists mainly from Australia, New Zealand and Canada. Then there were two from India, myself and Rama Rao, both ex of the IPC. Also there, were one or two artists from the West Indies.

At the somewhat effusive opening, the £50 prize donated by Lord Croft for the best artist in the show, went to my fellow countryman Rama Rao. Present in the sizeable audience was none other than my new hero, W.G. Archer. It gave a tremendous boost to my self-confidence to be told by the great man that my paintings outshone all others in the big show. He was unimpressed by the award of £50 and said rather ungenerously that Rama Rao was 'a rat' (Rama had been to see Archer and had 'pestered' him with a catalogue of grievances and pleas for help in his career, something Archer despised).

My other reward was a photograph with Francine in the *Commonwealth Today* magazine. The show led to something soon after the opening – a letter from a West End gallery, the Anthony Tooth Gallery, offering to take me on if I was free. I was invited to a meeting at the gallery by its owner, Anthony Tooth.

The same evening, two visitors arrived at my door. They were my old friend, the now newly-married Salman Haidar, and his striking-looking wife Kussum, a Hindu. Salman had come bearing 'wonderful news'. A gallery had contacted him and asked for my address. Had they been in touch? I showed him Mr Tooth's letter. Salman had also brought a bottle of wine. We had a hearty hug and raised our glasses in a shower of smiles all around.

I had already spoken to Mr Tooth and arranged to see him the following day. The Anthony Tooth Gallery was a long lower-ground-floor

room of a smart shop in quiet Maddox Street off the roaring Regent Street W1. Tooth was a tall mid-forty public school product with greying sideburns and impeccable manners. Every time he spoke, he ended the sentence with a little laugh and the word 'What?' We got on well with each other straight away. The only other presence in the gallery was his mother, pushing seventy and, his dog, Basset, a cocker spaniel.

We had an hour-long meeting. The upshot of which was a full-blown show for me to be held in June, giving me a good six months to prepare for it. He would like to visit my studio asap to talk further. 'Would the weekend suit, Balraj. What?'

'Perfect, Tony. Sunday at six. I'll give you a drink. What?'

We had a shake and a laugh.

Thereafter, Tooth visited my studio often to see how I was getting on. A few weeks before the show, he came with a man he introduced as Sheldon Williams, a renowned art critic. Williams had a weekly column in the Paris-based Herald Tribune and he wrote for some British publications, too. He had seen the Commonwealth show and said he had liked my stuff. In between, I did something I had been longing to do ever since I had first set foot on English soil. On a hot summer's day, I took a trip to the Lake District in honour of my two great favourite of English poets, William Wordsworth and Samuel Taylor Coleridge. Dr Singh took me there in his old banger. From Tintern Abbey we went to as many other landmarks I could think of, I drawing every moment of the day. Back in London, I had filled up quite a few canvases from my notes. These were pictures full of incident and atmosphere.

Sheldon spotted the lyrical aspects of the landscapes and said, 'That was a day well-spent, Balraj, in the Lake District.' Souza said exactly the same when he came to lunch with Barbara one day.

Looking at a long canvas in greens and yellows populated with vertical leafy elements he said, 'This looks like a grass hopper's

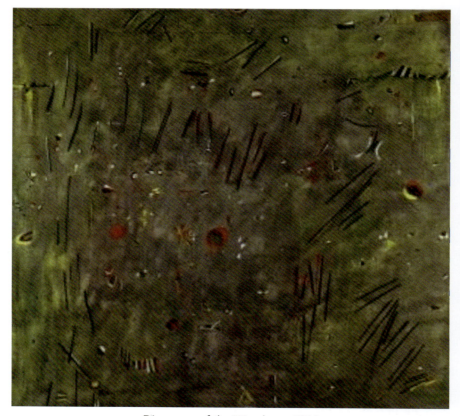

Discourse of the Wanderer, 1966

eye-view.' (I have still got that painting along with a few others of that memorable visit to the Lake District. A few have been sold by Sotheby's over the years).

Well, well, well.

The show opened on the 8th of June. The High Commissioner couldn't come to the Private View due to another engagement, but he came a day earlier in the afternoon, an honour as diplomat Tony Tooth put it to him, and it was an honour. However, he dispatched his deputy high commissioner to attend the Private View. P.N. Haksar became a close friend in due course. He was chosen as Indira Gandhi's PA when she became Prime Minister of India a couple of years later. He introduced me to her at a prestigious reception the High Commissioner

held for her in his house in Kensington Palace Gardens. Amazingly, she seemed familiar with the Delhi art scene and asked me at length about my painting. Amazing also was the party itself. For I got talking to a very tall gentleman who introduced himself as Brockway. Not as John, David or Peter Brockway. But just plain Brockway. He kept referring to my mother who had done this with him here or said that to him there. I was puzzled. For my darling mother spoke not a word of English nor had ever set foot in England. Then the fellow said something and pointed to 'my' mother in the throng, Prime Minister Indira Gandhi. We all knew that her son Rajiv Gandhi was an apprentice with Rolls Royce at the time. The gentleman had mistaken me for him. I learnt later that the tall fellow was Lord Fenner Brockway, a very important member of the party. But I was not a little amused to be mistaken for a Prime Minister's son who would one day step into her shoes and like her, be assassinated by fanatics.

But back to my show, Peter Townsend, Editor of the influential *Studio International* reproduced one my paintings in his magazine and after lunch at the new tandoori Restaurant, Kwality near his office, we became life-long friends.

The critic Sheldon Williams of the already mentioned *New York Herald Tribune* did a flattering review in his paper.

The *Telegraph* said in its London Day By Day column that my paintings seemed to have been done by an Indian Canaletto. *The Indian Statesman* went to some lengths in praising my art, devoting most of its London correspondent's weekly dispatch from London to my work. *The Arts Review* carried reproductions of my pictures as did *Art and Artists*. Above all, what gave me the greatest pleasure was what W.G. Archer said: he would arrange a show for me at Oxford's Ashmolean Museum, the most august museum after the British Museum.

Meanwhile, my new friend Ravi Kumar of Paris got me an invitation from his brother, Virendra of Delhi's Kumar Gallery to offer me an exhibition there in the New Year.

When the London show came to a close, we packed our bags to decamp to France for the summer. In Metz, the warm-hearted 35-year-old successful businessman, Jean Kieffer, again generously placed his large and sumptuous house with a huge garden at our disposal, and went to live with Claudine in her apartment in suburban Borny. That summer, France had what the French call a *canicule*, an unbearably hot few weeks.

This suited me admirably. It meant work, work, work which I loved above all else in the world beside my little family. I girdled my loins, as wrestlers say in India, to get cracking downstairs in the large concrete Kieffer garage with one small window with iron bars for light. By the side of my concrete bunker across a pathway, Jean had erected a chicken wire enclosure 18/20 foot square. It housed his newly-acquired pedigree puppy he called Blakey, and a huge exotic bird with a long colourful tail he had recently brought back from military service in Madagascar. A telephone booth-like shed was its abode kept warm by an electric heater for the African creature. This was accomplished by an electric wire going through my window which dangled into the tropical bird's booth. It was my duty to give the two food and drink every day. I loved to have them for company. In its own way, it was inspirational – man and bird and beast together!

Also inspirational was where I found myself to be – in the great medieval cathedral city of Metz. It floated on history on the banks of the meandering Moselle and it peeped over Germany, France's historic foe. On Sundays, we all went for a three-hour-long lunch at a country inn by the river. It was a delectable family ritual, a must for most French families.

But I had to make a day trip to the equally delectable Paris to show my new work I had brought from London to Mme Capitaine. I boarded an SNCF train first thing one morning for a remorseless three-hour journey to the French capital.

My work was all landscape-based. Mme Capitaine was bowled over by it. For a chat, she took me to the famous La Cupole a couple of hundred yards away in the renowned Blvd Montparnasse. We sat on the pavement terrace over a very strong coffee she said she loved. The Indian in me didn't – we have a sweet tooth. But I loved what she said about my paintings, music to my ears and sweeter than any mithai. Rubbing her fingers to make a point about their *'finesse'*, she offered me a show in October. Taking leave of her, I rubbed my fingers but with joy. For that meant I had much work to do starting from tomorrow, and much to look forward to from perfumed Paris to delightful Delhi.

I spent a good few hours in the company of my friend from Delhi and his film star of a Parisienne wife Françoise. They took me around the city's magnificent boulevards and comely rues in their gleaming new Volkswagen. When we saw the sun set on the virgin white Sacré Coeur, making it blush, and upon the impassive crown of the city's most famous monument, the Eiffel Tower (wherever we went it came with us), they dropped me at Gare de l'Est. Three interminable hours later, I was in the ivory-pale arms of Bibish with angelic baby Nathalie fast asleep in the pram. I couldn't wait for the morrow to invade my 'garage studio'.

. . .

Many a morrow came and went. Also came, and it continued to come, was work. I knew not a soul in the grumpy old city of Metz which had been a German territory since the Franco-German War of 1860 which the Hun had won. It reverted to mother France in 1918. Older people in Metz still spoke German, the language they had been brought up with. Early every morning I went down to my 'studio', the brutal-concrete dark and dingy garage with a 60cm window just below the ceiling. I painted till lunch, singing loudly old Indian songs, the heart-moving numbers of immortals Mukeksh, Mohammed Rafi and Talat Mahmood.

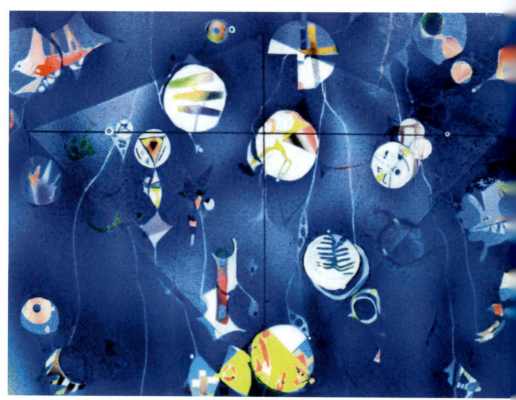

Blue, Blue, Blue, 2019, acrylic on canvas, 36 x 34 in.

Then I came up to play with Nathalie, as beautiful a baby as was ever born, a perfect subject for a renaissance-masterpiece. Her grandmother and aunt bought the most exquisite clothes for the most huggable child and everybody's favourite in the neighbourhood. Her mother dressed her with care, playing and singing. Soon after, she was put in her cot for her afternoon do-do, and I went down to carry on working. I came back upstairs about six when I heard her cry – she had woken up and was hungry. I was not hungry. I was thirsty . 'O for a draught of … the warm south' in my case, for a drop of Scotland's greatest contribution to art, science and literature – guess what?

To repeat what I have already mentioned, I was happy as a pig in a pool of mud.

The weather changed. August brought clouds and rains. Francine was getting bigger with our second child. My Paris show was fast approaching. I was working like mad. (Years later, my first literary agent, brilliant and beautiful Yvonne McFarlane, once said that I was a man driven. I asked if she was insulting me. No, she replied. 'It's a compliment.')

Then one day, Jean took off on a business trip to Eastern Europe with two business associates. Travel and business restriction between Western Europe and countries behind the Iron Curtain had just been relaxed. All three were in the same meat business on a large scale – all three had immense cold storages. The three friends were going to Romania far away. They went in Jean's big black DS, a French limousine with a distinctive design. Late the same afternoon, I heard the habitually quiet bird from Madagascar start screaming and howling. Alarmed, I took a look from my little window. What I saw stunned me. Little Blakey had got his neck entangled in the lose electric cord dangling inside the enclosure and was going round and round in a deathly frenzy to free himself. The more he tried, the more trapped be got. And the beautiful bird was in equal frenzy, screaming his beautifully feathered head off to draw attention from the house to free Blakey from his death trap. I dashed out to find out what was going on. Instantly,

I reversed the chord's entanglement and managed to save the poor little beauty's life. The bird instinctively knew that the little beast was in serious danger. Only a human being could save him. It was a most amazing and deeply moving spectacle involving man, bird and beast. Moving and touching. A memory that was to live with me forever.

A couple of nights later, we heard the little dog wail loudly in the dead of night. This was bizarre – he was well fed by me, and had played chasing me in the garden and just being himself – a happy little doggy. There was no earthly reason for him to howl so, as if he was in deep pain and was crying. The morning brought an immensely baffling sight – the door of the chicken wire enclosure was wide open and both the bird and the dog had disappeared. I could have sworn that every evening I had firmly closed the door after feeding them.

I really could have sworn that I had shut the door and bolted it from the outside as I did every night. Somebody, a mischievous neighbour or a wicked night prowler had obviously opened it and left it open on purpose. Shocked and mystified, Claudine and I drove through all streets in the neighbourhood and beyond, asking everybody if anyone had seen a beautiful exotic bird and a little puppy. But no one had.

Then came the most awesome, horrendous and the most tragic news of all – there had been an horrific road accident in Romania involving a French car. Very early that morning driving at 120 kilometres per hour, it had crashed into a tree by the roadside, instantly killing all three of its occupants. The driver, apparently, had fallen asleep at the wheel.

The dog, the bird and the death of three men – I never understood if there was a connection. Animal and man and natural intuition! I have been wondering ever since.

. . .

The show in Paris was a breath of the good French air for me, making me say *'vive la France'*. It fetched me some fortifying good reviews

and a delightful eight sales. They were mostly of small paintings but with two biggish medium-sized bought by Ravi Kumar's friends, the American Literary Agents Donald Kongdon and his wife. However, the best part of it was Ravi confirming my show at his brother Virendra Kumar's gallery in Delhi. It would take place in February of the New year, 1967.

With a few francs in my pocket now, I returned to my wife Francine who was growing more bulbous with our second child. But I had business at hand – the forthcoming exhibition in Delhi in the not-far-off February of the New Year, it gave me just enough time to make new work for the show and rush back to Metz in time for the imminent birth. So off I went to India by the cut-price Syrian Arab Airlines recommended by Ravi.

. . .

I must pen here a few words about my stay of six weeks in the country of my birth, upbringing and character-forming. The first person I telephoned was, of course, my old mentor Mulk Raj Anand, now become Chairman of the Lalit Kala Akademy, India's foremost art establishment. The first thing he said to me was, 'You have got an Oxford accent.' It made me laugh. W.G. Archer had obviously written to him about me. Anand was visibly pleased when he saw my paintings. After that my old chums like the ever-charming Pat Rai, Prince Harry and brilliant Salman Haidar now with the Ministry of Foreign Affairs, joyfully took over. My days there then just flew past in a flurry of dashing from my home in Karnal, to Delhi, Chandigarh and back in endless sessions of hugging and laughing and tears at meeting and then at leaving.

Among other memorable occurrences was meeting the novelist V.S. Naipaul.

Haidar asked me out to lunch one day, saying I would meet someone interesting. The lunch was at an ultra-trendy joint, La Bohème, in the

metropolis's throbbing commercial heart, Connaught Place. There was the Bombay gallery owner, the tall and imposing Kekoo Gandhi I knew. And there was a diminutive huddle of a man of dark hue and small gimlet-eyes, the great novelist V.S. Naipaul, all whose books I had read.

Obviously, I was delighted to meet him, and he was no less pleased to know of my admiration for his work. (We began to meet regularly after that during his short stay in Delhi. He was on way his back to London from Tokyo where had been sent by *The Times* to interview a Japanese nutter, one Mr Matsuda, who had bought a whole-page ad in *The Times* for a reported £25,000 about something faddish or the other. (Imagine that in 1967 – £25,000! – the fellow must have been a total utter nutter, presumably the reason why he was never heard of again).

We had a superlative lunch with the great man eating well – we all ate well and talked a lot. Later, Naipaul went to see my show and remarked I was too young to be so successful. Nonsense, I replied. I met him several times after that and I introduced him to several of my well-heeled friends like Pat, his cousin Punnu and two more of their chums. One of them owned a very long black Buick. VSN liked being taken to lunches and dinner with us. We all felt flattered and honoured. But one thing we all noticed, but left unsaid, was that the famous fellow always trundled off to the loo when the waiter appeared with the bill.

My show attracted excellent reviews, an outstanding one was by Charles Fabri of *The Statesman*. Good sales followed. I wanted to stay on in India, but I had to dash back pronto, pronto. For Francine was ready to deliver any day. It became any time as I enplaned from the Palam to Orly for our second child. I arrived in Metz twelve hours too late for the birth. The new-born, a girl, had to be named straight away according to the French custom and law. Francine gave her my mother's name Kaushaliya, a lovely name, also the name of God Rama's mother. It would make her popular in India just for that

reason alone when she grew up. Her looks placing plenty of icing on the cake, as it were.

. . .

I used to keep a journal, a page or two every day. I couldn't but dwell on my meeting VSN in those pages. My abiding memory, already mentioned, is of him ducking the waiter with the bill approaching. This trait of the great writer was corroborated by others equally well-known in the London literary world I came to know subsequently. First by Eric White, of course, then novelist Harry Hoff (pen name William Cooper), poet, and the editor of *The London Magazine*, Alan Ross, among others.

I met Naipaul only once after that – at Prime Minister John Major's memorable dinner at the Banqueting House in Whitehall in honour of India's Independence exactly thirty years later in 1997. Admittedly, it was a long time after our Delhi meeting, yet I don't want to miss the opportunity of writing about one of the greatest writer of our times. For such occurrences are few and far between.

The PM's dinner was a Black Tie or National Dress affair. The great dining hall adorned with a magnificent Rubens ceiling had seating for three hundred only. Spouses, therefore, were not invited. Even ex-PM Margaret Thatcher sitting two tables away from mine was without Dennis. There were two exceptions though. They were the newly-married V.S. Naipaul and the newly-ennobled Swaraj Paul. They had insisted on coming with their wives, I was told by a disapproving organiser.

VSN and I said hello each other over drinks at the Reception. He was well-familiar with my name, he said, but admitted he had forgotten meeting me in Delhi thirty years ago. That was understandable – I am known to forget meeting people only a week ago.

While I sipped the good Prime Ministerial champagne, pretty good in fact, Naipaul and his newly-acquired young wife drank orange

juice. The latter being Muslim and the former a well-known party-pain-in-the-ass. The novelist looked cartoonish, more like one of the waiters hovering around in a black bow tie. His wife looked rather glamorous by visible contrast in a green Muslim outfit, not a sari. They made an incongruous couple, more so when one realised how deeply the fellow derided Muslims in his writing. It was said that she had married 'the novelist, not the man'. That historic occasion is memorable for me for I very nearly missed the damned dinner.

It was a black-tie affair. But I did not have a dinner suit. However, my publisher Miles Huddleston (Constable) and a great friend of my height and build, had one. He loaned it to me. When asked for the black bow tie, Miles said it was in one of the pockets of the jacket. As it happened, I did own a lovely silk shirt. Come the Big Day or rather the evening, I shaved, bathed and got suitably spruced up to kill. The tie which was in a jacket pocket was there all right, but it was one which you literally had to tie into the right knot. And this I did not know how to do. I made a dash across the Mews to neighbour John Ball formerly of the Foreign Office who surely knew how to tie the damn tie. But he was not in. John's blonde wife Jill and I ran hither and thither, but found no one who knew the secret of tying a tie; just a piece of cake for every public schoolboy. But none of my neighbours was the type. My breaking bread with the PM was off. I was heartbroken. Just when I was ready to throw the towel in, as they say, and was about to call the whole thing off, Jillo had a brain wave,

'Balraj, you can always ask a waiter to lend you his.'

'Jillo, I can't do that. I'd look a fool.'

'It's that. Or ... But wait a sec,' she yelled, spotting a builder on a scaffold. She accosted him loud enough to make the poor young fellow fall off the lofty scaffold. 'Russell, do you know how to tie a bloody tie?'

'Of course I do. Had to do so at school every morning, didn't I?' Young Russell, an Australian public school boy now working as a builder in London, saved my life. The Prime Minister would yet have

the pleasure of my company at dinner after all! And the great waiter VSN.

. . .

Back to the family hearth and home. My new babe named lovingly after my loving mother Kaushaliya, filled our lives and our temporary French home with spring sunshine. Like her two-year older sister, the ever-howling little wonder of nature was another perfect model for any great renaissance painter. She inaugurated another super summer in France for me – just holding her against my chest, just being there felt good and inspirational. On another level, France's culture fascinated me. The naturalness of its prowess to exuberate matchless fashion and chic, to-die-for food (foie grass) and the poetry of its wine (champagne) exalted me.

In Delhi recently, Naipaul had confessed to me in passing that he wished he was born an Englishman. The man of many contradictions and inferiority complexes had his own reasons for saying that. Here I had no such complexes – I was too happy in mine happiness as an Indian married to a French girl and living in France. It did not make me wish that I born a Frenchman.

Soon, too soon came the time to return to England with my young family. Again, I came alone to deal with the degrading prospect of looking for a flat. It was degrading because of the newsagents' racist window notices exactly as I had encountered them in my first week here. After knocking my head against a few brick walls, and finally finding a rather nice two-bedroom flat on Hendon Way NW11, I went to see my great friend and mentor, Francis.

I had not seen him for a couple of years. During this time, quite a few changes had taken place in his life. And they were more than little seismic changes. He had left his middle-aged concubine Lisalot and the three daughters he had sired with her, abandoned them more like. He had set up home with a luscious 17-year old Irish beauty,

Barbara (who had to obtain her mother's written permission to tie the knot with him in a registry office.) The old rake had occupied the top floor of his big house which had now become his and his new catch's living quarters, while his erstwhile family occupied the basement. It was an odd, even bizarre arrangement. But it seemed to work. We wined and dined each other, FNS, sticking to his teetotal-ism. It was here that after lunch one day, he put a black and white film on his projector. That was the first and last time I watched a mind-blowing pornographic film – Francis and Barbara giggled all through it and Francine was half buried in embarrassment.

Winter came and it was time once more for us to go to France for Christmas. As usual, a lot of work happened, I say 'happened', for this was how my painting worked. Singing, often loudly, I painted in the concrete bunker of a studio in my belle soeur's garage. Then the following summer, I had another show in Paris. From then on, I continued nonstop with my brush and palette exploiting little mishaps and accidents in my work as I went along, and incorporating them in my work. Suddenly, I realised that my abstract forms derived consciously and unconsciously from landscape, were beginning to change. I began to paint landscape not how it appeared to me, but what it made me feel as I looked at it, say, for instance a mustard field (there is a painting). This was an instinctive process. Similarly, I began to be more interested in and attracted to the microcosm than to macrocosm. The seed in a newly-ploughed earth about to sprout into a living green shape held greater fascination for me than the bush, the trees and the visible valley. I never really quite understood that, but more importantly felt it appealing to an inner something in me.

On a human level, as I delved further, this inquiry began to reveal associations with human forms that were not directly recognisable. This was in certain ways my response to my visit to India where like the rest of my family, friends and Indians on the whole, I had remained impervious to the Indian Condition as I like to call it

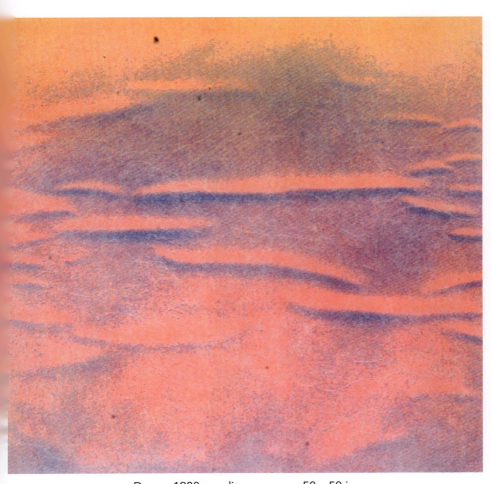
Dunes, 1980, acrylic on canvas, 50 x 50 in.

(poverty, untouchability, sectarianism and the like), humming around like distant sinister sounds. In due course, this would lead to something more meaningful – the ever-present *Human Struggle*.

Still in Metz, I also took to the pen, my original love for the written word brimming out of me. I had started keeping a journal. While I recorded my daily existence and wrote about the curves and angles of life around me, I also began to revive submerged memories of my life in India from my childhood onwards. I more than loved the exercise. Soon these began to morph into short stories that were directly derived from dormant memories of my childhood and youth in India. I sewed them together like a garment and the result was a sort of novel which became funny, soon very funny, as I wrote more. I used to laugh to myself like a lunatic as I evolved my very personal brand of humour. When time came for the young Khanna family to return to London, I had a roll of new paintings under my arm and a nascent novel in my hand.

It was September of 1967 and signs of autumn were already everywhere around my sister-in-law's big house, yellowing grass and wind blowing dryly. In London, fiercely pollarded leafless trees stood as guards on street pavements presenting a uniquely macabre, even haunting sight like the one I had encountered immediately after my arrival in London five years previously. I had never seen trees like these anywhere else.

Again, I came back here first. I stayed with my old chum Billa in Golders Green, the best cook in the vicinity renowned for his curried lamb trotters and TDF lamb bhuna gosht. On my second day in London, I went to see my other great friend Francis Souza.

While we were away in France, a lot had happened in my valued friend's life, a veritable earthquake. In Belsize Park, he had been leading a peaceful albeit somewhat disjointed existence with his one-time 'wife' Lisalot and three daughters in the basement, and himself with his child-wife Barbara on the top floor. Strange it might have

been, it was peaceful nonetheless. Peaceful till a bolt of lightning from the blue yonder tore it apart – bankruptcy and the loss of the house. Whatever happened to his former mistress and his three very young daughters, he did not disclose, but luckily for the lothario, he had in better days purchased for a few hundred pounds the tail-end of a lease on a flat in a grotty mews tucked away in Maida Vale a couple of miles away. That was his love nest which now became home to the master painter and his delicious muse. She was there, of course, but with another girl, her sister visiting from Ireland I rightly presumed.

'How nice to see you, Balraj! But why didn't you write you were coming? And what are you doing here?'

'Handsome as ever, the rascal. Isn't he, Francis?' mused Barbara.

'But what are you doing here? I thought you had settled in France, Paris perhaps. But what are you doing in this Godfuck racist place full of pansies, this England?'

My friend was in a foul mood. I had chosen the wrong day to visit him. I'd better be making my exit pronto, pronto. I said to myself.

'But Francis, I thought you loved this place. This beautiful England.'

'Anyway. What are you doing here?

'I am looking for somewhere to live.'

'You don't say?'

'I do, Francis.'

'You can have this place. Our little flat.'

'You don't say, Francis.'

'But I do. I've signed a contract with a gallery in New York and am flying off to the Big Apple in a couple of days.'

'How wonderful.'

'I'm sick of this shitty place where no one knows what art is. Including all its so-called art critics. Especially these supercilious bastards. Especially. Take the man of the *Telegraph* for instance. And the poofter of *The Sunday Times*. Constipated colonialist snobs. Racists to the last drop.'

'But you are a highly respected artist here. You have a book written about you by Edwin Mullins no less. And you have said on the back cover of it that you 'make more money from your painting than the Prime Minister does from his politics. You have …'

'That was said in an unguarded moment of bravado. We all have such moments. But read what critics like David Sylvester say about me. And what the *Telegraph* shit writes about my last exhibition of black paintings is that any significance they might have is the fact that you cannot see anything in them. That is the best way these fucking English critics have to say about my great work. Racists all. Their DNA.'

'You have a painting in the Tate, Francis.'

'So what? It was not bought by them. It was given to them.'

We were getting nowhere. My friend was deeply embittered. Molested by circumstances (mostly engineered by himself not for lack of talent, but for limitless abundance of ego and bravado), he felt events were contrived against him because he was an Indian upstart daring to succeed while swimming against the tide that was the Britishness. Or rather, English. He and his ilk had no place in it. They never had, nor would they ever be given any. My mentor and friend was a man wronged, deeply wronged by forces of impossible odds arrayed against him. He was a man abandoned by all those he thought were his friends. Especially his so-called critic friends, the Sylvesters, Mullalys, Russells … Thanks to them, his recent shows had been abysmal failures. He hadn't sold a thing.

The painter with a big mouth who made more money from his painting than the Prime Minister did from his politics was not able to pay the mortgage payments on his big house. Result – bankruptcy, which the shattered great artist said was a result of a barbaric conspiracy to destroy him.

I felt sorry. Deeply so. But here he was with a new young wife and evicted from his mansion to bum his life in this quaint little hovel. But luckily for him an American gallery owner had come to his rescue and

offered him a contract to pave for him a bright future in the world's greatest city of bright lights.

'I'm going. And this place is yours for thirty quid a month starting from today …'

'What about …?

'Oh, Barbara? She will stay on here with her sister for a few days to sort things out …'

'Are you serious, Francis?'

'At thirty quid a month the place is yours. Fully furnished with a brand new carpet.'

An improvised lunch materialised at his oak dining table courtesy of young Mrs Souza. The painter informed me that the table was an acquisition, along with two benches, of a barter for a painting with furniture manufacturer one Malcolm Lazarus. Over coffee, the great man produced a writing pad and wrote out a contract. Witnessed by his young sister-in-law, we signed it across a postage stamp he happened to have in his wallet.

Thus 3A Pindock Mews, London W9 became officially mine. I have lived here ever since and seen my daughters through school – Lycée Francaise – university, and build their careers. Nathalie is a film-maker and Kaushaliya, an architect. Now a grandfather of three, I have witnessed many a drama – familial, national, international.

I have also lived through a variety of isms in art – good, bad and ugly – and ways of making art, but followed none other than those of my own making. Once during an unscheduled visit to the Alsace countryside, I chanced upon a stunning example of nature's play with itself. I saw two deeply scarred ancient tree trunks intertwined with each other like two lovers in a passionate embrace. Or they could have been two Neanderthal savages interlocked in mortal combat. The spectacle made such a deep impression on my psyche along with my recent scheme of thinking about my painting, that upon my return to my studio in my sister-in-law's garage, I found I was experimenting

Birth of a Nation, Bangla Desh, 1971–72

with tortured and twisted human forms. This caused a departure in my style. The outcome of which after several months was an exhibition of the body of work at Galerie Transposition, inspired by that new vision and approach to my work.

That was my most successful show in Paris commercially. Eighteen, mostly small paintings, got sold. But also sold were some large ones. Happily, the 54"-square oil PAGAN RITUAL did not sell and I still have it.

I went to see Mme Capitaine In Paris one day to round off the show. I found her in an unusually exuberant mood.

'Let's go and have lunch at la Coupole, Balraj'. I have to tell you something.' I had never eaten with Mme Capitaine.

Wow!

'Something happen today.' she said over an aperitif, Pernod. 'A lady come from the Ville de Paris to view your exposition this morning. She

Francine at the the vernissage of my One Man Show at Galerie Transposition, Paris, in 1972, with the painting *Birth of a Nation*

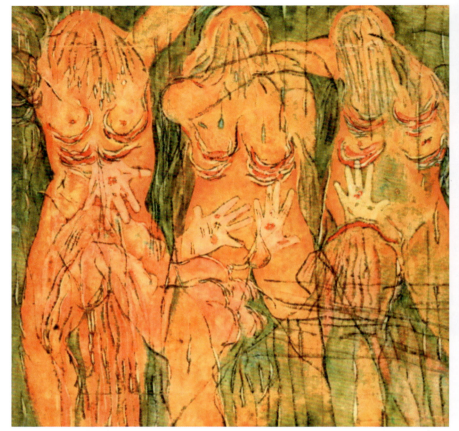

Pagan Ritual, 1968, oil on canvas, 54 x 54 in.

do so every exposition. After one hour of looking, young Mme Odile Briot not only buy your large powerful FIGHT FOR THE BODY for Paris, but also one small one for herself. It never happen before. Never.'

I leapt off my chair and planted a kiss on her left cheek.

'Balrhaaj!!!'

. . .

I had forgotten what W.G. Archer had once said, something in passing about a show for me at the Ashmolean in Oxford. It was one of those too-good-to-be-true things. But I had a surprise – a letter in the post. It was from one Dr James Harle, Keeper of the Oriental Section of

the Ashmolean Museum, Oxford. It said that Bill Archer had spoken highly of my work last summer. He wondered if he could come down to London to see my paintings one day in the near future.

James Harle, fifty or so, tall with a 1940s stage actor's fashionable moustache, came with his equally good-looking wife Carola late one morning. They spent a good couple of hours over an improvised French lunch talking and looking. To my immense delight and total surprise, they bought a medium-sized painting. Crowning their visit was an invitation to exhibit at the Ashmolean in Oxford of ancient colleges of the highest learning in the land, taking to the pinnacle of all that was human knowledge. The show was to be held that autumn.

I was totally in love with the legend of the ancient town of knowledge. I was 28 and exhibiting at the Ashmolean no less, left all my friends in awe. Consisting of some twenty plus paintings, my show opened on a crisp and bitterly cold November morning in a large ground floor room. There was a notice board with my name and the dates of the exhibition 2 November – 5 December 1968 under the immensely tall and imposing Palladian portals, much like those of the British Museum itself. A good private view crowd turned up. James Harle keeper of the Eastern Section of the Museum took a painting for its own collection, an honour, though it was not one of my best works.

All present were impressed. The Parisian Punjabi Ravi Kumar no less. By now we had become good close friends, visiting each other in the two capital cities, one of pleasure and fun, the other of commerce and power. Like all young Indians, our friendship flourished on the premises of constant banter, laughter and eating together Punjabi dishes cooked by him.

In fact I learnt to cook from him. Our meals were accompanied by an extravagant but warm exchange of rude words, essential amongst Punjabi men friends, a leftover from their boyhood. The bugger was well-connected worldwide.

On one of his visits to London soon after my Ashmolean show that winter, Ravi took me to meet a friend who was also a collector of modern art, Ravi said. He told me a bit about his friend, an old Hollywood woman. Ella Winter was not an actor or a director, but she knew every actor, director and producer. She collected contacts, especially of the great and the good. She also collected art, good and great art.

'She once owned one hundred Paul Klee watercolours!'

Staggering as that sounded, what Ravi said further left me partially breathless:

Her husband was the film writer Donald Ogden Stewart. Ella and her hubby were a famous Hollywood couple who had been blacklisted as communist sympathisers as the Cold War set in. They were among the Famous Ten Hollywood individuals who had to flee from the US to avoid persecution during the so-called Macarthy Witch Hunt of the period. The Stewarts lived in Frognal in nearby Hampstead in a house once inhabited by a former British Prime Minster, Ramsay MacDonald.

'You are going to meet Hollywood Royalty in exile. So look like those you are going to fight, as they say. So look your best.'

In the bus to Hampstead, Ravi told me that Don was a Hollywood scriptwriter who had been awarded an Oscar in 1939 for the all-time great box office hit PHILADELPHIA STORY with his namesake James Stewart and Katharine Hepburn. Furthermore, Don was a close cinematography pal and collaborator of Scott Fitzgerald of THE GREAT GATSBY fame.

Boy oh boy! this was living history if history can be viewed as such. I couldn't wait to get off the double decker from my house in W9 to a former Prime Minister's house in NW3.

103 Frognal turned out to as I had imagined it to be – intimidating with a grand drawing room, walls plastered with paintings and the carpeted floor crammed with sculptures. Through a conservatory well-filled with floral exotica, there was a view to a long terraced

garden. Scores of flowering shrubs filled it. It vaguely reminded me of a lapidary inscription in Delhi's 17th-century Red Fort's royal quarters: 'if there is Paradise on earth, it is this, it is this, it is this'.

I am exaggerating.

A glass of wine and 15 minutes of us being there, the warm-hearted grand-motherly hostess with the mostest art let it be known she disapproved of my attire, giving me a loud kick on my derrière – I had done my best to look my best.

'I was expecting to meet an artist, not a debonair trainee executive. Raavi said you were a painter.'

'But Ella, Balraj is a painter,' Ravi said.

'Then take me to see what he does.'

'Your word is my command, madame.'

'And where is your lovely French madame, Raavi?'

'In Paris, Ella. She'll be here tomorrow.'

Over lunch in the dining room next to the library on the ground floor, it was agreed that the mistress of this big and beautiful house, this funny old woman, would come to my humble abode to see my paintings the next day.

My heart jammed in my throat. I wanted the next day to dawn there and then. Now!

My friend arrived first, with his just-arrived-from-the-French-capital wife, beautiful Françoise. She had never been to Pindock Mews. She was sort of dumbfounded to see such a huge body of my work.

'Mon dieu! You've been busy, Balrhaaj.' That was how the French always pronounced my name.

If the young French lady was impressed, the old American woman was certainly not even moved. She merely rattled off names such as Klee, Miro, Kandinsky, Gorky and … she said my paintings reminded her of.

'But essentially, it is you. Very much you, Balrhaaj.'

The Jewess Ella Winter, too, pronounced my name like the French.

She returned Francine's half embrace greetings with smiles. Then she looked and looked, turning canvases stacked facing the wall and did not once glance at the cup of coffee Francine had placed for her on Souza's long oak table in the dining room under a skylight. I had hoped that the loaded art collector might buy a small painting, small because there wasn't an inch of wall space for anything larger in that house of hers. I was deeply disappointed when the lady displayed no commercial interest whatsoever in acquiring anything. Yet she surprised me, hitting me cross-bat for a six lofty enough to go over the pavilion at Lord's a long way away. 'Balhraaj …' she muttered.

A mile-long silence followed.

'… You know what?'

'What?'

Was she at last going to say she was going to buy this painting or that after all?

But no.

'I have never done it before, but I am going to do it now. I am going to have an exhibition of your paintings in my house.'

'WHAT?'

'Yes, an exhibition of your paintings in my house 103 Frognal. Let's go there for a spot of lunch and to look around. Thank you for coffee, dearie,' she said to Francine.

Down in the street, we hailed a cab and ten minutes later we were in a former British Prime Minister's house to create spaces for an exhibition of paintings by a young Indian who, according to Winston Churchill, was no better than vermin as WC in his youth regarded all my countrymen. This young man was now about to adorn the wall of a former fellow Prime Minister's house, albeit of the opposite political views. What irony. What an honour.

Sunday, the 8th of December just around the corner was named for my One Day One Man Show at 103 Frognal, London NW3.

. . .

A rather pleasant morning for December. It displayed an encouraging hint of the sun. A good start. Having risen early as usual, I arrived early circa nine, even though we had spent much of the day before to hang the show. Just to make sure everything was just right.

Everything was. There was wine a-plenty, both red and white. And soft drinks. Ella's daily had made a mountain of tiny triangle of assorted sandwiches. I knew it would get demolished before the clock had traversed to mid-morning.

Guests started turning up immediately after ten, gusts of them. I didn't think people started drinking early in this country. How wrong I was? But happy on the whole. Ella was trotting around, greeting guests by kissing the air around their cheeks. Some she hugged as long-lost beloveds, fuddy-duddy contemporaries all, many on crutches.

Her husband Don was indisposed, we were told, and was bed-ridden upstairs. I excused myself and went upstairs to greet him. In the master bedroom of two spacious single beds, there were some sofa chairs and a writing desk etc. The master of the house was reclining, his wizened face popped out of a lightly padded quilt. Unwell he might have been and silent, but the renowned humourist was yet loud in displaying his talent. This was illustrated by the calligraphy on the headboards of the two beds. One of them said Mr Donald Ogden Stewart. The other indicated the bed belonged to Mrs Donald Ogden Stewart. That made me laugh.

'We like people to know who's who around here.' Don also laughed.

Back downstairs, it seemed that people from page after page of the nation's WHO'S WHO had invaded 103 Frognal – I must have been the least known of ten score and upwards of them. We started selling paintings. At least two of the buyers would become life-long friends. They were Mary Gilliat and Roger Gilliat, a distinguished neurological surgeon whose father had been the personal physician of the late King George V1.

'Boy oh boy!' I said to nobody.

Mary bought a lovely big all-pink painting entitled An Area Of Festivity. It was priced £150. She asked me for a discount. So I reduced it to £120. That was the start of a beautiful friendship lasting over decades.

Then there were Charles and Pat Sonnabend, cousins of Illeana Sonnabend of the famous Paris gallery. A few years later, they would commission me to adorn their garden swimming pool with a mosaic in cosy leafy St John's Wood. I made one, very sexy, with my own hands, around all its sixty-foot long and 18-inch high wall around the pool, taking me four summers. At £300, it was a pure labour of love, making visitors say Charles should have added at least one more zero after 300. (this was something I would do time and again in the future and no regrets – sheer love of labour). There were many others of fame and means beside them who lit my life with wit, charm, and learning.

In the hubbub, Francine arrived mid-afternoon with three-and-a-half-year-old Nathalie. (Maman, Francine's mother visiting, looked after eighteen-months-old Kaushaliya whom I began to call my Pepie). They looked around and then went straight up – it was too noisy downstairs. Most of the people had congregated in the Stewarts two/three large rooms downstairs and the entrance hall with the doorbell never ceasing to ring.

Once I happened to be by the front door and had to answer it. As I opened the door, I came face to face with a little man with white hair. He looked vaguely familiar. Accompanied by a wife and daughter in her early teens. After having taken a good look at the pictures – the girl appeared to be struck by one in particular – then they went upstairs to see the indisposed master of the house.

Not long after, summons for me came from upstairs.

'Don would like to see you.'

Upstairs, the visiting man and woman sat in sofa chairs by Don's bed and the young girl was playing with Nathalie on the carpet away from them.

'Meet our artist in residence, Charlie,' Don said.

Charlie! The penny dropped. The expression on my face must have told the guests how I felt.

'I have a story to tell my grandchildren that I met Charlie Chaplin. That he came to my show.'

'And Victoria has seen a painting downstairs she would like to buy,' muttered mine good hostess glowingly. That made my day twice over.

. . .

But the euphoria of a museum show at the Ashmolean no less, the country's second greatest after the British Museum, and the great lady Ella Winter's memorable One Day bash, was shockingly short-lived. A totally unexpected seismic kick in my ass was just around the corner.

The doorbell in 3A Pindock Mews rang one morning about nine and disrupted my routine of writing. I took a moment or two responding to it. Downstairs, I came face to face with a very tall and very thin man of stern countenance carrying a bulging satchel. He assumed I was the so and so he had some business with. He stated he was a bailiff with orders to take possession of 3A Pindock Mews immediately because I was its illegal occupant.

'You must be joking,' I cried and said this, that and the other to the effect I had been let the flat by my dear friend the great artist F.N. Souza.

The fellow told me that great or small, Mr Souza had been declared bankrupt quite some time back. As such he had no legal right to rent it out. It was immaterial if I had been paying him rent or not.

A shouting match ensued. It brought Francine, still in her nightie, down. I told her what the bailiff had said to me.

'Darling, the gentleman is a bailiff. He says we are here illegally. He has come to evict us. He says we have exactly twenty minutes to pack up and take whatever we can and leave.'

Francine unceremoniously told him to bugger off.

'We have two small children, one three and a half years old and the other a mere six month! Where the hell do you expect us to go?'

'It's none of my business, I am afraid. My business is to ensure you leave and put a lock on your door. Any resistance would be met with force,' saying that, the bastard pulled out a massive padlock from his bag with a bolt, screwdriver and the rest.

This sent the 21-year old French girl into hysterics. I nearly gave the monster a knockout right-handed punch on his ugly mug. By now neighbours had come out in the Mews upon hearing Francine scream. Anything could have happened. Someone sensing serious trouble, dialled 999. A police car materialised within minutes. When I showed them the piece of paper like Prime Minister Chamberlain returning from Munich after meeting the Führer in 1938, the police officer politely informed me that the agreement on it was not worth the paper its was penned on in spite of the postage stamp. The man smirked, looking around. 'It was written by a bankrupt individual who had no right to write it.'

We looked from face to face among the sympathetic throng. But saw no sign on any of hope.

'You have twenty minutes. Go back upstairs and get your stuff,' the bailiff shouted.

In the Mews there lived another French woman, the beautiful Anick who could have been Brigit Bardot's first cousin. With her husband, Irishman Tony Folley, we were good family friends, wining and dining each other. Anick was vivaciously funny. The Irish Tony had a quick wit and a splendid love for Guinness. He was a man with connections.

'Not so fast, Mister. Not so fast,' Tony spoke quietly but with authority. 'Nobody is going nowhere. Perhaps there is a way out. A close friend of mine is a well-known solicitor. Let me speak to him. Maybe he can help stay this order of on-the-spot eviction. I hope my friend is at home.'

We all trooped upstairs for Tony to use the telephone. Luckily, Tony's friend was at home. As we held our breath, he spoke at length with the bailiff who kept nodding gravely to himself menacingly. If I felt half in the grave of suspense, my wife was in one doubly deeper. After a good few minutes, smiles suddenly broke on the Irishman's handsome face, pulling us a little out of our joint grave.

Life was restored to us fully when it was announced that wonderful Tony's wonderful friend had agreed with the thin man with fat padlock that he would arrange with the solicitor of the Francis Souza's Receivers to agree to allow me to buy the remaining few years of Mr Souza's defunct lease on the flat if I could do so straight away. I had put in a trunk call to Francis in New York. It finally came through sooner than I had anticipated. He was desperately sad about it all. 'These bailiffs are all leeches, the sons of godfuck bitches', he said. 'Do the best you can for yourself, Balraj. But don't forget to take the carpet in the living room with you if you do have to go. It's new.'

That made us both laugh – here I was at the verge of being thrown out into a London street with my young family, and there he was across an ocean going on about his new carpet!

Tragedy averted. The bailiff went away. End of the story.

It was the end of one story, but it was the beginning of another. After several days' of negotiations, the price agreed between the two sides for the remaining six years of the Souza lease was £750.00, not an unreasonable-sounding sum. It meant that if I could come up with the money, 3A Pindock Mews would become my property for those six remaining years of the lease.

It all looked fine and dandy, but with just one little thing – where was I to find £750 within seven days, a very large sum in 1968? I had no more than £150 in the bank. And it would take at least three weeks to get money from my family in India, that being time scale those days for money transfers internationally. Unlike now when you can dial any

number in any country of the world at any time of the day or night, back then, you had to book trunk-calls which cost the earth and could take up to twenty four hours for telephonists to make your connections.

My Belle Mère came to my rescue, if only partially. She lived on a salary. But she could borrow money from her employers, the French Tele Communications. And she borrowed the maximum she could, the princely five thousand Francs, about £300. That still left me quite a bit short. But somehow, my family in India managed to have the money sent to me through mutual exchange of rupees into pounds, a common practice then as now amongst family. The house now became ours and we could continue to live in it rent free till the lease expired. Then it would revert to the original owner, the Church of England. In due course, I would be allowed to buy it outright for it to be mine for ever. Till then, though, I would take a mortgage on it for a staggering 40 grand.

All this was too much for my unmathematical head. And I left it to the whizz kid of the family, Francine, not just a pretty face, but also one with brains. She managed to have the sum reduced to 36 grand.

. . .

More shows followed in quick succession. One group show at the Cartwright Hall circa 1969, would go down in my annals memorably. A large painting measuring six foot by eight, FOREST WALK, painted that year was purchased by the Museum for its permanent collection. It was directly inspired by the Bois de St Bernard outside Metz. It would be chosen by Tate Britain for its great historic exhibition, ARTIST & EMPIRE, nearly half a century later in 2015–17. Tate Britain's brilliant curator Carol Jacoby wrote a profoundly insightful essay about it and my painting on the whole. I was so moved, humbled and honoured by it that I felt it must be included in these pages.

A show came along the next year, 1970, at the well-known, but much under-valued Commonwealth Institute. This new wave architectural behemoth boasted an immense gallery strictly for artists from the

BALRAJ KHANNA b.1940
Forest Walk 1969

Oil on unbleached calico 172 x 213
Cartwright Hall, Bradford

Forest Walk marks a decisive event of Balraj Khanna's early career. In 1969 he suffered a catastrophic motorbike accident and was taken to rural France to recuperate. The work evoked sensations of coming back to life and his first steps in the woods, which in turn summoned impressions of the wooded hills of Khanna's youth and deeper resonances of fairytales and myth. The flickering blacks and whites on a green field suggest light shifting through moving leaves above or dappled ground below, and flashes of red imply flowers, birds, animals or other presences perhaps, like young Krishna and his brothers or Red Riding Hood. Despite this suggestiveness, the work remains entirely abstract.

Khanna was born in the British Punjab in 1940 at a time of unrest and change culminating in its partition during independence and the creation of Pakistan and India in 1947. In the 1950s Indian artists and writers explored identities that reflected on their country's heritage and future. In 1961 Khanna graduated in English and literature at Punjab University in the new capital Chandigarh, designed by Le Corbusier, and travelled to Britain to continue his studies the following year. The outbreak of war between India and China interrupted his plans. He joined the artistic community in London and resumed his childhood practice of drawing and painting, quickly becoming integral in the 1960s international abstract movement and laying the foundations for a global career.

International abstraction chimed with both a universalism and an orientation towards the abstract in Indian art, and Khanna pioneered abstract colour-field painting in London, exhibiting at the 2nd Commonwealth Biennale of Abstract Art in 1965. Artists after the war were preoccupied with an art of effect, one possessing non-illustrational physical qualities that could bypass intellect and act directly on the viewer. Khanna in his writings on Indian art identifies a complementary tradition of *rasa* and *bhava*, an evasiun of real appearance in favour of forms and colours that 'arouse in the beholder the desired response'. His work orchestrates a call and response of concave and convex forms, qualities he admires in Indian sculpture, in a modern idium, and familiar in the curves and planes and harmonious asymmetries he would have experienced in Le Corbusier's Chandigarh Capitol – especially the latter's *La Main Ouverte*, at once 'open hand', bird and abstract shape – as well as in the work of Paul Klee and Joan Miró, to whom he has often been compared.

Khanna's art has a distinctive immersive quality. Large works like *Forest Walk* fill the field of view and deny the observer conventional clues to distance or depth. Even the canvas plane, so fundamental to the American abstraction championed by Clement Greenberg, is evasive; in later works Khanna devised ways of texturing the surface with sand and breathing the paint onto the canvas through a pipe to enhance this. Space is defined by shapes that are at the same time suggestive of cosmic and microscopic scale. They remind us of things at once underwater, airborne, or in an astral or infinite spice. Their coherence and harmony come from the way the curves and undulations, repeated colours and patterns, keep the eye dancing across the entire area of the canvas. The effect is effervescent, often festive, but at the same time enigmatic and fragile.

As well as this 'very essential emotional aspect', Khanna's work has a 'strong intellectual base'. His carefully conceived shapes appear both natural and man-made, with birds and bunting, fish and flags, figures and toys, motifs that also populate his work as a novelist. In more recent works Khanna has cut his shapes from a single form, their jigsaw relationships tantalisingly retained, in a reference to the 'big bang'. This motif of simultaneous unity and disintegration is an appropriate one for an art after Empire, at once distinct, personal and universal. **CJ**

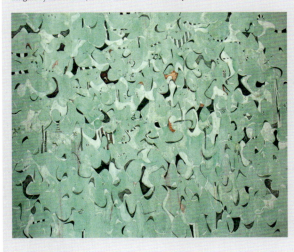

Commonwealth countries. It gave me the opportunity to give vent to what I doted on doing best – make large-scale paintings. I found this format liberating. I felt it expanded my horizons as I grappled with wide expanses of space, filing them with feelings exuded by a variety of colours. Along with very small works, this show contained a few

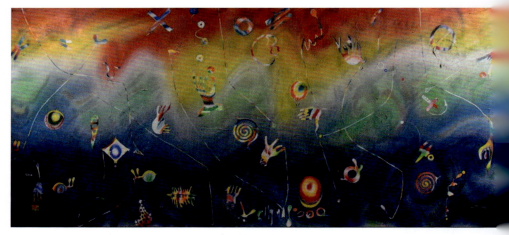

Festival, 1970, 72 x 144 in.

six-footers. But what gave me the most freedom, and fulfilment, was the 6 by 12 foot painting I entitled FESTIVAL. Swarming shapes in reds and judiciously chosen bits of other colours contained by taut lines made the painting twinkle merrily.

(It was shown in my first New York show at the Herbert Benevy Gallery the following year, in 1971, where it wowed the Americans who love to think big and do big and who came to my show. A young couple wanted to buy it. But the painting's size was too big for their living space. Instead, they walked away with two six-footers.)

Painting the big FESTIVAL and other large works was to give me the confidence to meet the challenge of making paintings more monumental. Thus, sometime later at the turn of the century, I would go on to win a prestigious national competition. It was to create a painting measuring 26 feet by 48 feet to cover the Safety Curtain of the newly reconstructed 1898 Hippodrome Theatre of Birmingham. It was the largest outside London with 2,000 seats. The painting was also the largest in the country. The money for this mega project was to come from the European Union, a highly coveted commission. It paid off my mortgage, making 3A, Pindock Mews W9 2PY legally mine for the next 999 years as the documents said. Art pays!

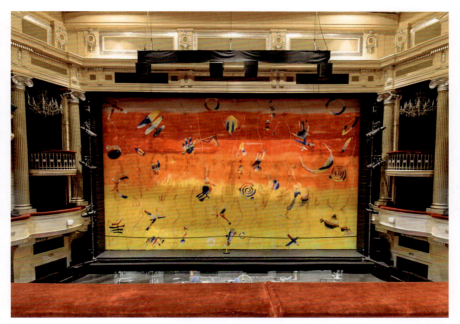

Astral Dance, Hippodrome Curtain, 2001

Ella Winter was a hostess who loved entertaining. So did I. So we started lunching chez one another. When she came, she wanted to see my new stuff, buying a small painting now and then. One day the feted American said why didn't I try New York, the bubbling new art capital of the world. 'I know a few people there who could help.'

That idea greatly appealed to me. It sent me flying over the moon and beyond. I had more than enough work in 3APM. I rolled up a number of canvases and I got a cheap return ticket for the incredible sum of 60 quid with the new Laker Airline. When ready to take off, Ella gave several introductions, the foremost among them was her best friend, Dr Josephine Martin, a distinguished psychiatrist renowned for her work with the poor black community in New York City. Ella said I must call on her first.

NYC did to me what it does to every first timer there even when one is still in the plane above it, a gargantuan cement sculpture, a mind-boggling spectacle. My mind still boggling, I arrived there on a

Invite to my first One Man show at
Herbert Benevy Gallery, New York, 1971

fine Friday morning. I checked in at the YMCA for one dollar a night and called Dr Martin. I was told by the housekeeper that Dr Martin and her husband Dr Robert Schwartz, an economist, were away at their Long Island house for the weekend.

Bowled over by the skyscrapers and sheer glamour of NYC, I couldn't stop looking up at its deep chasms till I got cramps in my neck. I walked and walked and saw the glorious city's every sight. I loved the MOMA and was staggered by the breath-taking Met. I waited for Monday. It was long in coming.

Monday eventually came and with it came an invitation to supper that night: 'Bring your paintings with you,' said Dr Martin – music to my ears.

I turned up at No. 35 West 95th Street with the roll of paintings under my arm like an Indian carpet-seller, just as I had done on my first trip to the world's sexiest city, Paris.

'Jo. Robert,' Ella's friend Dr Josephine introduced themselves. They had two other guests – the young black Civil Rights leader George Foreman and the black Mayor of Mississippi, Unita Blackwell. It was a supper to sing for.

'But where are you staying, Balraj?' asked the hostess towards its end when I had unrolled my canvases and they were all bent over the pictures.

I told them.

'Oh, the Y. No, you are not staying there.'

'But I am, Dr Martin.'

'But you are not. And it's Jo.'

'But I am, Jo.'

'No, you are not. You are staying here from tomorrow. With us. In my office and consulting room. It has a large convertible sofa …'

Just like that, I had a new family to belong to. This sort of thing never happened to anyone even in India, legendary for its hospitality – nobody invited anyone to stay after meeting them over their first meal together. I stayed my scheduled ten-day visit with my dream new hosts, sleeping on the sofa bed in Jo's large Office-cum-Consulting Room in their tall red stone house, eating with them, going out with them and just being a member of the family. It seemed I had known them all my life. Jo and Bob said exactly the same. They had only one son, also named Robert, who was working in Tokyo at the time.

Not only that, now I did not have to trundle across the great and mad city which never went to sleep with the roll of paintings under my arm looking for a gallery. For Jo found one straight away – Herbert Benevy Gallery in fashionable up town, owned by an old friend of hers of the same name. It all sounded too good to be true. But once again it was true and it was good. On the phone, Ella said to me it was due to my 'all-pervasive charm'. Jo and Bob listening, chuckled, spreading their all-pervasive charm and drowning me in it and a pool of laughter.

My first show there next spring was a near sell out and I sold my first painting for a thousand dollars. When I got back from the gallery that evening and gave Bob and Jo the news, they leapt from their flamboyant, ornately carved ivory twin chair and embraced me. Then Bob gave us a drop of bourbon. Glasses raised, he telephoned London. After a long wait, when he did get Francine, she was overjoyed in 3A Pindock Mews. Here in 35 West 95th Street, I deeply wished what every man would have wished for – being back with his wife and his girls.

I would have another no less successful show in the Big Apple the following year, my last there. For soon after, Julia Benevy became seriously ill and alas, and very sadly, passed away. The gallery had to shut down. But compulsive travellers Jo and Bob, now one family with us, visited us quite often. They spent some time with my sister Raj in Chandigarh where they were received with, characteristically, open arms.

Time passed. I painted more and more, moving from semi-figuration back to my own, newfound, abstraction. More shows came one after the other. At the same time, I kept working on what was to become, from a series of reminiscences of life in India, to a disjointed long story. I had two shows in London at the same time. One was at Ian Birksted Gallery in Museum Street opposite the British Museum. Due to the size of the gallery, rather small, it was to be a small show with one notable exception, the 12 foot by 6 canvas OUR OWN LITTLE KINDERGARTEN (bought by the Gallery of Modern Art, New Delhi, from my exhibition with Avinash Chandra there in 1983 at the Lalit Kala Akademi, India's national showpiece for its Modern Indian Art – it is still there with the NGMA, of course).

The other, a Major Show of well over fifty paintings, opened at the University of London's spacious Bedford Way Gallery. (Sadly, it closed down not long after the exhibition). It was opened grandly by Patricia,

Lady Harewood, wife of the Queen's cousin, Lord Harewood. The cumulative effect of these two seminal events was good write-ups and some welcome cash.

Until then, I had been teaching, although part-time. This was soul-destroying nomadic 'supply teaching'.

Supply Teaching was filling in for absentee teachers at north London comprehensive schools. Teaching at these schools was comprehensively bad. Non-existent, in fact. Most schools were so bad in terms of discipline and education that 'teaching' was the least of concerns at these temples of learning. (It was not unknown for some poor young female teachers to break down and rush in tears to seek solace and shoulders to cry on in the staff rooms from the 'theatres of war' some classrooms were known as).

I was doing my utmost – we all were, the regulars and the supplys – to reach out to pupils from 11 – 16/18. Even though officially my subject was English because of my MA, yet I had to 'teach' everything, from English (grammar did not exist), history, geography, sociology to woodwork and needlework. My only fulfilling days were those when a colleague in the art department fell ill, or went on long maternity leave or became victim of some sickness real or concocted. Then I got on with 'teachin' because I drew everyone's pencil portraits. Then the kids said, 'You orright, Mr Karna.'

Years later, I got a regular part-time, three days a week – post at two comprehensives one after the other. Before that, I had to trudge on. Because our daughters were born in France and had a French mother, we did not have to pay their school fees which at their prestigious Lycée for non-French pupils was shockingly expensive like at any top English public school. But we had yet to pay for their *nourriture*, their lunch. And we had to shell out for their private transport to and from their Lycée in SW7.

Money was always very tight, to put it mildly. So much so that Francine had to start stitching up army soldiers' dud shiny brass

belts for trendies much in fashion suddenly. This fashionable accessory replaced the usual leather belts. Francine earned one shilling per belt to make a few pounds a month for housekeeping. She never had enough money to buy a pair of stockings even. But the young French girl of a good bourgeois background never complained – we had a roof, albeit one leaky, over our heads, and were eating well. Thank God I sold a painting from time to time. But I plodded on without ever thinking about what I did not have or was missing. The only thing important was my art and my family. It didn't bother me or cramp my style if I often went without the school lunch which cost a pound, and bought a premium bond with it instead (I have yet to hit the jackpot) from the post office (I still have one dated 1973). I contented myself with a cup of tea and a bag of crisps. When I sold a painting, I saved the proceeds, knowing I would need the lolly one day.

Ella had seen a large all-red painting – RED SPREAD – over lunch chez moi of red kidney beans cooked my way with spices, quantities of garlic and ginger – rare to find at greengrocers' in those chaste days in England – and a ton of tomatoes. She had loved the painting, and my beans.

Even though the painting was a bit too big for her house, she would buy it one day, she often said. But that day didn't come till her very last on earth.

I was teaching when a member of the office staff came to say my wife wanted me to telephone her – it was urgent. Half trembling and fearing the worst, I asked a colleague next door to mind my class and dashed downstairs to the staff room. On the phone Francine said that a call had come from 103 Frognal to say Ella was very sick. Ella wanted to see me and that red painting. Would I bring it along?

Relieved beyond words, I took the day off and dashed home. Once there, I removed the painting from the stretcher, rolled it up and took it along with the stretcher and hopped in a taxi to Frognal. Reaching

103, I put the RED SPREAD back on its wooden frame and went upstairs to see Ella.

Ella was in bed. She had had a stroke, but she was still compos mentis enough to want to see the painting. When it was held up for her, she asked Don to write out a cheque for 4/500 pounds or whatever I wanted for the painting. Of course, I wanted none of it – sell a painting to a very dear dying friend?

Ella expired that night. Impossibly grief-stricken, Don passed away the next day. There were obituaries everywhere about Donald Ogden Stewart and his wife Ella Winter including in the *New York Times*.

At an auction by Bonham's in their New Bond Street Rooms three decades later the self-same Red Spread appeared for sale. It got sold for a respectable five-figure sum. Who bought it? I never found out, nor ever wanted to. It was a present to a much loved friend on her deathbed, perhaps the first and last in history.

I was writing copiously at the same time. Waking up early, I wrote from six to eight before dashing off to school in Kentish Town. I wrote in my free periods. At lunch, when my colleagues rushed to the staff room for the daily confabulation, mostly bitching against the Head or the deputy head, or lambasting the OFSTED inspectors for their ineptitude. I stayed in the room where I had my last 'lesson' and wrote.

All this resulted in my longest, the earliest and most promising long short Indian story ending in becoming a proper novel. With a pounding heart, I gave the manuscript to my friend Peter Townsend, editor of *Art Monthly*, the country's best art magazine. What if he said it was awful? He didn't say anything of the sort. Instead, he said he loved it.

My tail up at 90 degrees, I gave the manuscript to my art critic friend Peter Dormer. He said he read the MS wherever he was – in the bus or the tube.

My good cricketing chum and fellow pubbist Brian Walker's brilliant and beautiful girlfriend, Yvonne McFarlane worked for a

publisher, the Ebury Press, who published coffee table books only. A publisher nonetheeless. Gingerly, I gave my book to her one Friday expecting her to take her time reading it. But the charming girl telephoned first thing on Sunday, surprising me.

'You rascal,' she said, flooring me – what on earth did she mean, the ever-pleasant ladylike Yvonne? What had I done?

'You have written a damn good novel. I love it.'

Then she said Ebury didn't publish novels, but she had a good friend at Michael Joseph who did. She would like to try her. Would I give her my permission to do so?'

Would I now?

Her friend at Michael Joseph one of the top names in the world of publishing was a senior editor, Alison Burns. Word got back within days that she, too, loved the book. The novel as *Nation of Fools* was published next year, 1984, by Michael Joseph to rave reviews. It was great. It was humbling. It was unbelievable. I had never ever even dreamt of it. And more was to follow as already mentioned.

The same year, I was invited as a visiting artist to India by its Council for Cultural Relations, India's equivalent of the British Council. Francine went with me. As guests of the ICCR, we were housed in a top hotel, the elegant and opulent Kanishka, named after the 2nd century first monarch of the Kushan Dynasty. The hotel was in the heart of Delhi, the imperial capital of all dynasties to rule India, the last in the line being the non-dynastic Brits till 1947. We had a chauffeur-driven Hindustan car at our disposal and were suitably wined and dined by Delhi's art aristocracy and other such people. In return, all I had to do was talk, talk, talk about art in Britain and how the contemporary Indian art and artist could be, as they should be, appreciated and valued by Britain. One afternoon, our room telephone rang. It was young Kaushaliya speaking from London. Our girls had never telephoned us before. I feared the worst. My heart instantly lodged itself in my throat – something was dreadfully wrong and that's why

The great black American writer and leader James Baldwin giving me a prize for my unpublished novel *Partition* in 1991

Schoolchildren working from my paintings during my retrospective at the Arnolfini Gallery, Bristol, 1991

she was calling. That was me, the father – telegrams and international phone calls those days invariably were harbingers of bad news. Doom. I trembled.

'Everything all right, Pepie?' I had paid my tax bill for the year and discharged all other outgoings, then why was she telephoning?

'Daddy, there is a letter for you. It looks official. Shall I open it?'

'Yes, darling. Open it quickly.'

Kaushaliya opened the letter, I could hear her opening it.

'Guess what, Daddy?'

'What, Pepie'

'It's from the Royal Society of Literature.'

'Oh!'

'You've won a prize for *Nation of Fools*. The Winifred Holtby Prize. It is awarded by the Royal Society of Literature.'

'You are joking …'

Fourteen years later in 1999, 'Nation of Fools' was adjudged 'One of The Best 200 Novels in English Since 1950.'

Unbelievable stuff. Totally un-believable, the Prize and THIS. Too good to be true. Yet it was, it really was. And it was good, damn good.

THE END

GLOSSARY

Abba Jaan Muslim 'Dear father'
Ammi Jaan Mummy, Mum
Angrez English
Baithak drawing room
Banarsi fine hand-loom silk sari
Bania 3rd in heirarchy of Hindu Caste system, (Vaishya)
Barsati room on top floor of building
Bhagavad Gita 700 verse Hindu scripture
Bhangi Indian caste of 'untouchables'
Bhangra lively Punjabi dance
Bodi topknot
Bus 'bus, bus, bus' – 'enough, enough, enough'
Chapati unleavened flat bread
Charpoy woven string bed
Charra unmarried young man
Chaudhry Mayor
Chawk bazaar, crossroads
Churidor pyjamas
Desi native of India
Dhaab crater/pit
Dholuk drum
Dhurree rug
Dukandar shopkeeper
Gatta spun-sugar candy
Gora fair skinned person
Halla gulla hullabaloo
Harrapan inhabitant of Harrappa, Punjab
How Sen how it sounded to me as a very young boy, representing Hussain, Prophet's nephew
ICBM Inter Continental Ballistic Missile (Gorgeous Girl)

Jali perforated/latticed stone screen
Jaloos procession
Jamura a very young magician
Jawan soldier
Joon goli herb *Ashwagandha*
Jutti slipper
Kafila convoy
Khadi Kurta home-spun cotton shirt
Kama Sutra Hindu philosophy of sex
Kamiz shirt
Kothi house/villa
Laat Saheb Big Lord/VIP
La ill la ill-lill la Muslim *kalima* (There is no god but God)
Laltans portable lanterns
Lathis long ironbound bamboo sticks
Lotas ewers
Luli little boy's penis
Madaris street performers/jugglers/conjurors
Maidan open grassy space in city/town
Musalman Muslim
Nuggat type of pliable nougat
Paratha fried dough flat bread
Raat ki rani night scented Jasmine
Salwar legging mostly for women
Saraswati Hindu goddess of knowledge, music, arts and wisdom
Shikar hunting game
Sunnat circumcision
Thalis round trays containing assorted food in pots
Ziddi stubborn
Zindabad victory to, long live

WORK DURING THE COVID-19 PANDEMIC 2020/21

Photo: Philip Shalam

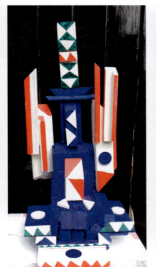

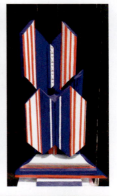
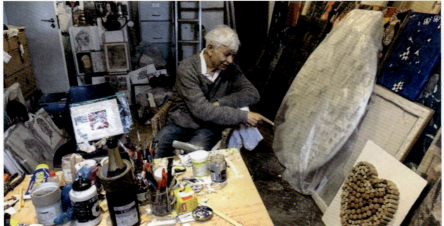

WORK DURING THE COVID-19 PANDEMIC 2020/21

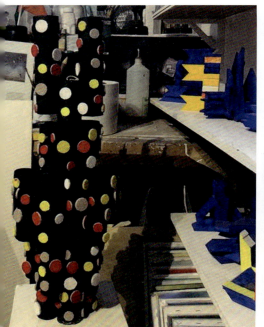
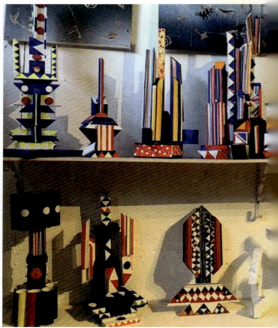